PRICELESS

The vanishing beauty of a fragile planet

Bradley Trevor Greive

International best-selling author of *The Blue Day Book*

Featuring the images of Mitsuaki Iwago

**Andrews McMeel
Publishing**

Kansas City

Other books by Bradley Trevor Greive

The Blue Day Book

Dear Mom

Looking for Mr. Right

The Incredible Truth About Motherhood

The Blue Day Journal and Blue Day Directory

The Meaning of Life

Other books by Mitsuaki Iwago

Serengeti: Natural Order on the African Plain

Mitsuaki Iwago's Whales

Mitsuaki Iwago's Kangaroos

In the Lion's Den

Mitsuaki Iwago's Penguins

Harp Seal Book: Three Weeks in an Arctic Nursery

Snow Monkeys

Puppies

Nature Calls: Mitsuaki Iwago's Earthly Wildlife Photographs

Priceless copyright © 2003 by Bradley Trevor Greive. Photographs copyright © 2003 Mitsuaki Iwago. All rights reserved. Printed in Singapore. No part of this book may be used or reproduced in any manner whatsoever without written permission except in the case of reprints in the context of reviews. For information, write Andrews McMeel Publishing, an Andrews McMeel Universal company, 4520 Main Street, Kansas City, Missouri 64111.

03 04 05 06 07 TWP 10 9 8 7 6 5 4 3 2 1

Library of Congress Cataloging-in-Publication Data

Greive, Bradley Trevor.
 Priceless: the vanishing beauty of a fragile planet / Bradley Trevor Greive ; featuring the images of Mitsuaki Iwago.
 p. cm.
 ISBN 0-7407-2695-1
 1. Endangered species. I. Title.

QL82 .G74 2002
591.68—dc21

 2002066607

Designed by Timothy Clift

ATTENTION: SCHOOLS AND BUSINESSES Andrews McMeel books are available at quantity discounts with bulk purchase for educational, business, or sales promotional use. For information, please write to: Special Sales Department, Andrews McMeel Publishing, 4520 Main Street, Kansas City, Missouri 64111.

Dedicated to the memory of

Gerald Durrell

JANUARY 7, 1925—JANUARY 30, 1995

loved and missed
by all creatures
great and small

PRICELESS

Most people assume that everything they care about will always stay the same . . . but it won't.

"In the end we will conserve only what we love and we will love only what we understand"

BABA DIOUM
African Ecologist

PRICELESS

The vanishing beauty of a fragile planet

If I were cruel I would tell you of a million wonders that you will never get to see and never get to touch.

Fascinating, beautiful creatures from all over the world that will never delight, amuse or astonish you.

Extraordinary lives of dazzling complexity that will never take your breath away

because we have already taken theirs.

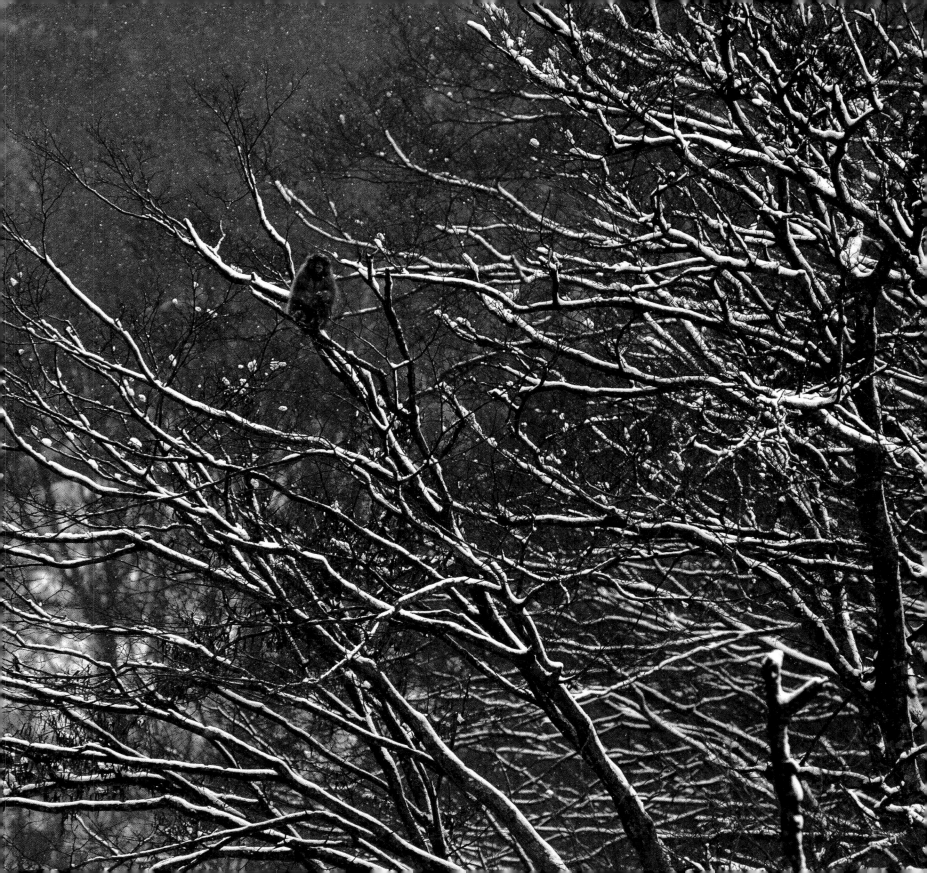

Instead, I will tell you about the incredible

colors

textures

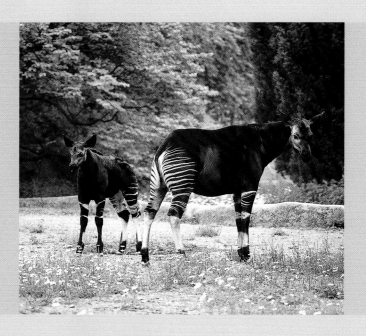

and

voices

that remain.

The priceless, living gems that share your world.

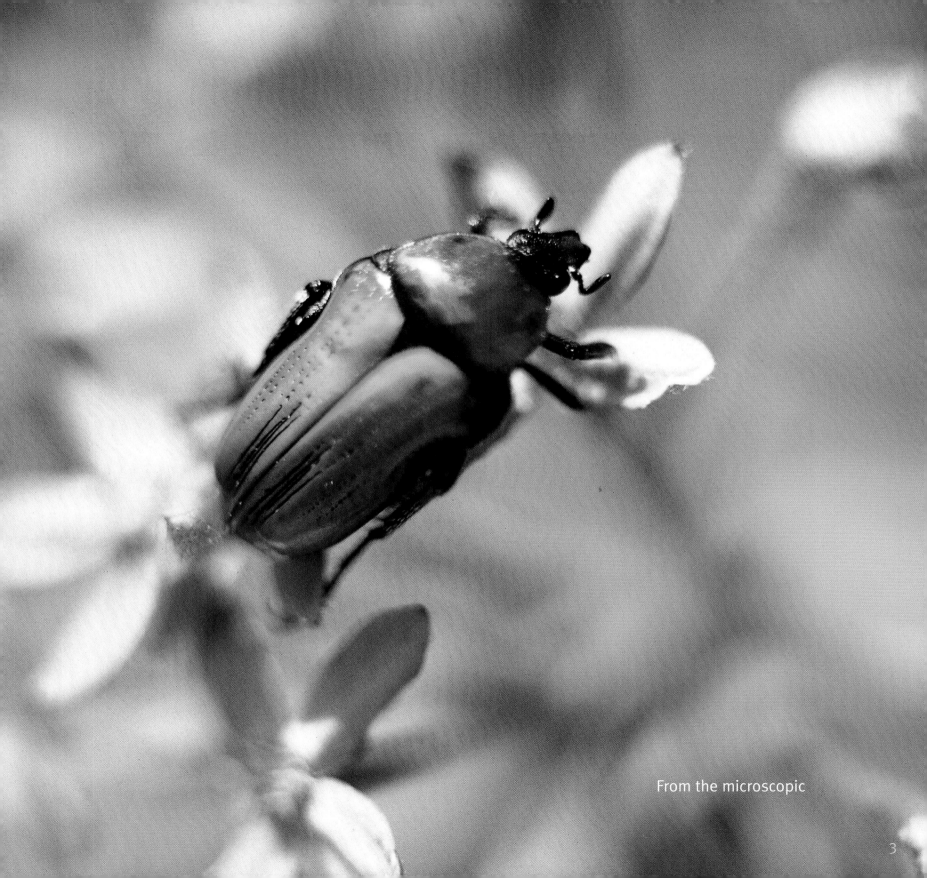

From the microscopic

3

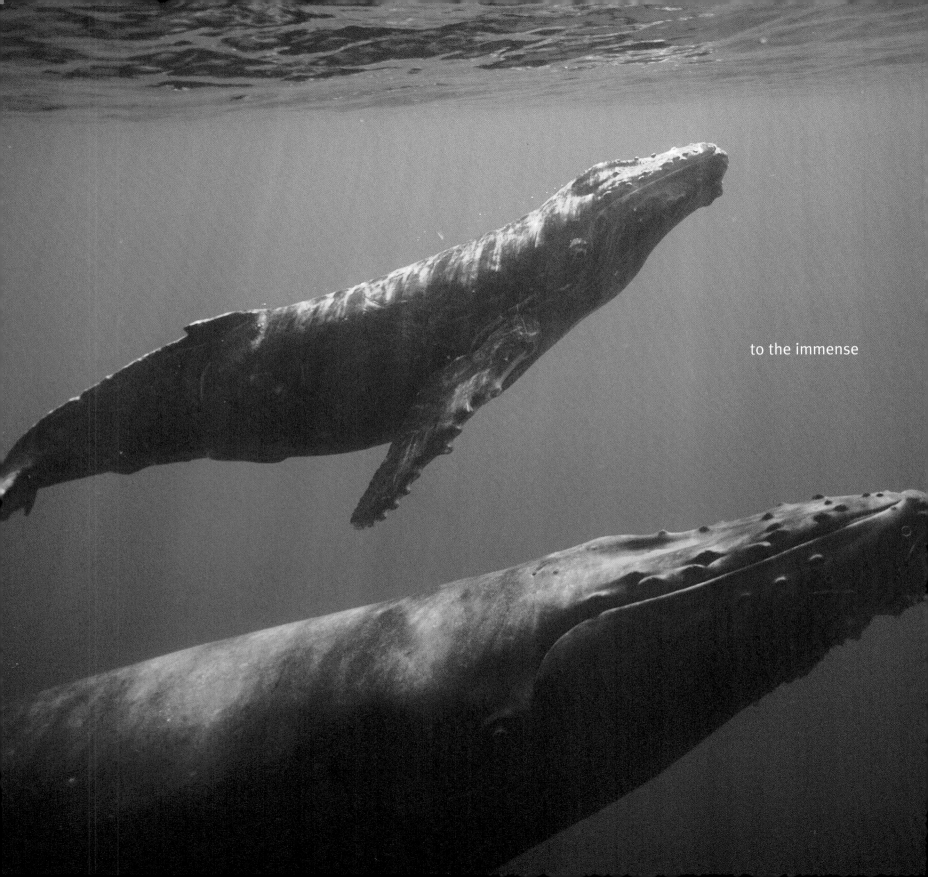

to the immense

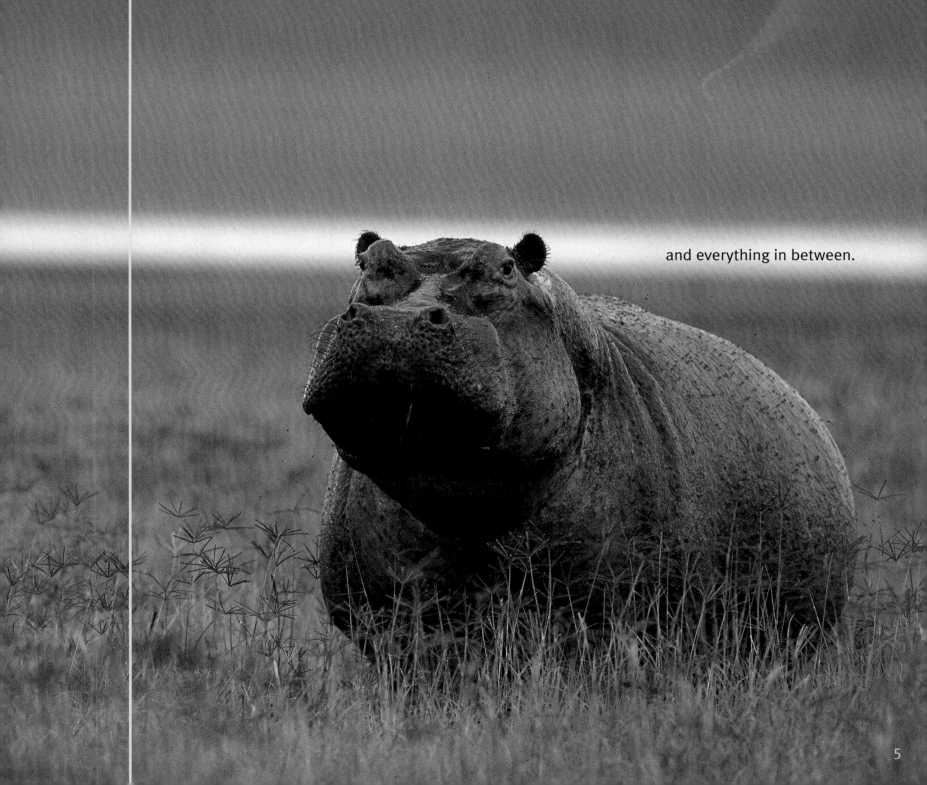

and everything in between.

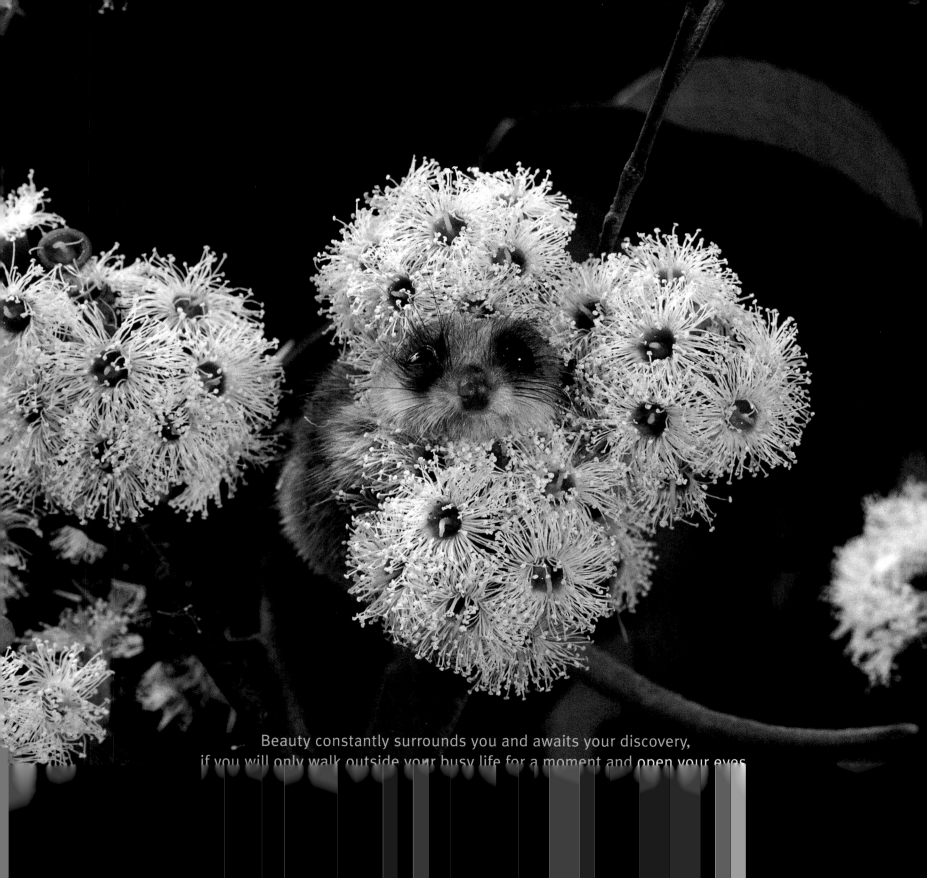

Beauty constantly surrounds you and awaits your discovery,
if you will only walk outside your busy life for a moment and open your eyes.

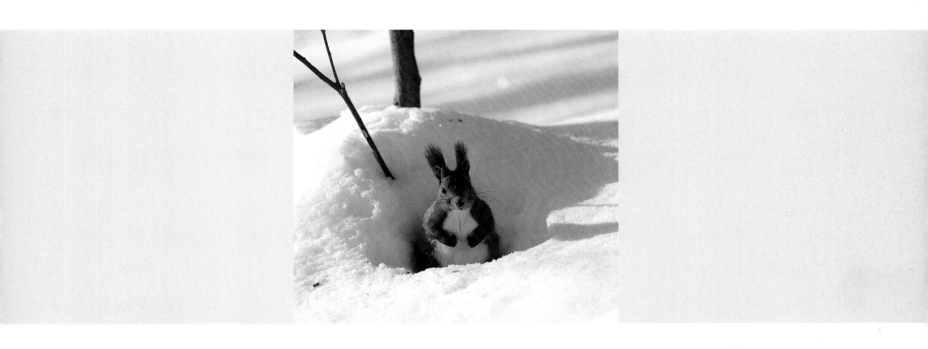

Nature is filled with delightful surprises.

We live among exotic neighbors who,
from the day they are born,
will breathe the same air and look up at
the same moon as you and, when they die,
will lie buried in the same soil.

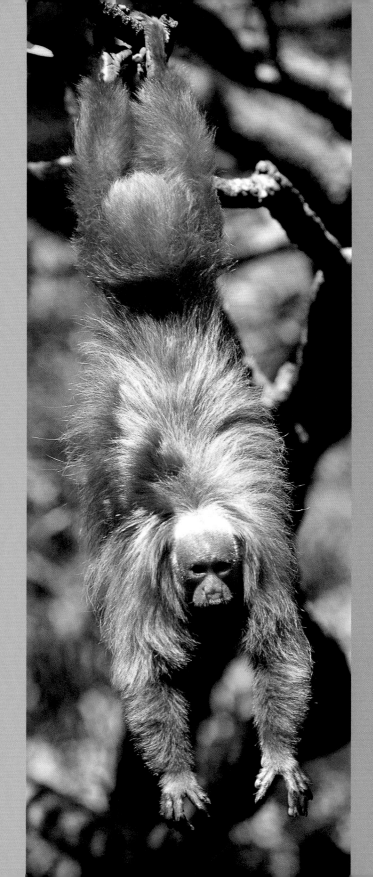

You have wasted your time on this planet

if you never witness Japanese cranes

perform their elaborate courtship ballet in the winter snow

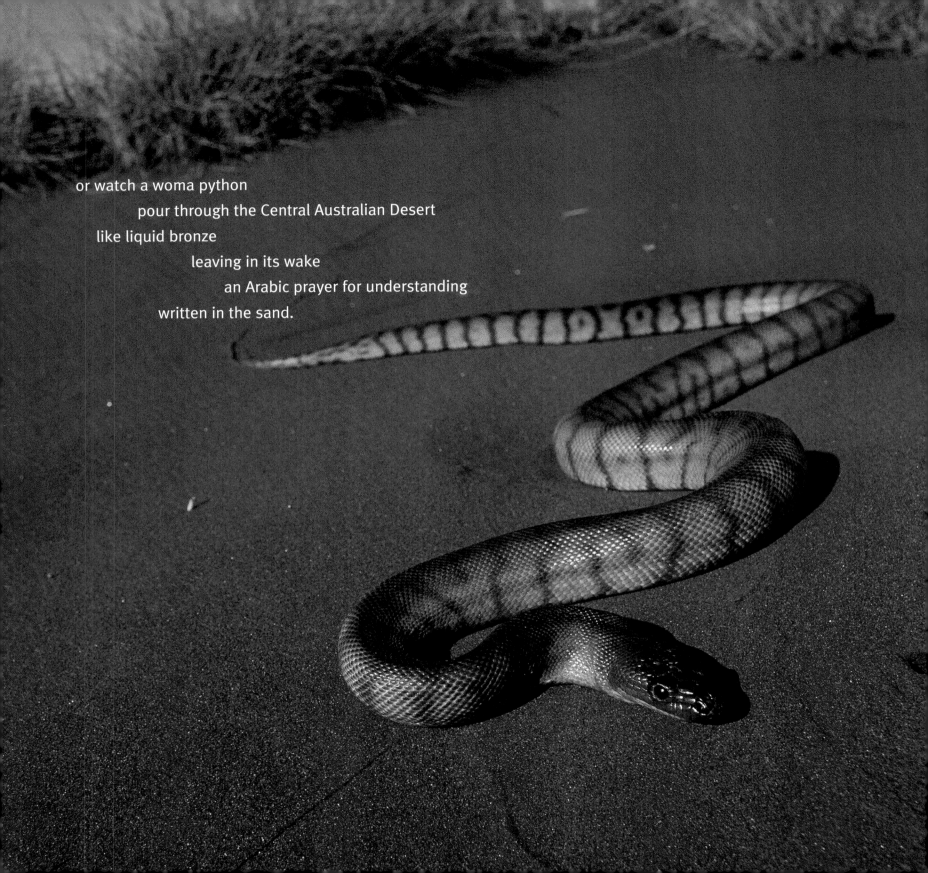

or watch a woma python
 pour through the Central Australian Desert
like liquid bronze
 leaving in its wake
 an Arabic prayer for understanding
written in the sand.

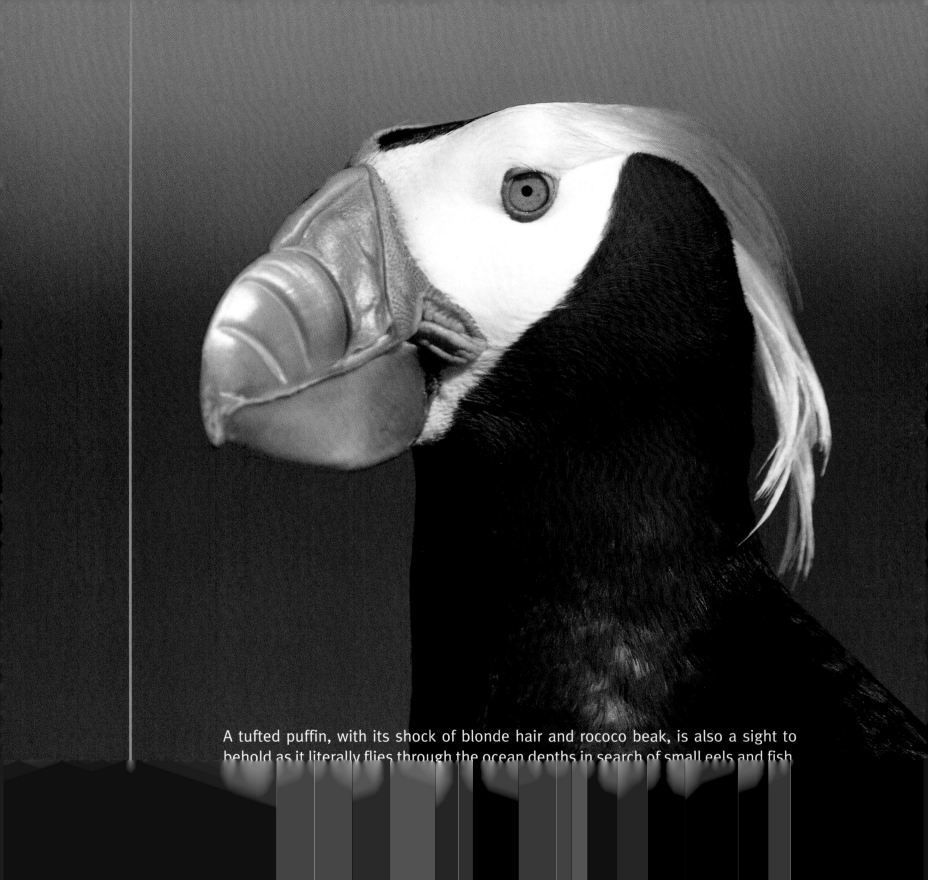

A tufted puffin, with its shock of blonde hair and rococo beak, is also a sight to behold as it literally flies through the ocean depths in search of small eels and fish.

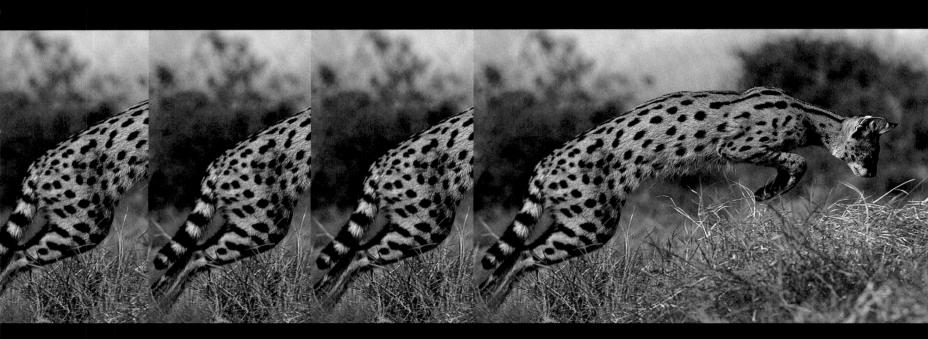

Equally astonishing is the plain-dwelling serval, most often seen as an explosion of black and golden fur, which has the extraordinary ability to leap high into the air and snatch flying birds right out of the sky.

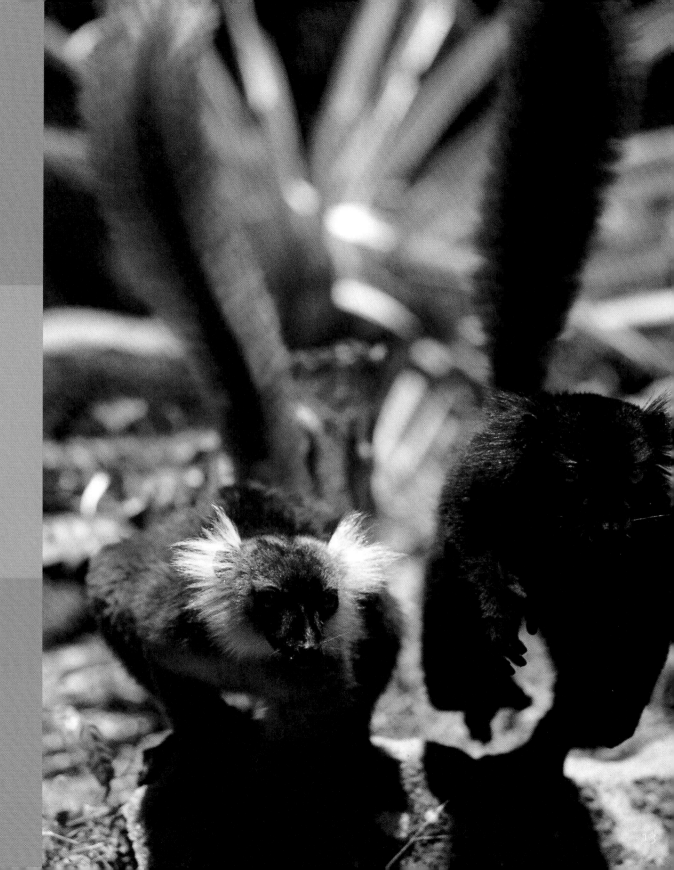

All the different lemurs on this earth come from the African island of Madagascar. As they run and tumble through the forest canopy lemurs call out with voices so musical and haunting that people once believed that the trees themselves were singing.

In nature there are just so many examples of amazing feats that simply defy belief.

A green sea turtle, for example, undertakes the longest migration of any living creature—an underwater journey

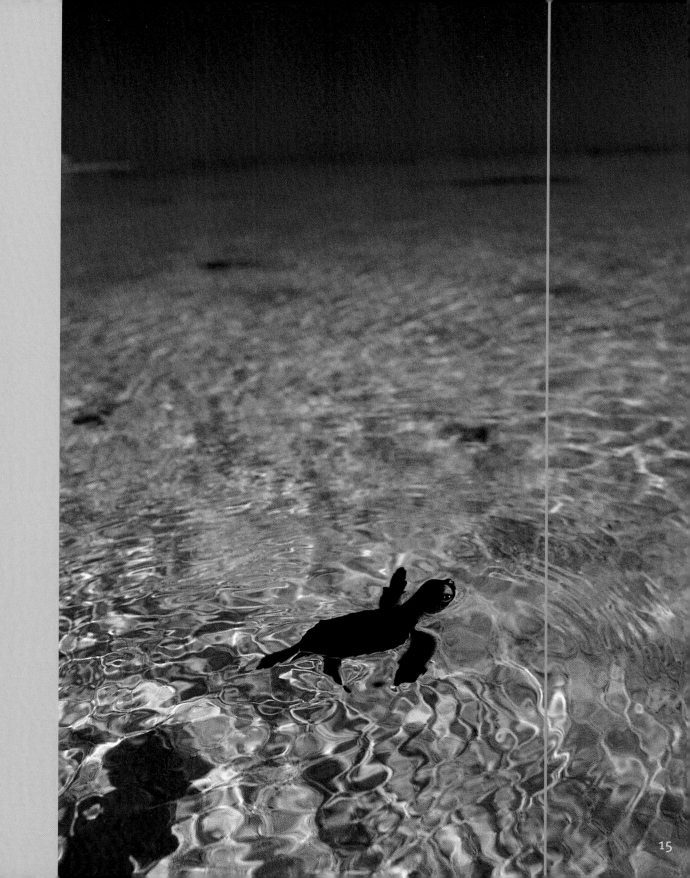

re than eighteen thousand miles.

Within the harsh dry country that Australians call the "Never-Never" dwells a smallish lizard that bristles with sharp defensive thorns and is actually an antigravity machine. Without moving a single muscle its violently corrugated skin miraculously elevates water from the ground and carries it up its legs and all along its body to direct a refreshing drink into its mouth.

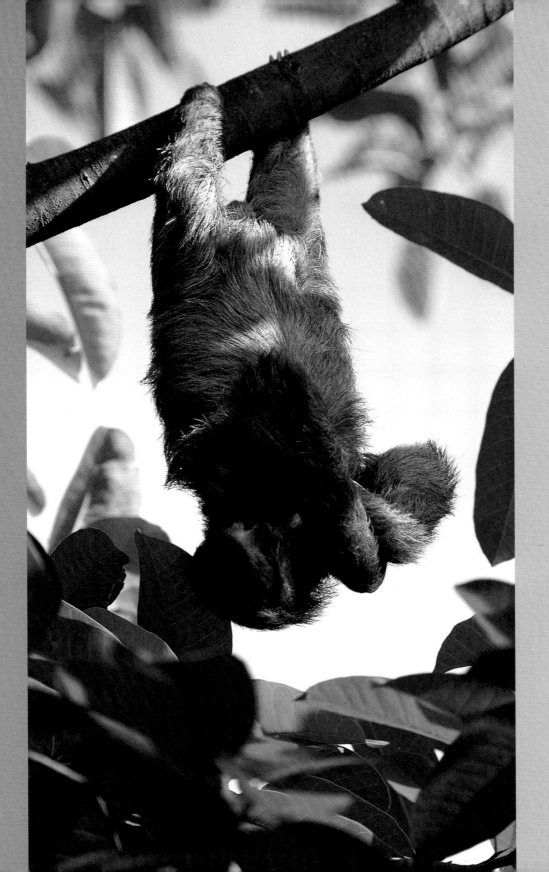

In the dwindling rainforests of South America the three-toed sloth lives a monastic life of quiet contemplation and meditation.

It barely moves at all.

Male sloths often spend their entire lives in the same tree.

17

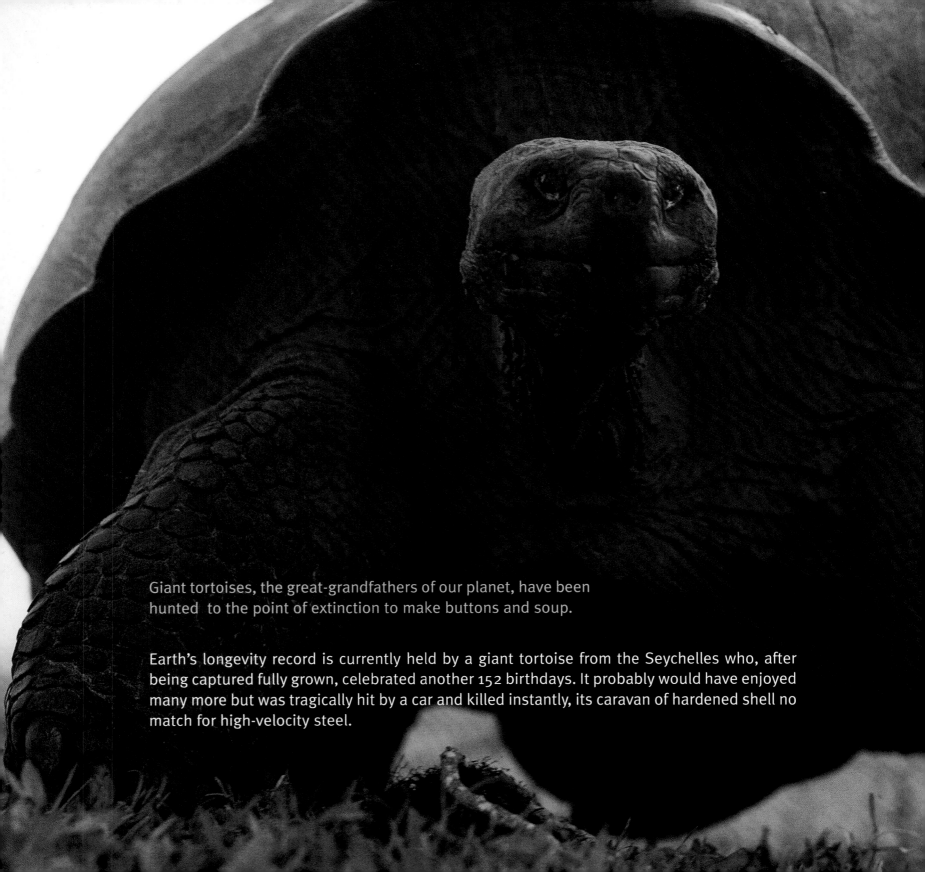

Giant tortoises, the great-grandfathers of our planet, have been
hunted to the point of extinction to make buttons and soup.

Earth's longevity record is currently held by a giant tortoise from the Seychelles who, after
being captured fully grown, celebrated another 152 birthdays. It probably would have enjoyed
many more but was tragically hit by a car and killed instantly, its caravan of hardened shell no
match for high-velocity steel.

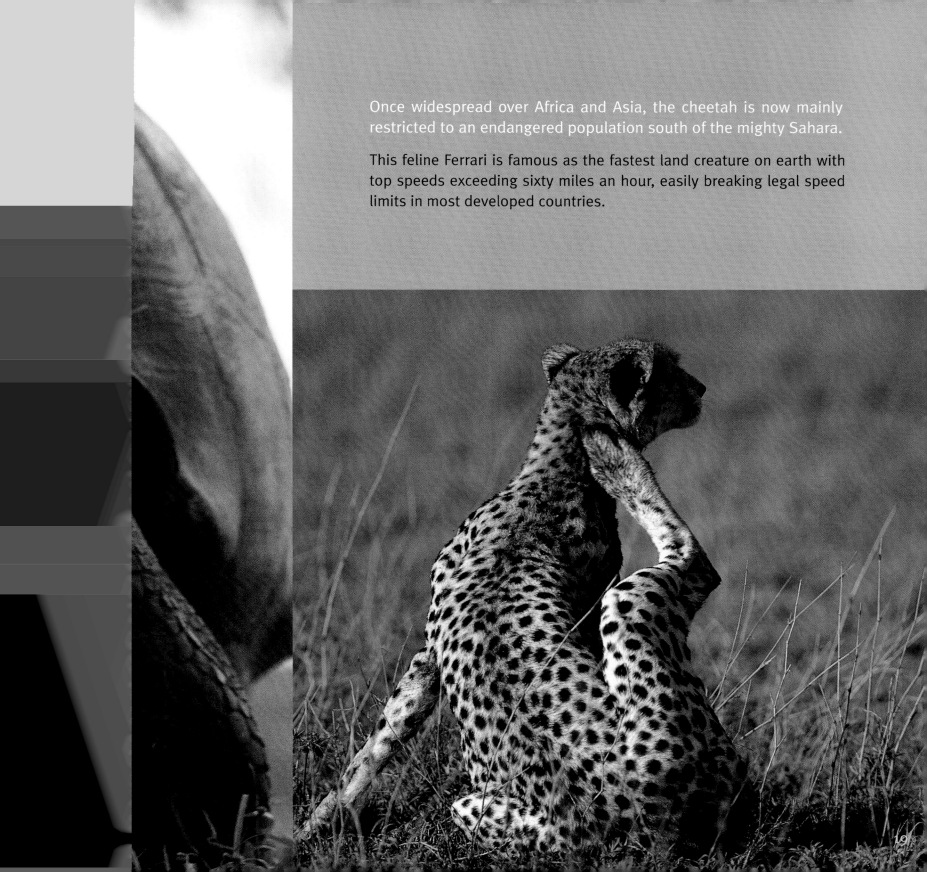

Once widespread over Africa and Asia, the cheetah is now mainly restricted to an endangered population south of the mighty Sahara.

This feline Ferrari is famous as the fastest land creature on earth with top speeds exceeding sixty miles an hour, easily breaking legal speed limits in most developed countries.

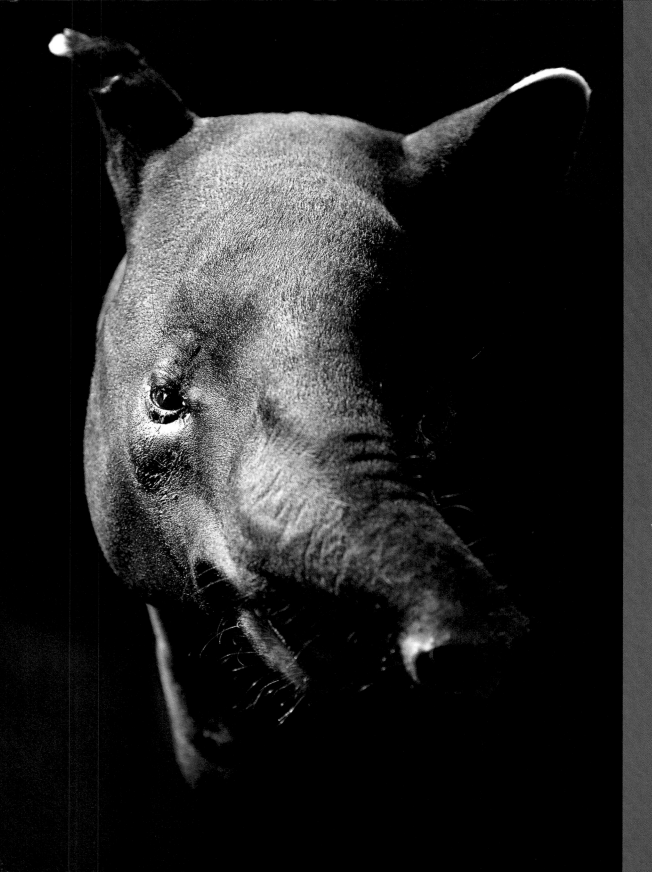

When fully grown the Malayan tapir is the size of a small pony. Built like a slim hippo, it has feet like a pig and possesses a shortened version of an elephant's trunk.
Believe it or not, its bold color pattern, black face and tail and broad white belly-stripe, make it virtually invisible within its rainforest home.

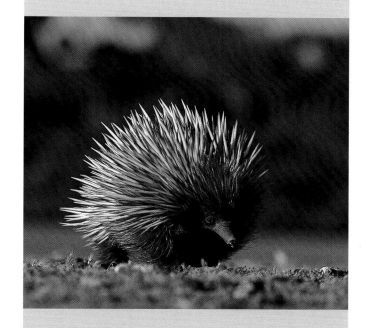

The bizarre echidna is almost too difficult to describe. This shy, ant-eating, burrowing mammal is covered in fixed quills, lays eggs and makes love in the "missionary position."

If these wonderful creatures did not already exist, no human mind could possibly dream them up.

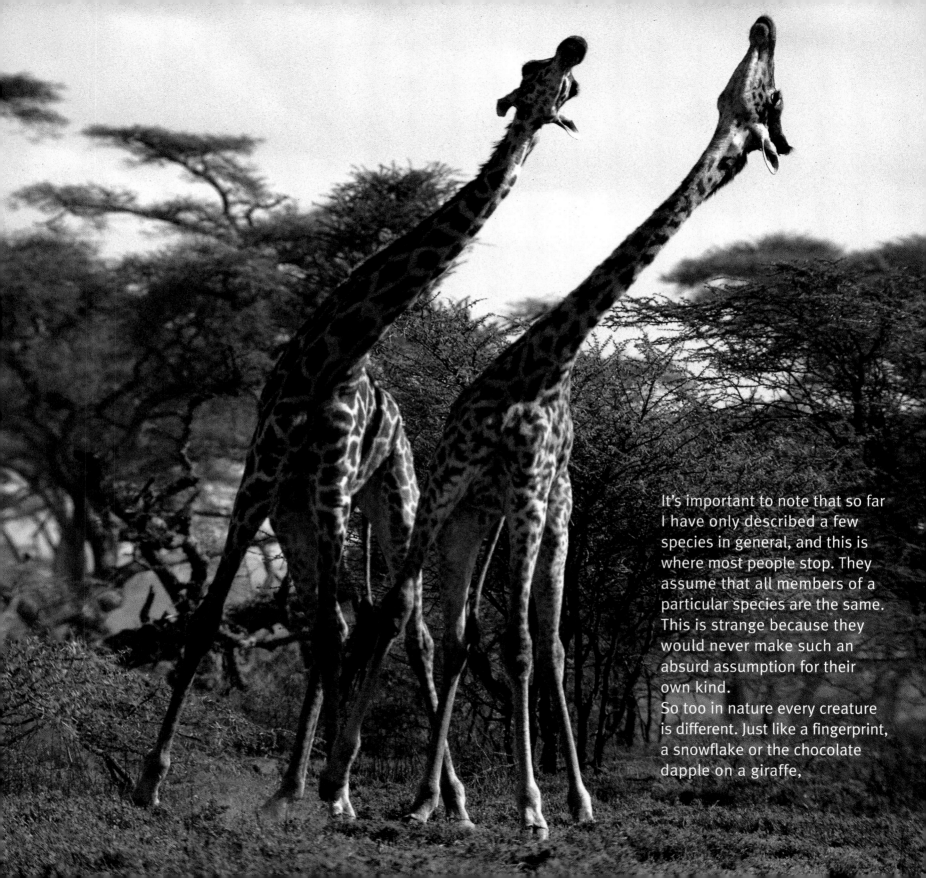

It's important to note that so far I have only described a few species in general, and this is where most people stop. They assume that all members of a particular species are the same. This is strange because they would never make such an absurd assumption for their own kind.

So too in nature every creature is different. Just like a fingerprint, a snowflake or the chocolate dapple on a giraffe,

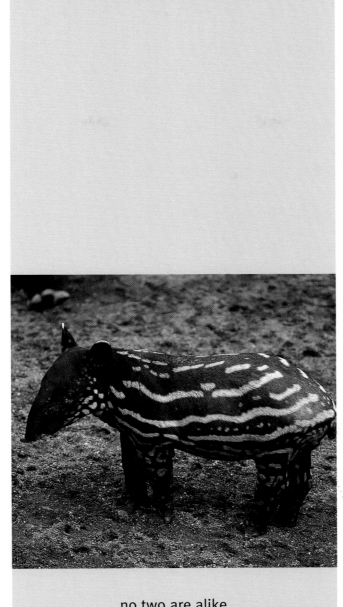

no two are alike.

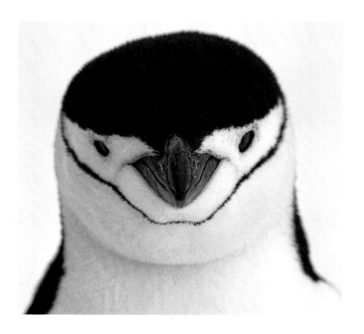

Every animal is a unique individual.

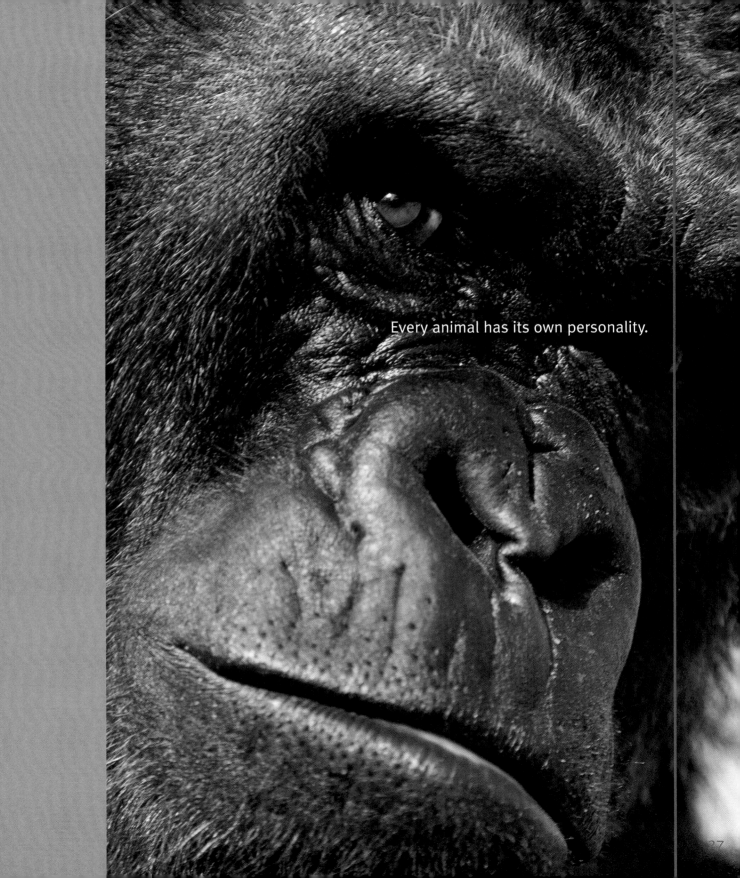

Every animal has its own personality.

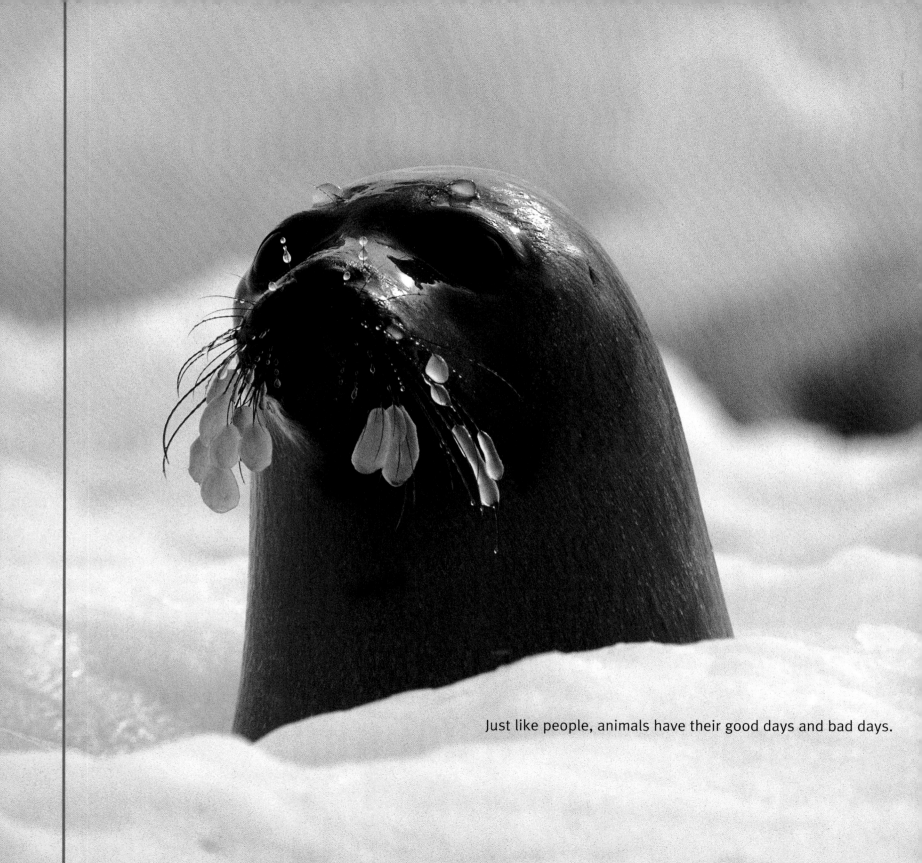

Just like people, animals have their good days and bad days.

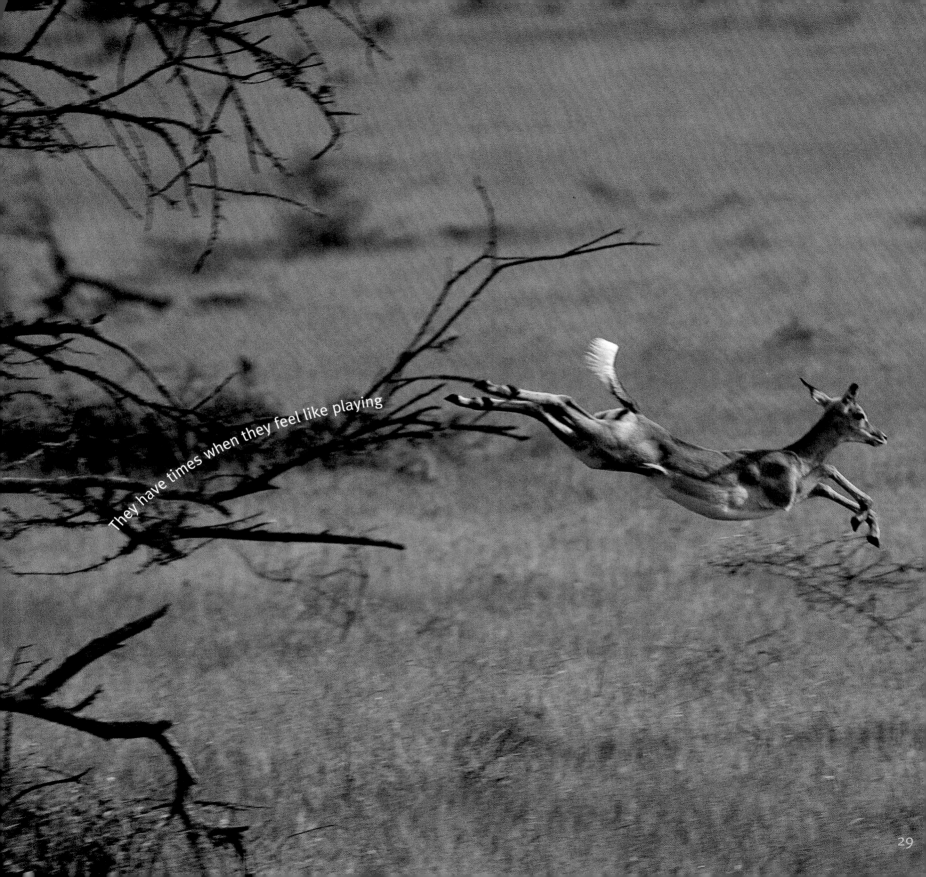

They have times when they feel like playing

and times when they feel like doing
absolutely nothing.

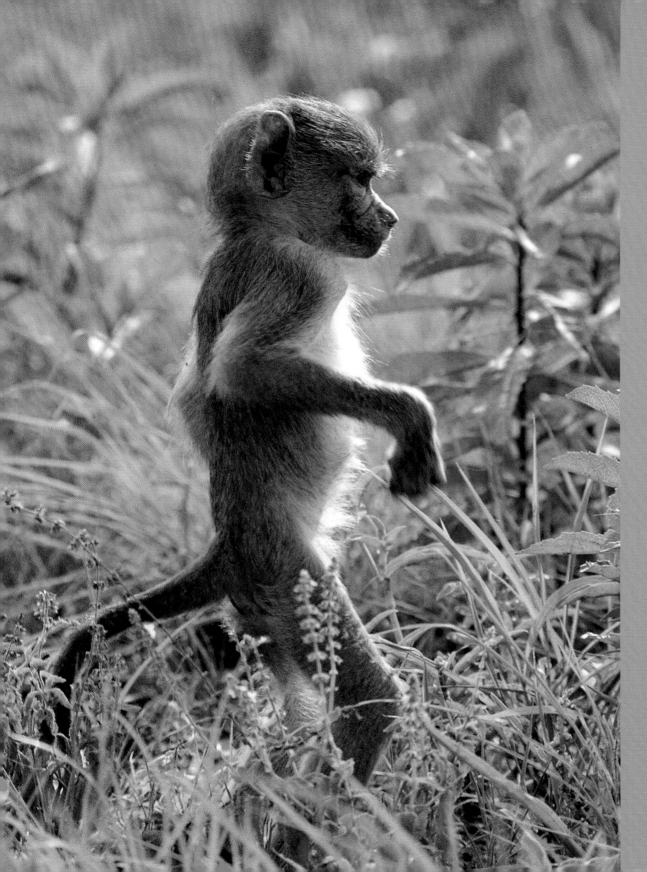

They like to explore and understand
their world as best they can
in their own way.

If animals get lost, just like a child
in a department store, they get
frightened and confused
in their own way.

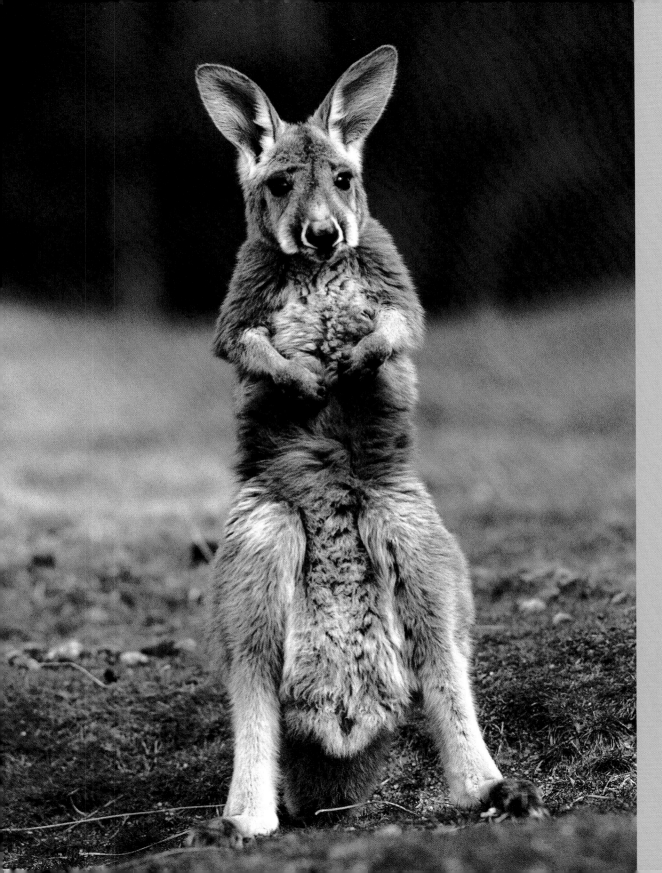

Every wild creature has its own list of favorite things, from foods they find delicious to itchy places they love to scratch.

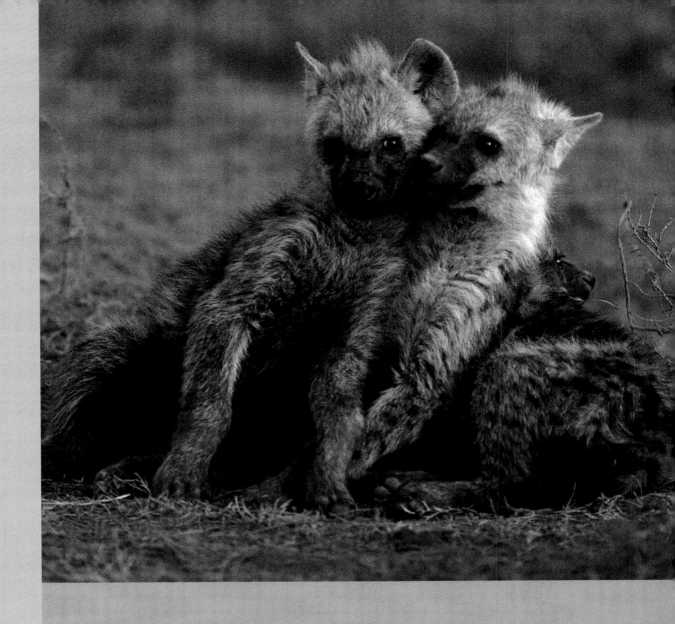

Animals have friends and enemies just like you and I do.

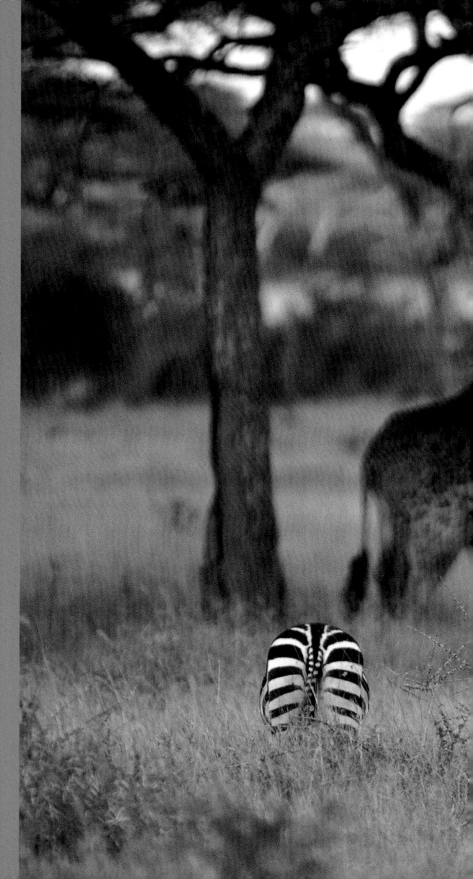

So then it seems naïve to look upon nature as a homogeneous lump of life when, in fact, we gaze upon countless individuals. Animals are as different from each other as we are, bound together only in the basic desires that motivate all living things:

To seek pleasure, to avoid pain and perhaps most importantly,

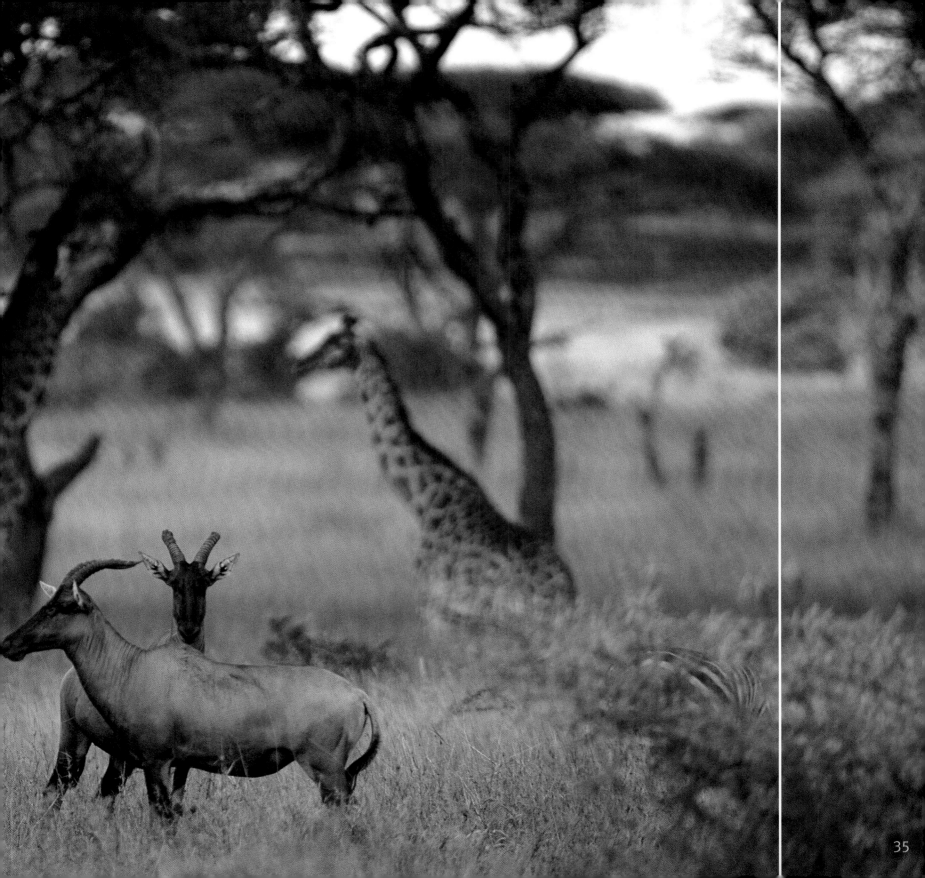

every living creature wants to be free
to live its life as it chooses.

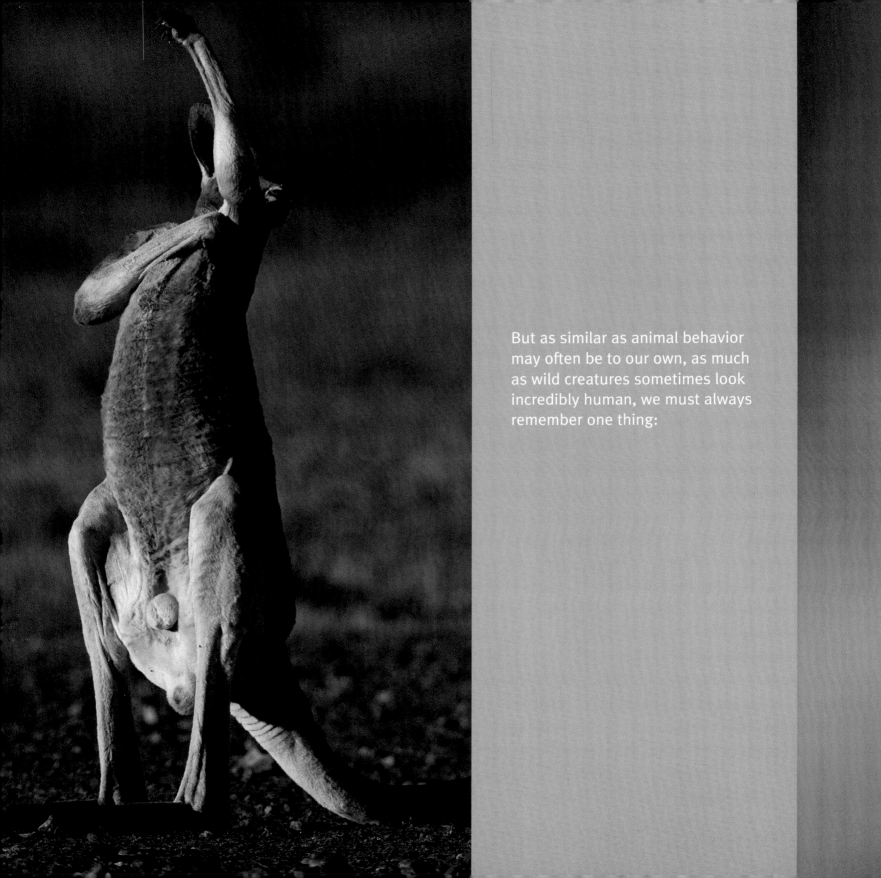

But as similar as animal behavior may often be to our own, as much as wild creatures sometimes look incredibly human, we must always remember one thing:

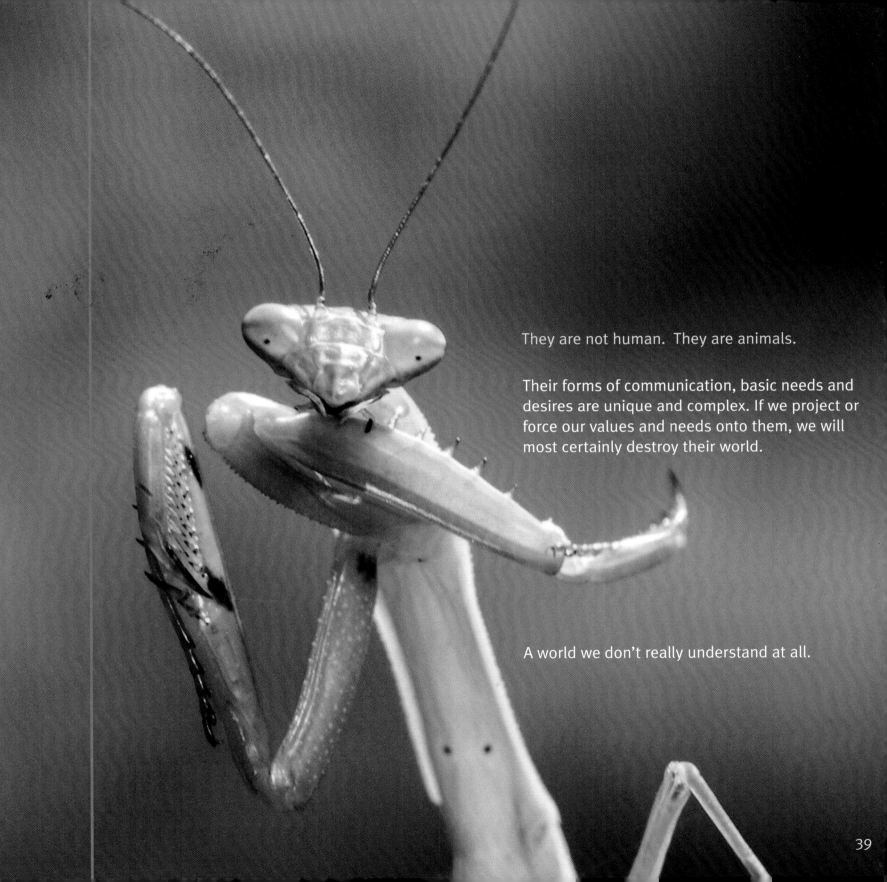

They are not human. They are animals.

Their forms of communication, basic needs and desires are unique and complex. If we project or force our values and needs onto them, we will most certainly destroy their world.

A world we don't really understand at all.

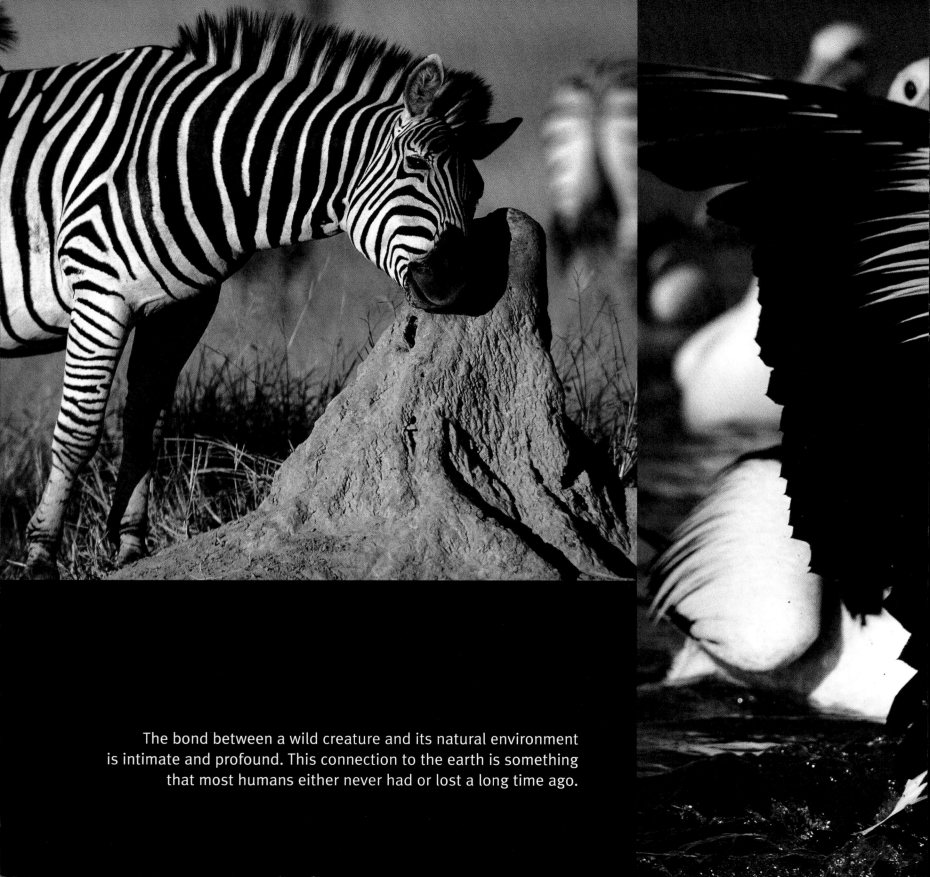

The bond between a wild creature and its natural environment
is intimate and profound. This connection to the earth is something
that most humans either never had or lost a long time ago.

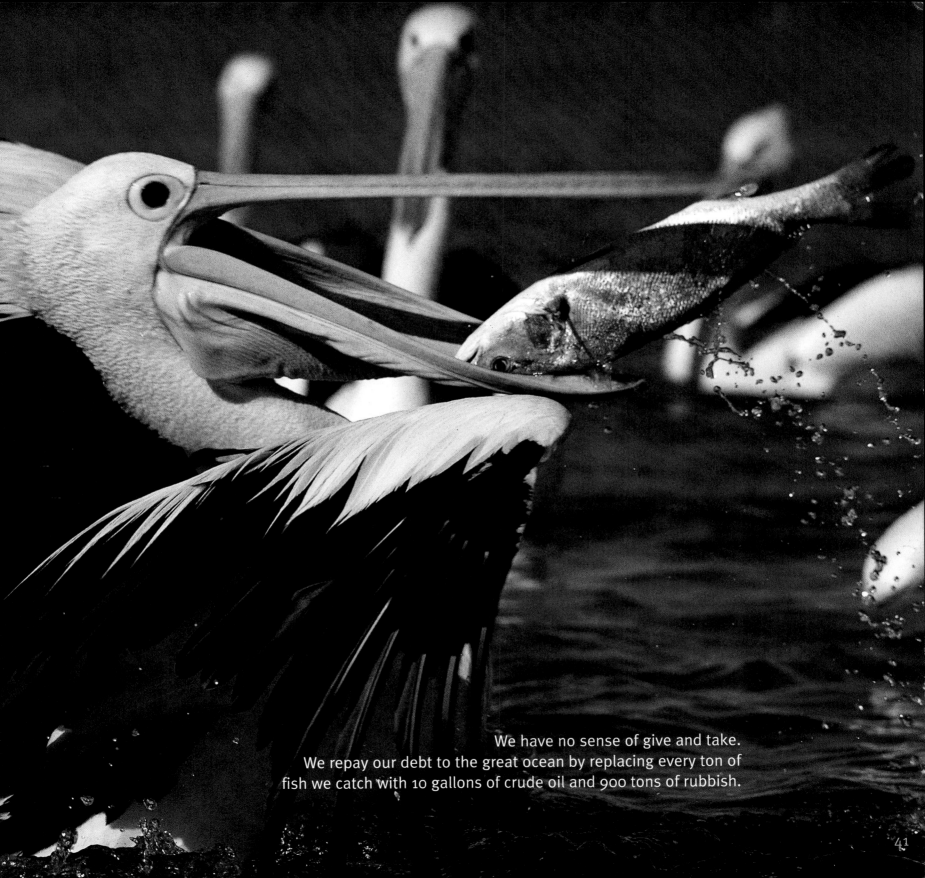

We have no sense of give and take.
We repay our debt to the great ocean by replacing every ton of
fish we catch with 10 gallons of crude oil and 900 tons of rubbish.

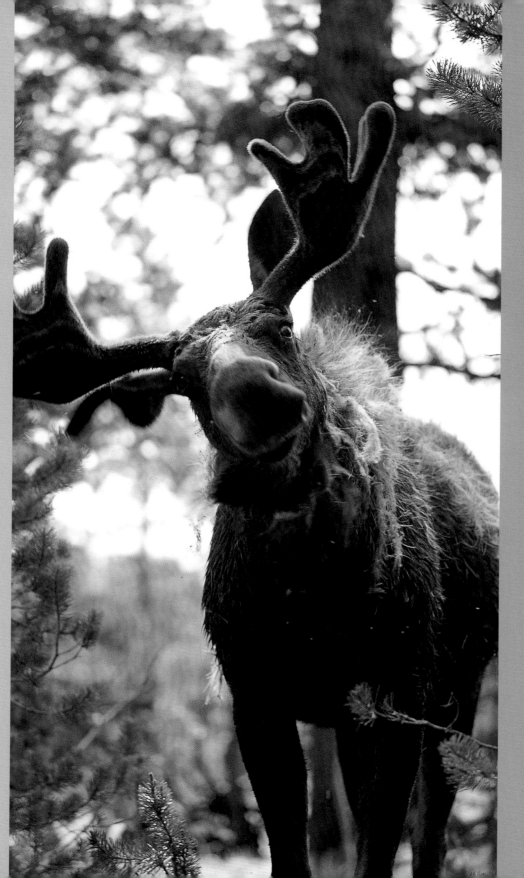

As we scramble to and from work, shout into phones and swear at traffic lights, our planet still turns as it did thousands of years ago.

In the time it takes for 180 plastic Barbie dolls to be sold in toy shops around the world a blue whale's heart will beat nine times.

Is it any wonder then that our species finds it so hard to relate to any other?

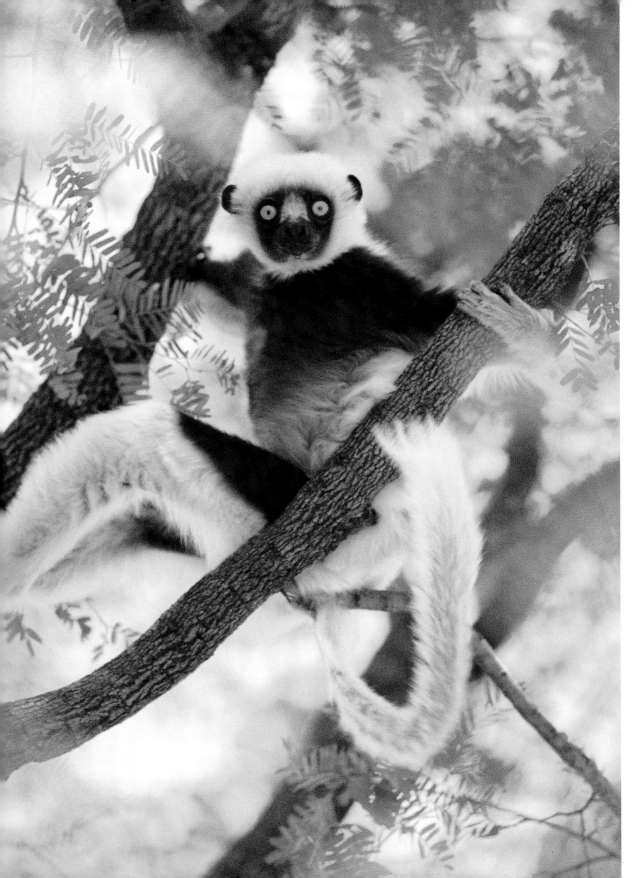

Is it any wonder that mankind and animals generally regard each other with fear

and suspicion?

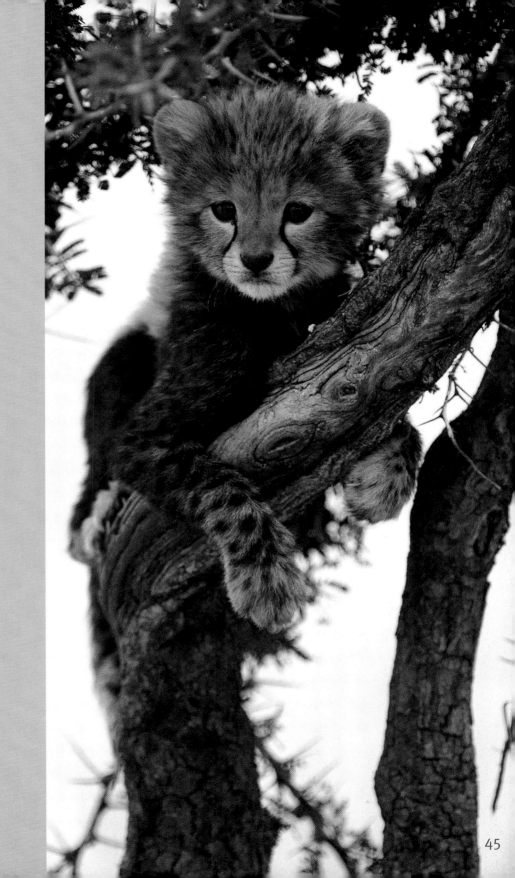

The only proven cure for fear
is knowledge, yet we know
so very little about the fragile
world around us.

We know so little about the
wonderful creatures whose
lives we touch every time
we turn on a light, start our
car or walk out the door
of our home.

We know so little about everything.

Our relationship with nature is perhaps doomed
to be strained and awkward because our
population has already overwhelmed the planet.
As we steadily creep across the landscape, we
devour everything before us and put up barriers
and boundaries where none has ever existed.

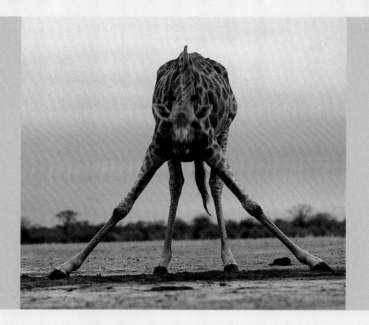

There is no balance.

And when there is no balance then
there can be no "win-win" solution.

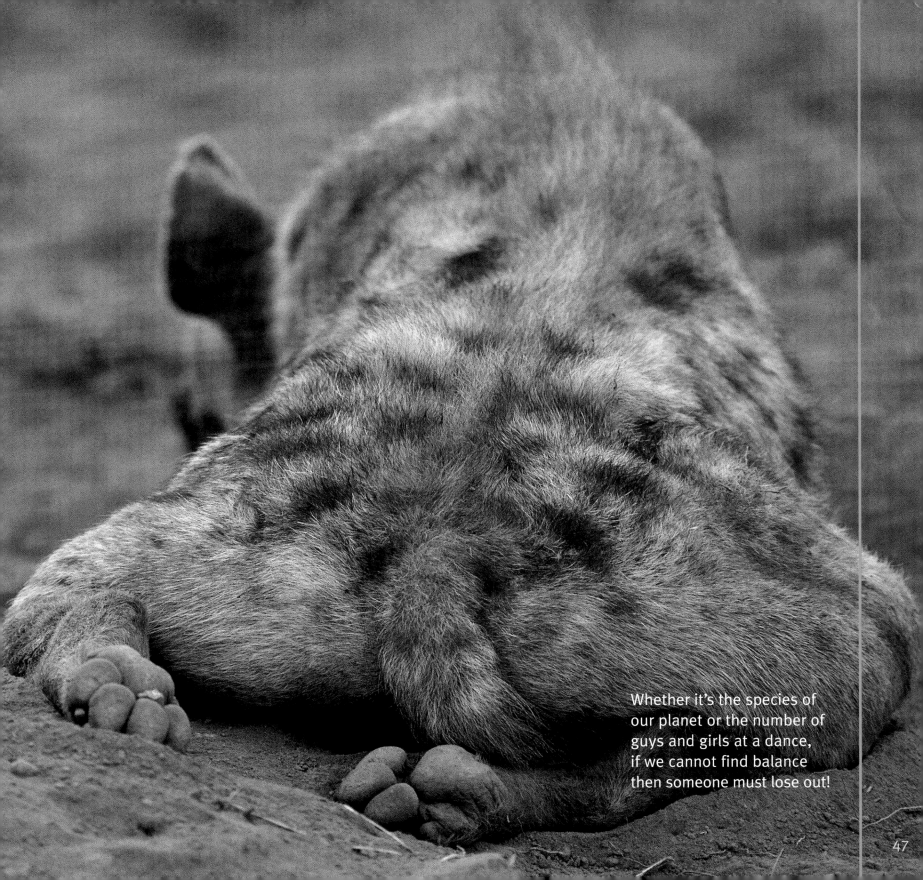

Whether it's the species of
our planet or the number of
guys and girls at a dance,
if we cannot find balance
then someone must lose out!

For the moment, at least, nature is the loser.
Countless creatures are being removed
from their homes and pushed
to the most remote
corners of the
globe.

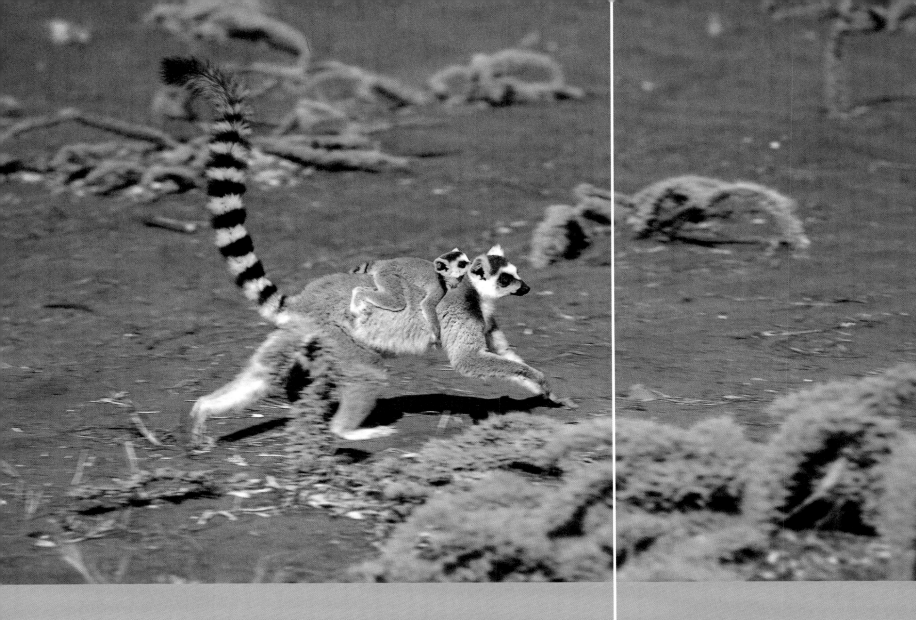

With humans now numbering six billion plus, more than all other mammals combined, there is nowhere left for other species to run. They are swallowed by our sprawl whether they like it or not.

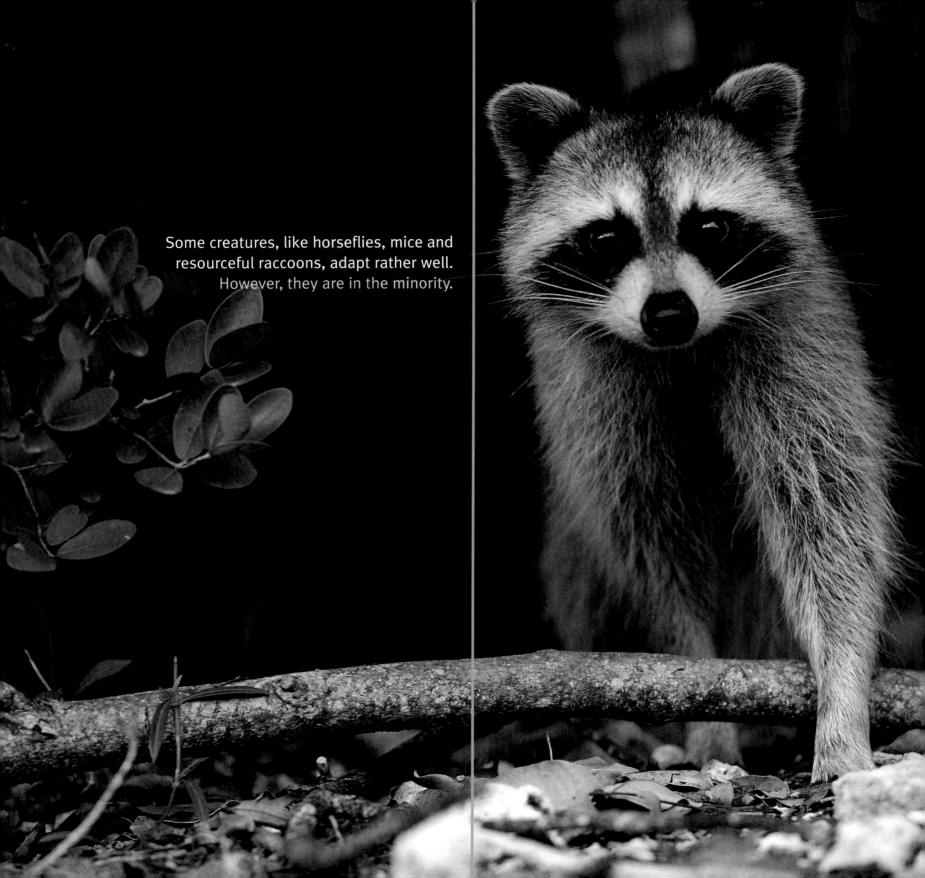

Some creatures, like horseflies, mice and resourceful raccoons, adapt rather well. However, they are in the minority.

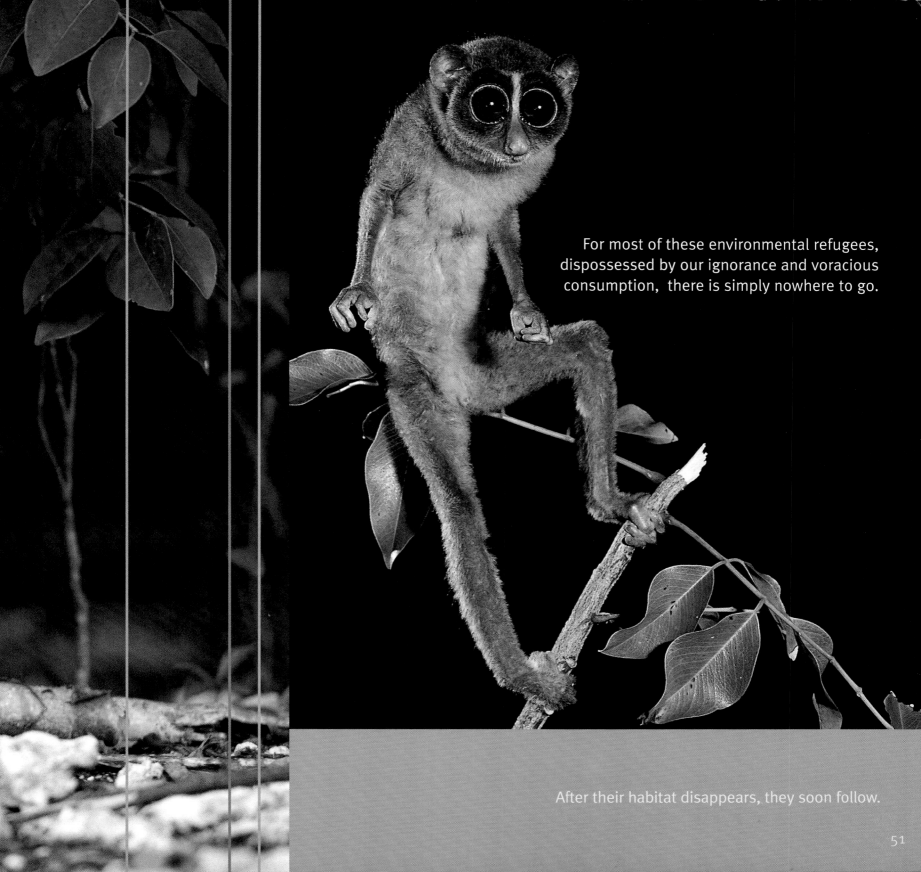

For most of these environmental refugees, dispossessed by our ignorance and voracious consumption, there is simply nowhere to go.

After their habitat disappears, they soon follow.

Apart from certain insects, the only living creatures to ever really rival human population figures were passenger pigeons. They were, as Gerald Durrell noted, "the most numerous species of bird that has ever been or ever will be in existence in the world."

So large were their numbers that when they took to the wing en masse they appeared to be an endless feathered cloud which cast a shadow across the entire USA. When they landed as one, their immense weight bent saplings and tore branches loose from mighty oaks. Naturally the flesh, eggs and young of these docile birds were fair game for hungry hunters. In 1869, seven and a half million pigeons were captured for eating in one spot. In 1879, one billion birds were captured and killed in the state of Michigan alone. Our appetite seemed to know no limits.

But with single flocks of up to two billion birds sweeping through the skies of North America, no one could argue that a species so plentiful, that bred so well and adapted so easily, could ever be endangered.

The last passenger pigeon on this earth died in the Cincinnati Zoo in 1914.

All life on our planet is contained in a region that is known as the biosphere. This may seem an immeasurably vast area, but in reality it is a very slim, fragile band. If the earth was reduced to the size of a soccer ball, the biosphere would be thinner than a single sheet of the finest tissue paper.

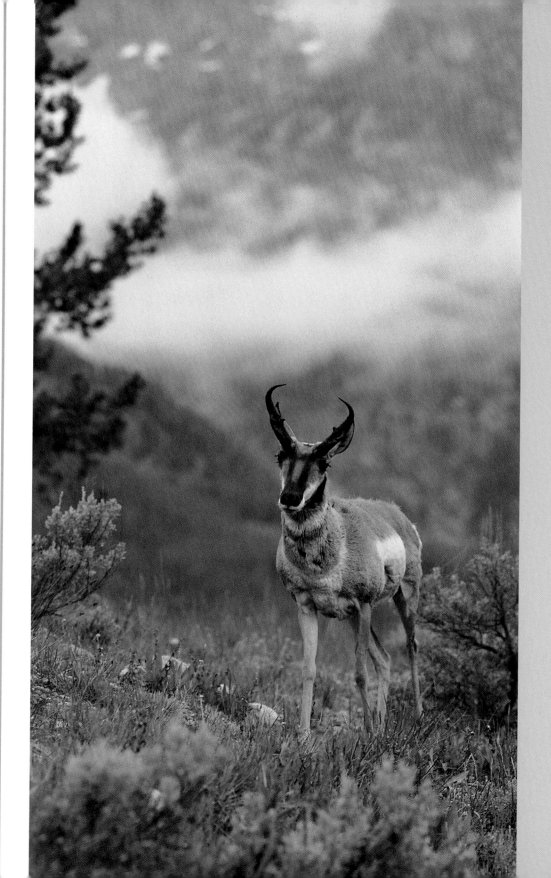

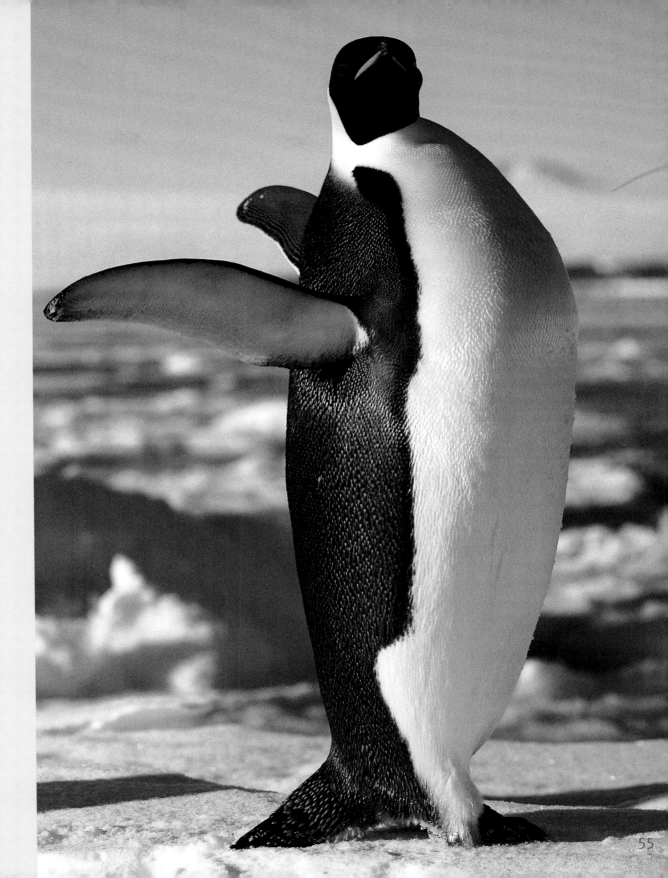

What is truly vast
is the almost limitless extent
of human influence.

You must understand that
you are the whole world,
not just the space
inside your clothes.

Your reach extends over every
horizon so that while there are
still areas that remain unspoiled,
nothing remains untouched.

You can irreversibly change the
lives of creatures you will
never, ever see.

55

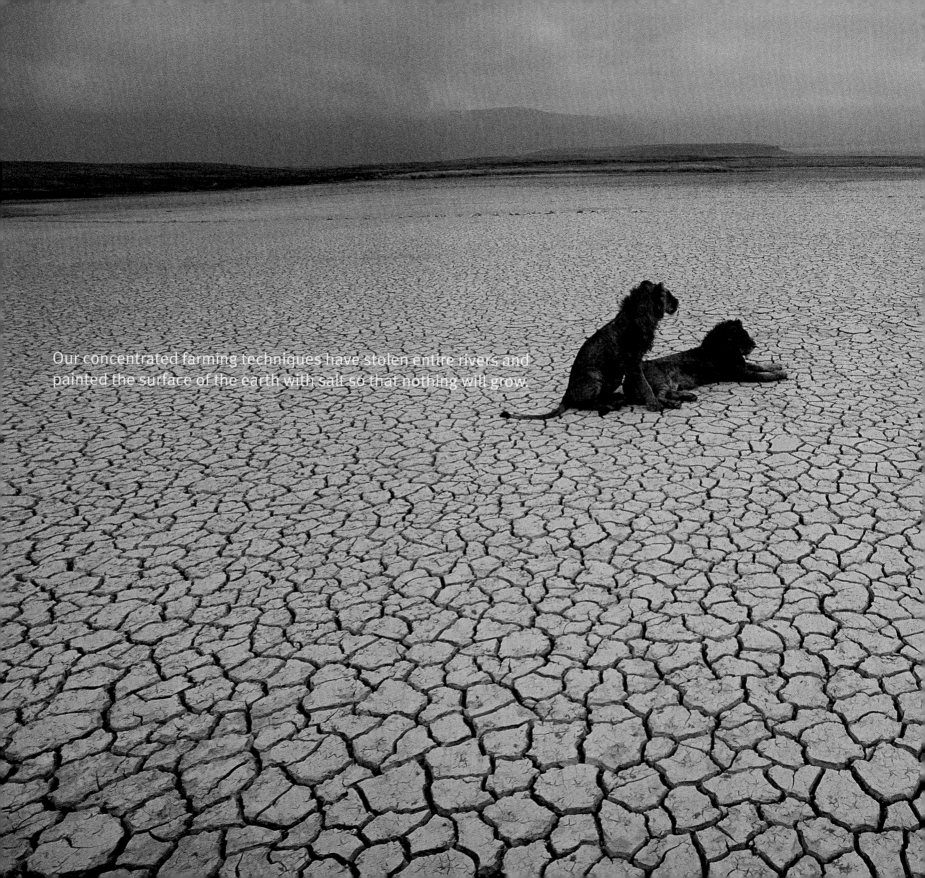

Our concentrated farming techniques have stolen entire rivers and painted the surface of the earth with salt so that nothing will grow.

To feed the furnace of progress we seek out the great trees that reach to heaven, hack them down at the ankles and shred them into chips and flakes. A gigantic emerald spear, hundreds of years in the making, can now be reduced to dandruff in a matter of minutes.

To visit the place where a forest once stood and find only an endless array of severed tree stumps bleeding over the horizon is to feel a loss so tragic that it reminds us of the endless rows of tombstones marking the final resting place of young men who fell in futile wars.

Today, every distinctive ecosystem on the planet, each containing unique plants and animals, is gradually shrinking except for deserts, which grow larger and larger every year.

Many scientists believe that in the history of our planet there have been five major extinctions. Catastrophic events such as giant asteroid collisions, floods and fires extinguished 90 percent of all living species that have ever existed. However, since human beings have walked the earth, the rate of extinction has increased ten thousand times. We expect to lose half of all remaining plant species in the next fifty years alone. The international Red List of Threatened Animals now has over eleven thousand entries for every star you can see with the naked eye.

It seems clear that our species is destined to be the cause of the sixth extinction.

There is no point where our world ends
and the animal kingdom begins.
There is no "us" and "them."
The overlap is complete.

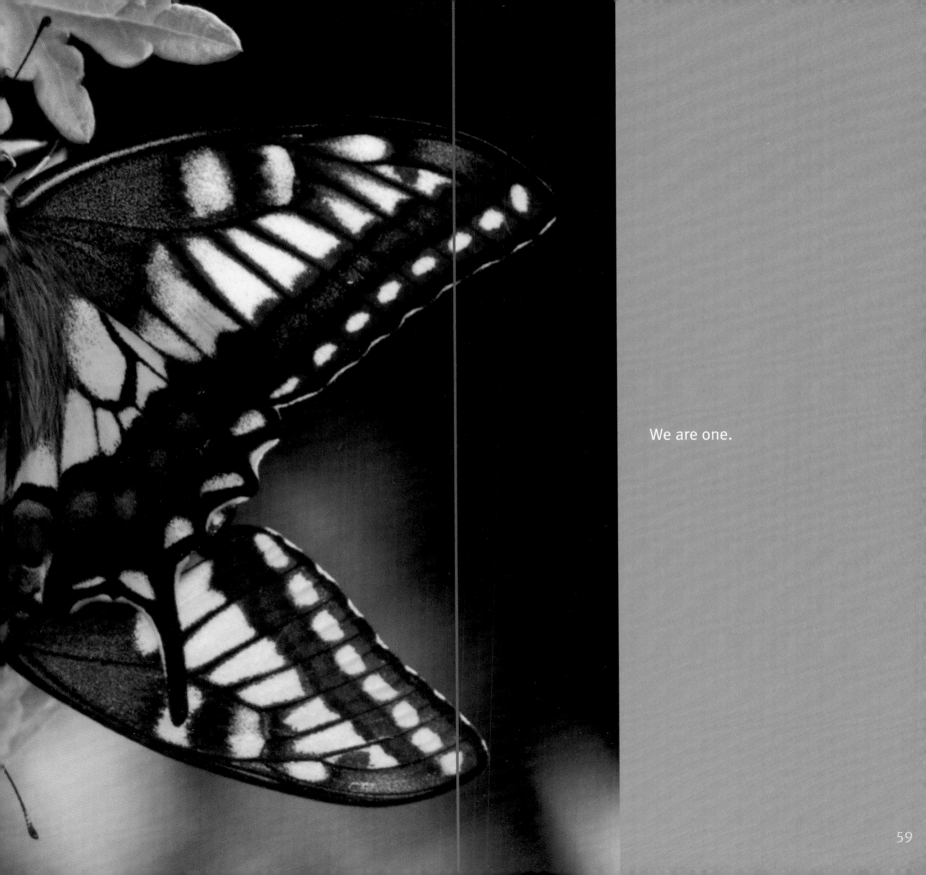

We are one.

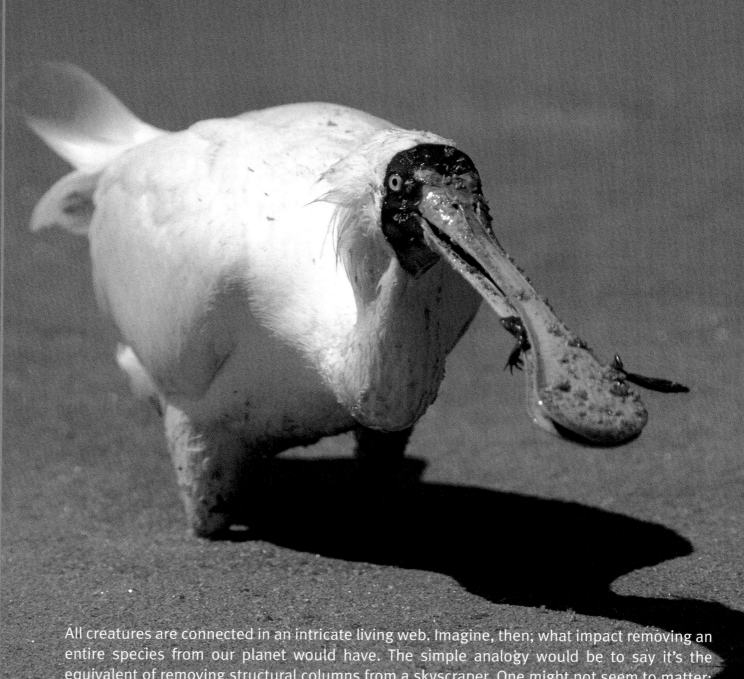

All creatures are connected in an intricate living web. Imagine, then, what impact removing an entire species from our planet would have. The simple analogy would be to say it's the equivalent of removing structural columns from a skyscraper. One might not seem to matter; two might also have little effect. As we continue removing columns, we notice some cracks and the ominous instability, but still, from a distance, the change and impending disaster are imperceptible. But rest assured, the more columns you lose the closer you come to the inevitable collapse of the entire structure, from which there will be no survivors.

Of course, unlike a building of concrete, glass and steel, we cannot simply replace or easily repair biological structures that have been destroyed or damaged.

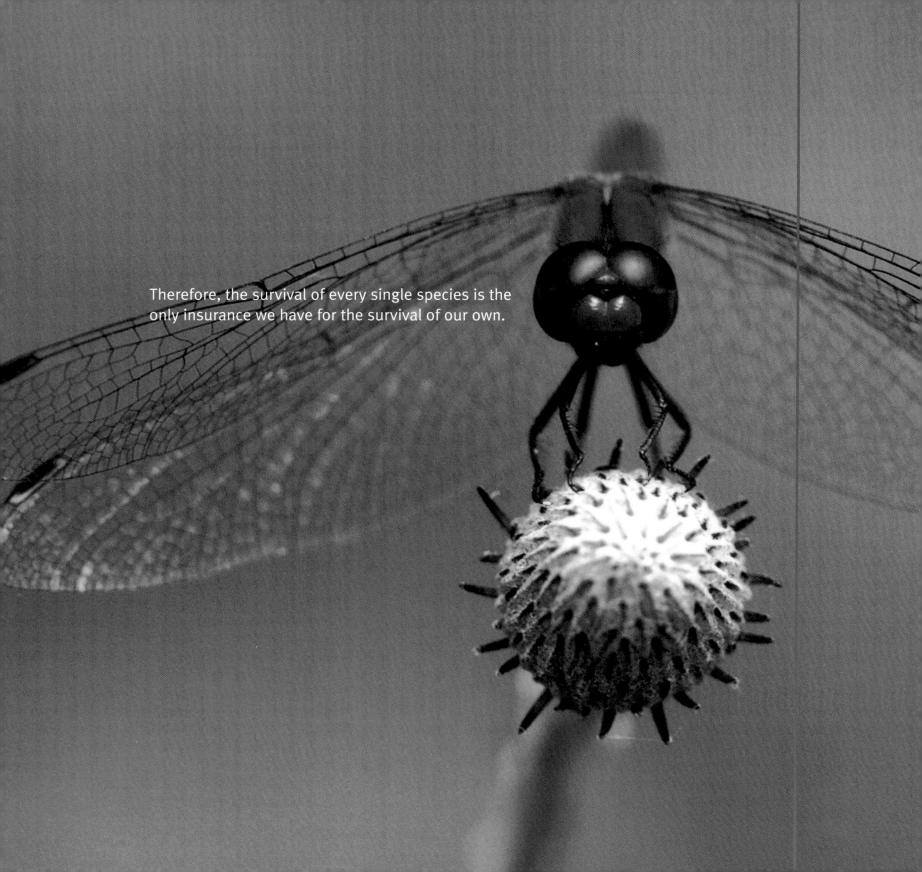

Therefore, the survival of every single species is the only insurance we have for the survival of our own.

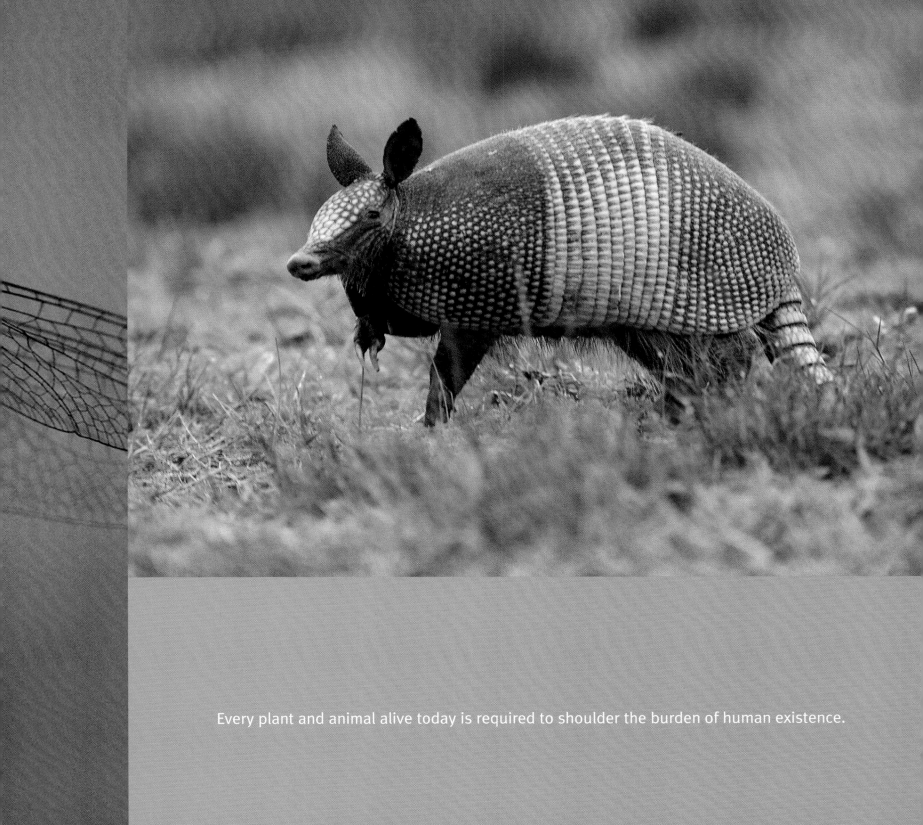

Every plant and animal alive today is required to shoulder the burden of human existence.

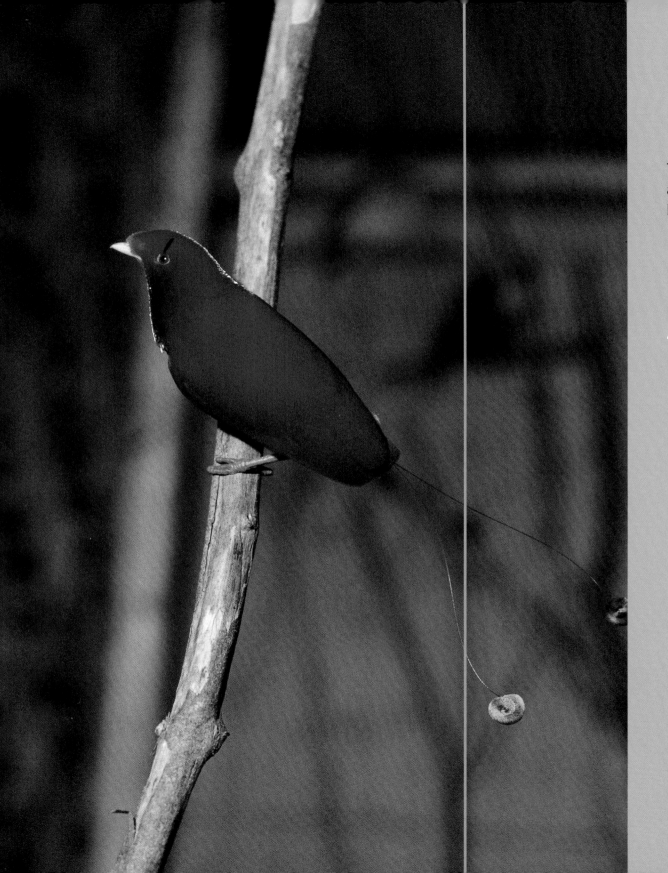

The impact of what we produce
and consume must be absorbed
by something, somewhere.

And whether it's rainforest birds,

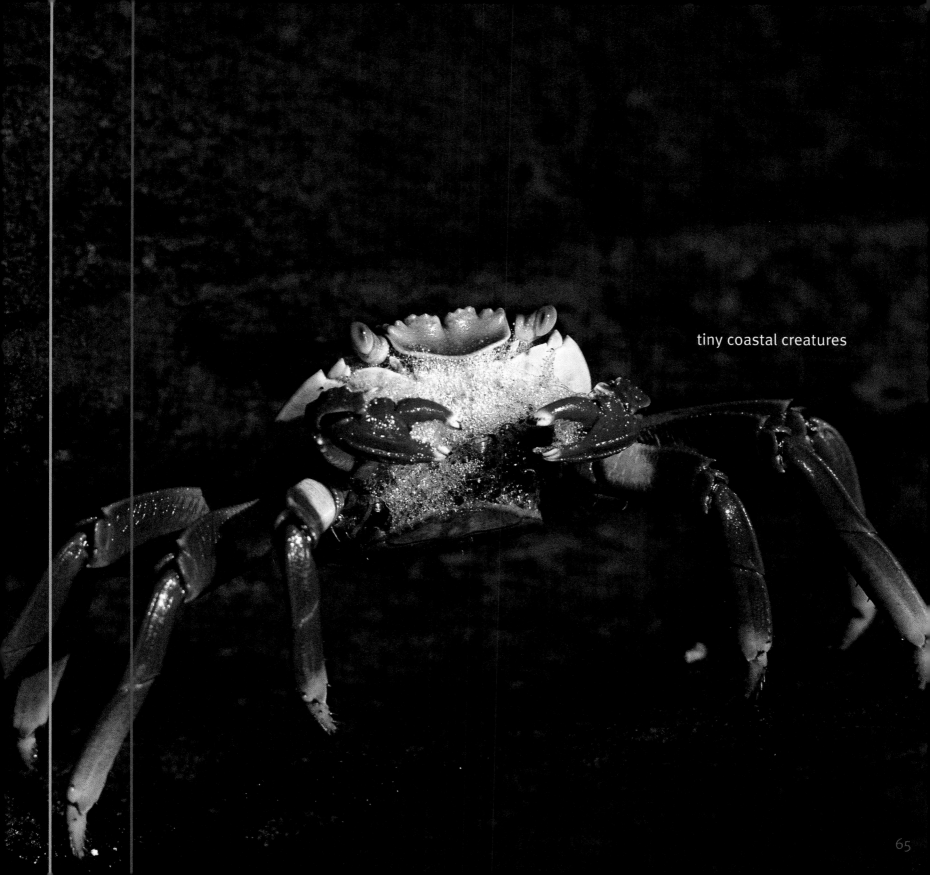

tiny coastal creatures

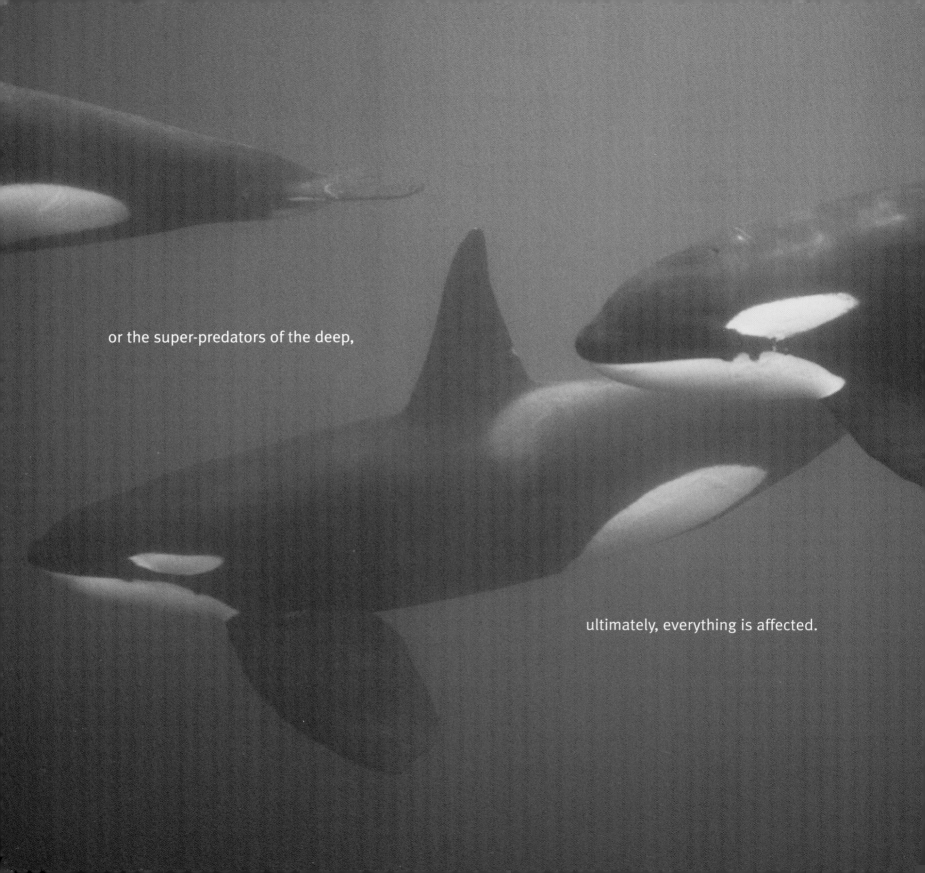

or the super-predators of the deep,

ultimately, everything is affected.

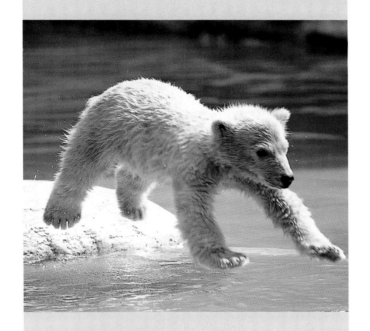

Scientists have discovered that even polar bears from the Arctic Circle and penguins from Antarctica, creatures from the two most isolated and pure eco-systems on earth, have a substantial build-up of toxic industrial chemicals stored in their fat deposits.

No one is alone anymore. No one is an island.

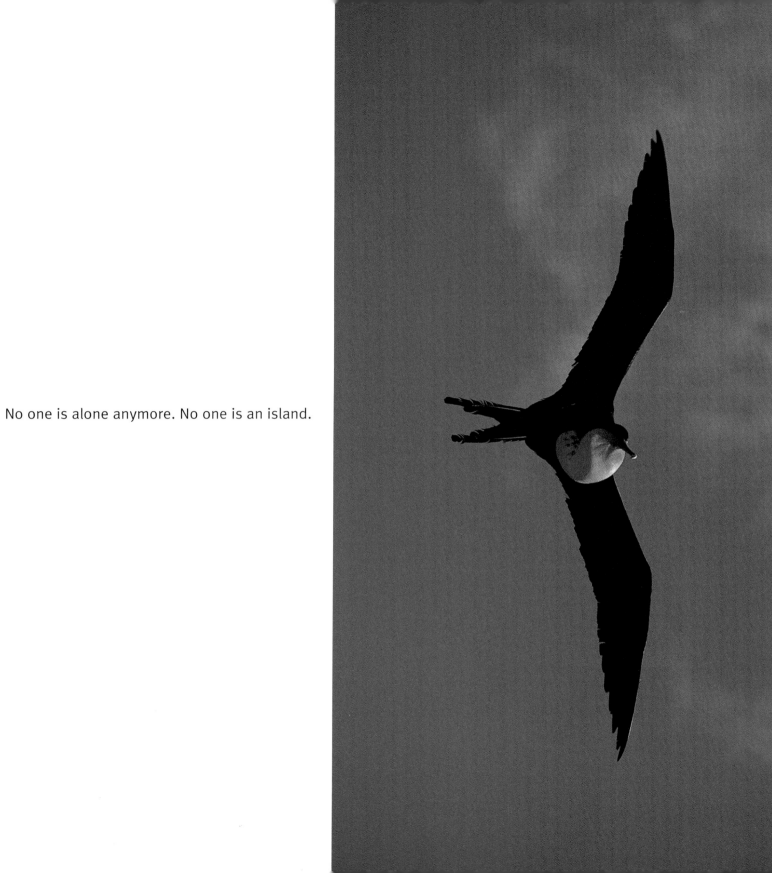

Of course, we cannot expect humans to treat animals any better than we treat each other. Sadly, our bloodied history of violent conflict and racial tension speaks volumes for the future.

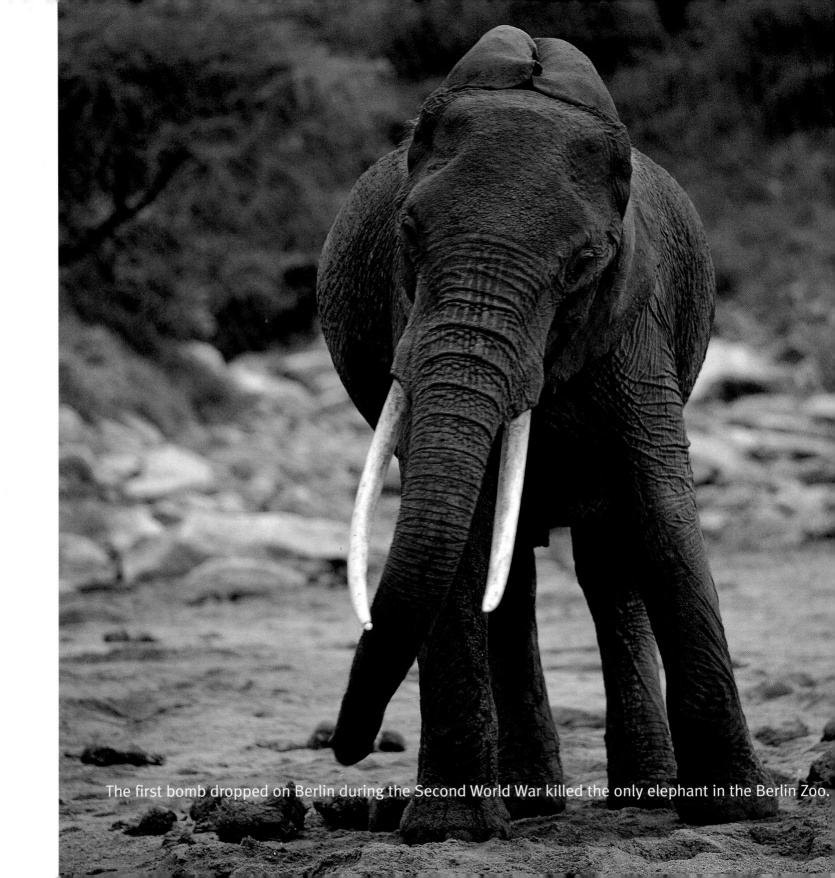

The first bomb dropped on Berlin during the Second World War killed the only elephant in the Berlin Zoo.

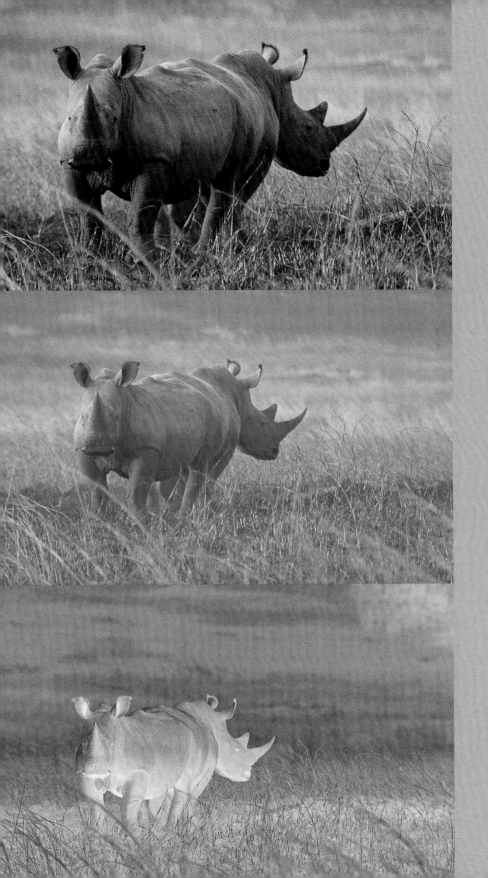

If nature has ever attempted to build an indestructible creature, it would be the northern white rhino. A beast so strong and so powerful that it is essentially a battle tank with hooves and, as such, is impervious to harm from even the most determined and capable African carnivores. In truth its heavily armored hide is virtually bulletproof—but not quite. Which is why it is now all but extinct.

The enduring legacy of this mighty animal is utterly tragic. Merely a few bottles of powdered horn sold by criminals for immense profit to pathetic men who foolishly think that this substance can revive their wilting manhood.

Imagine that.

An entire species reduced to a handful of dust.

Earth's
wild
creatures
are
definitely
very
vulnerable,
but only
slightly
more so
than we
are.

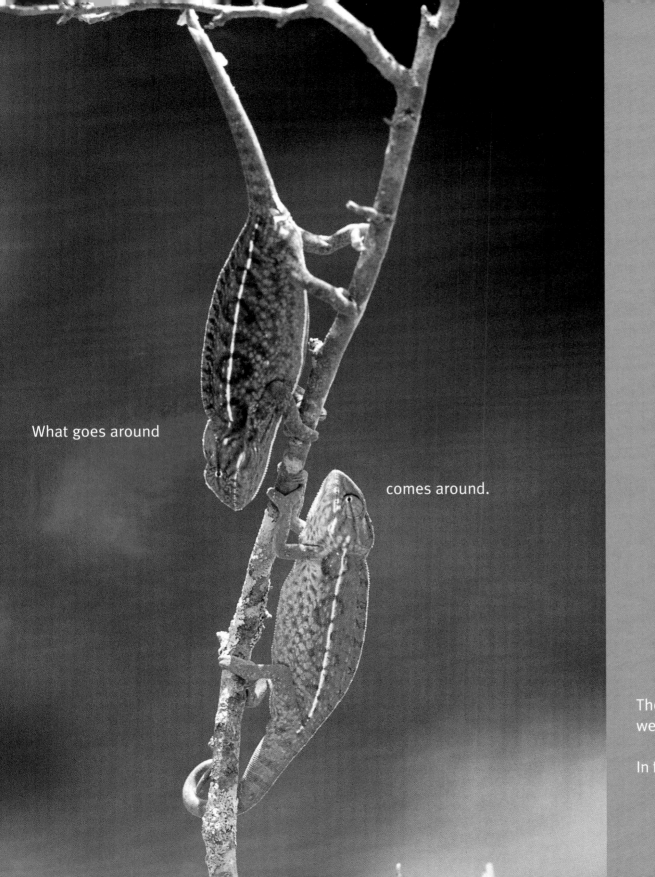

What goes around

comes around.

There is absolutely no doubt
we will ultimately reap the whirlwind.

In fact, we are already paying the price.

73

As we tear down forests
to expand our industrial
capitals, black city skylines
have stolen the mountains.

Look up into the heavens above any city or
town, and you can clearly see for yourself
how pollution is extinguishing the stars.

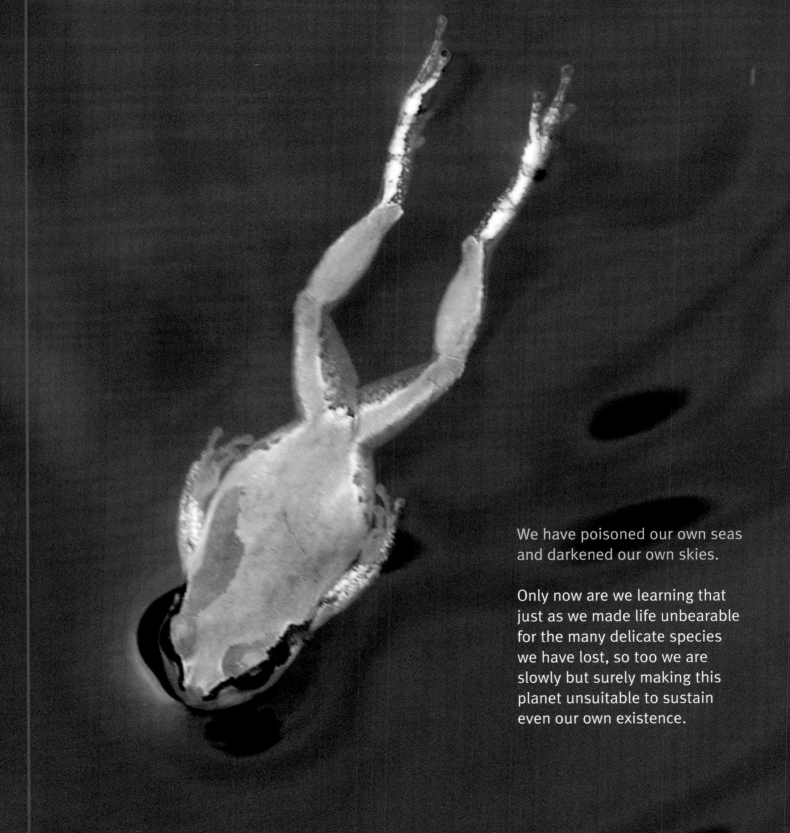

We have poisoned our own seas and darkened our own skies.

Only now are we learning that just as we made life unbearable for the many delicate species we have lost, so too we are slowly but surely making this planet unsuitable to sustain even our own existence.

Thankfully, this knowledge has spurred on many gifted scientists and engineers to search for new, clean, sustainable ways to create the energy that drives human civilization forward.

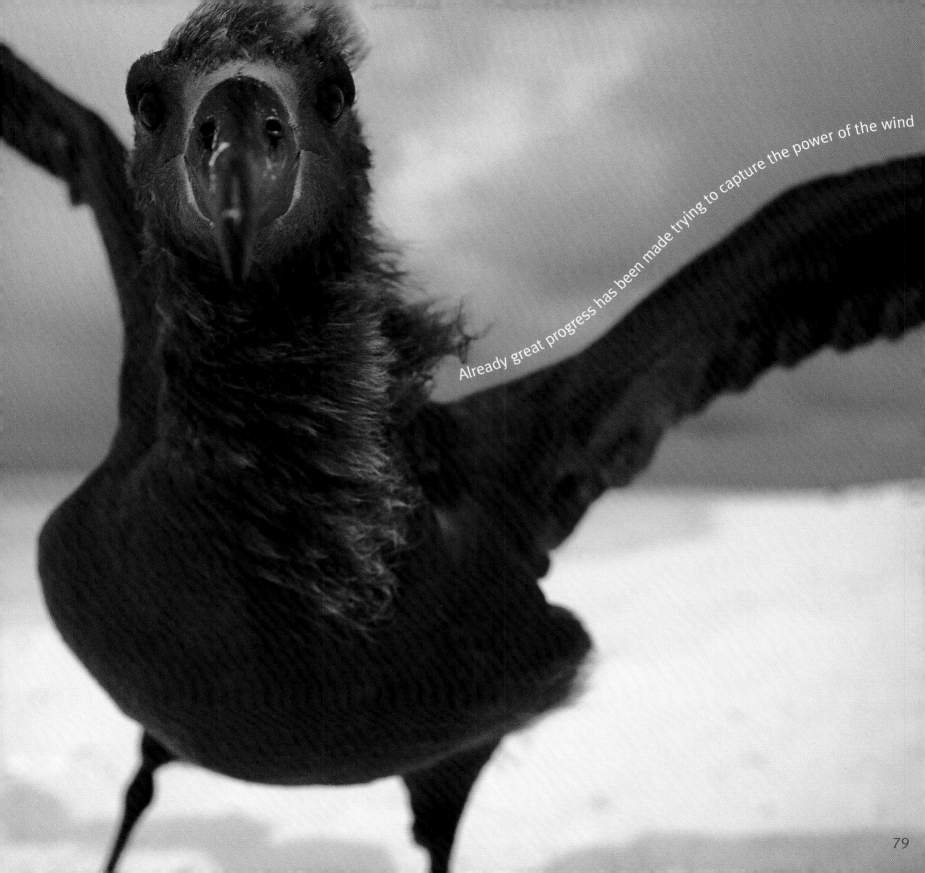

Already great progress has been made trying to capture the power of the wind

79

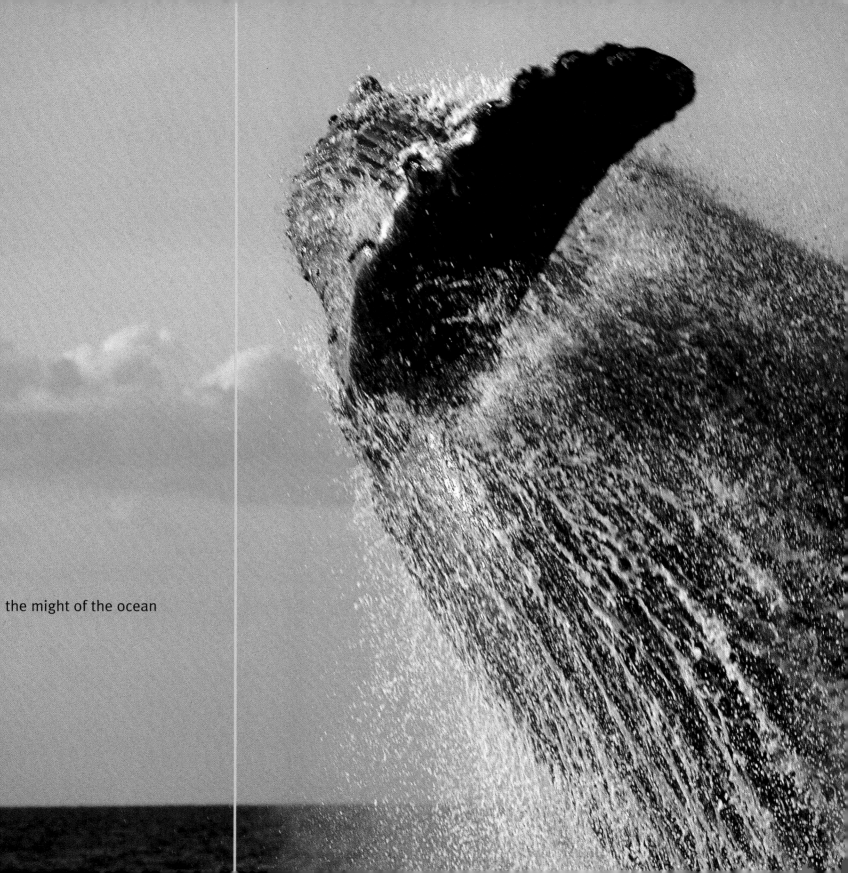

the might of the ocean

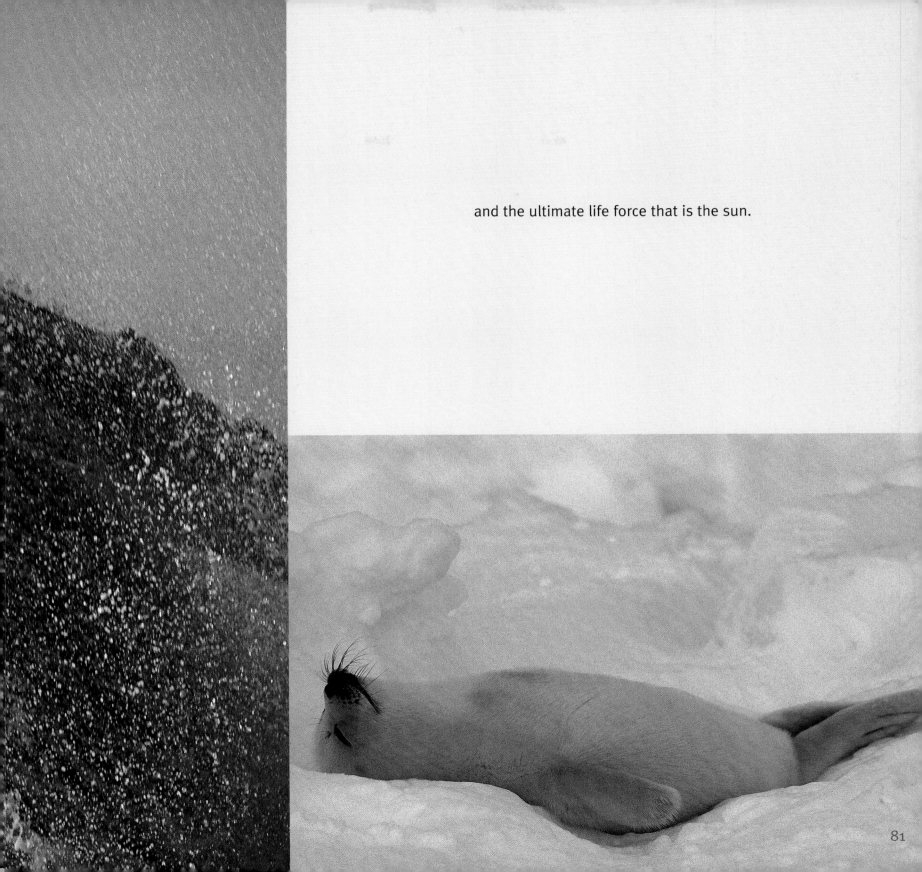

and the ultimate life force that is the sun.

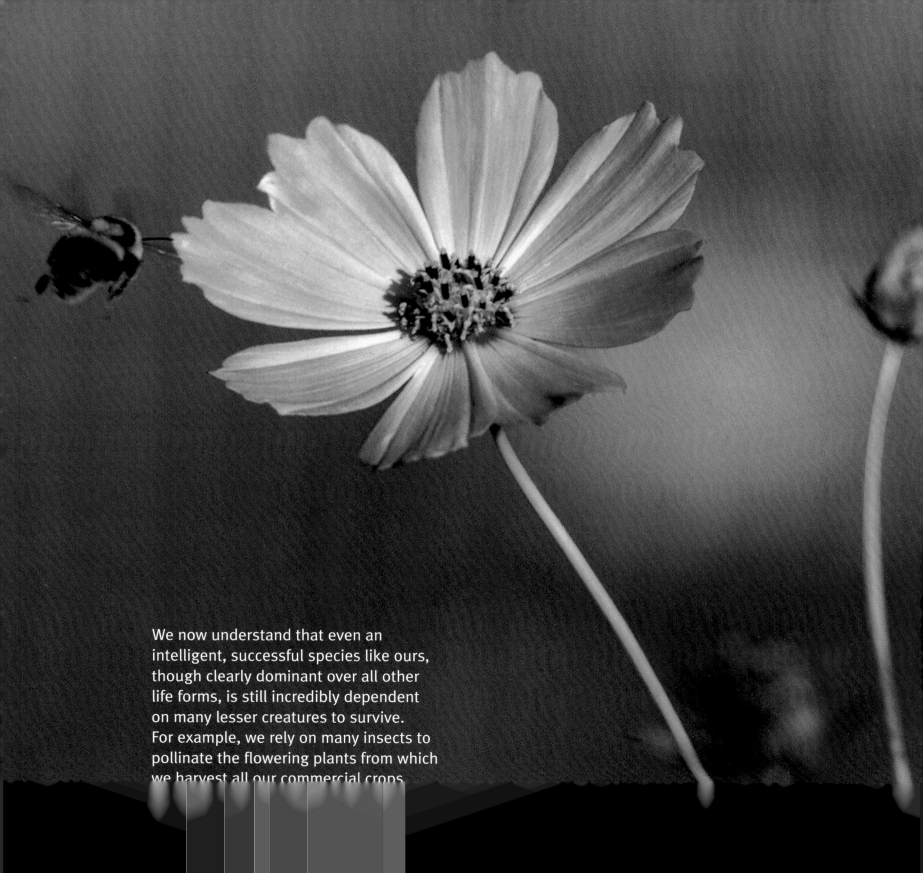

We now understand that even an
intelligent, successful species like ours,
though clearly dominant over all other
life forms, is still incredibly dependent
on many lesser creatures to survive.
For example, we rely on many insects to
pollinate the flowering plants from which
we harvest all our commercial crops.

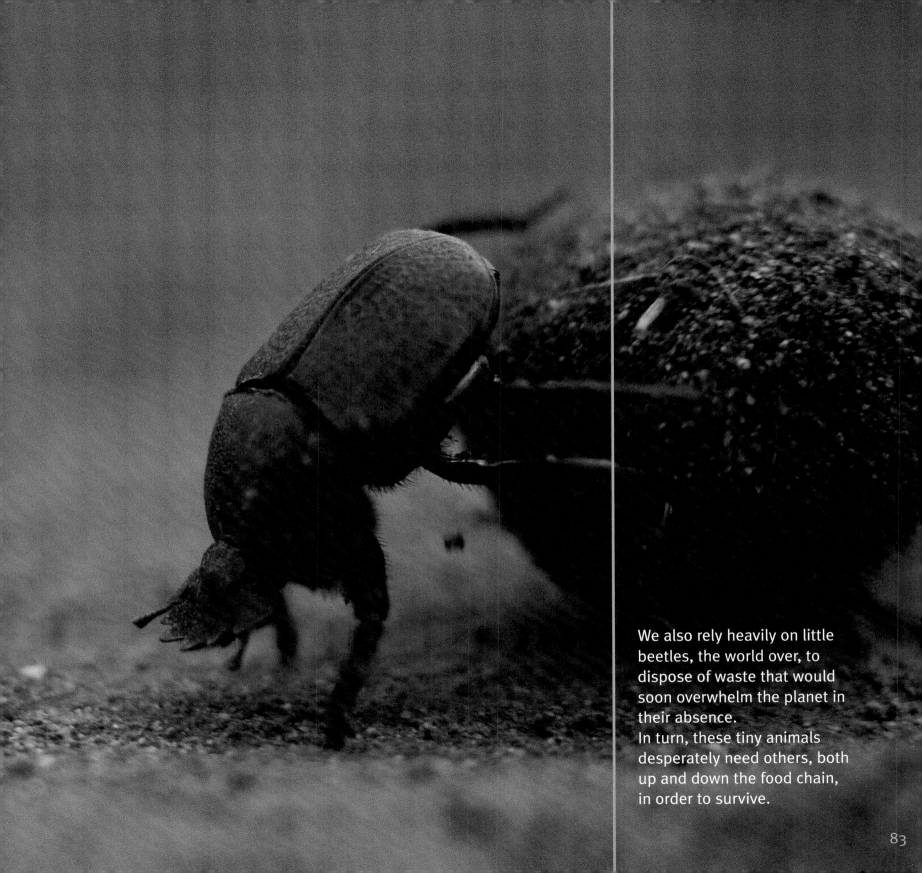

We also rely heavily on little beetles, the world over, to dispose of waste that would soon overwhelm the planet in their absence.
In turn, these tiny animals desperately need others, both up and down the food chain, in order to survive.

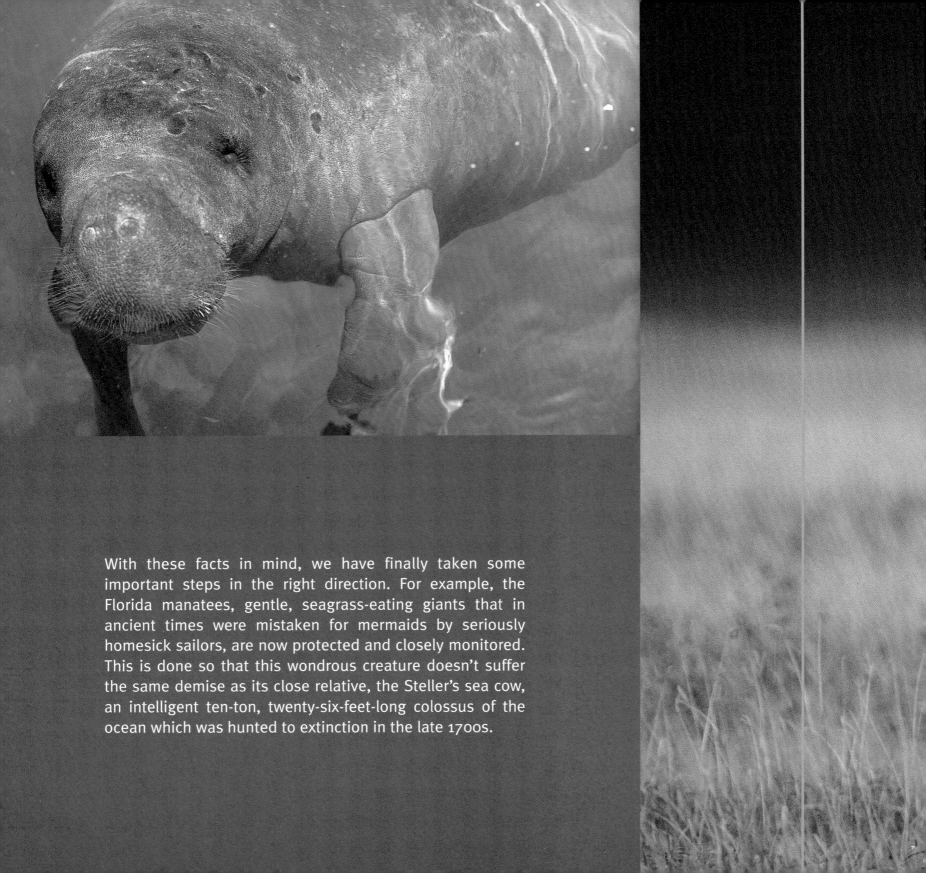

With these facts in mind, we have finally taken some important steps in the right direction. For example, the Florida manatees, gentle, seagrass-eating giants that in ancient times were mistaken for mermaids by seriously homesick sailors, are now protected and closely monitored. This is done so that this wondrous creature doesn't suffer the same demise as its close relative, the Steller's sea cow, an intelligent ten-ton, twenty-six-feet-long colossus of the ocean which was hunted to extinction in the late 1700s.

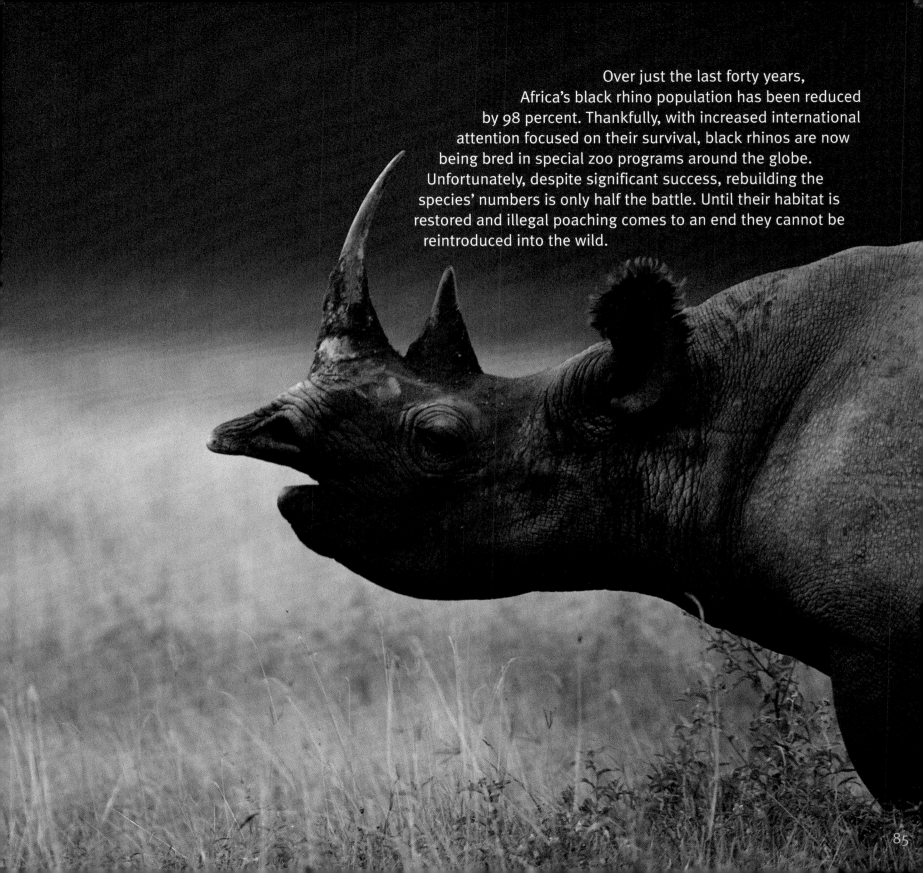

Over just the last forty years, Africa's black rhino population has been reduced by 98 percent. Thankfully, with increased international attention focused on their survival, black rhinos are now being bred in special zoo programs around the globe. Unfortunately, despite significant success, rebuilding the species' numbers is only half the battle. Until their habitat is restored and illegal poaching comes to an end they cannot be reintroduced into the wild.

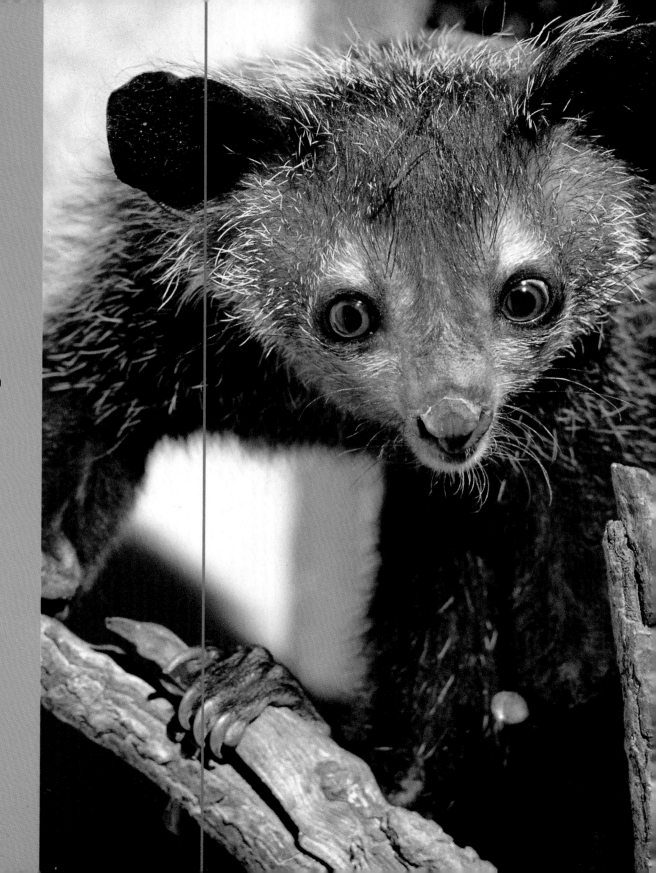

The aye-aye is a shy, nocturnal creature who spends most days alone sleeping in a treetop nest with its bushy tail curled around it for warmth. This ancient lemur with its cute face and elongated insect-finding fingers is completely unique to Madagascar, where 85 percent of its rainforest home has been cut down. To make matters worse, many aye-ayes were senselessly killed because some local people held the superstition that to see an aye-aye brought bad luck. It certainly brought very bad luck for the aye-aye to see a human being! Numerous rescue attempts, some initiated by Gerald Durrell himself, have salvaged this creature's survival. Since it breeds so infrequently and its habitat has been ravaged, it will probably remain on the endangered list for some time.

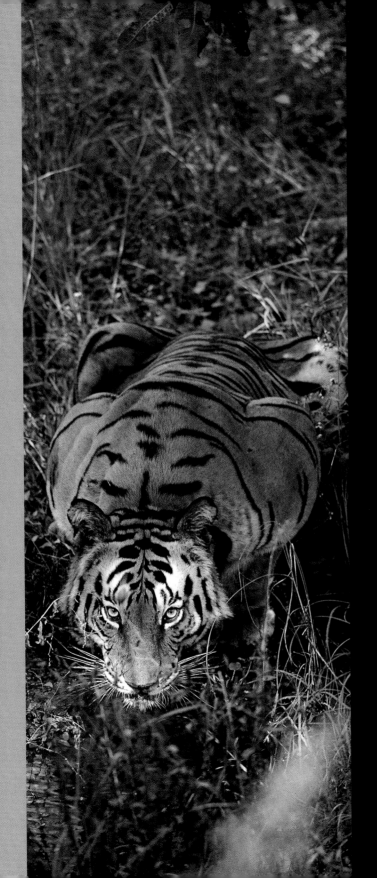

Long a champion symbol of global conservation efforts since a number of sub-species became extinct, tiger populations, although not remotely recovered, have at least stabilized in some areas. But larger breeding populations are still required everywhere to prevent unforeseen environmental catastrophes from wiping out another species. Recent forest fires in Indonesia reduced the wild Sumatran tiger population by half, from 400 animals to just 200 in little over a month.

Thankfully, with some species there has been modest growth. Through research and superior habitat management the Siberian tiger is reported to have increased in numbers from 250 animals to 370 over the last ten years. Again, we still have a long, long way to go but it's a good start.

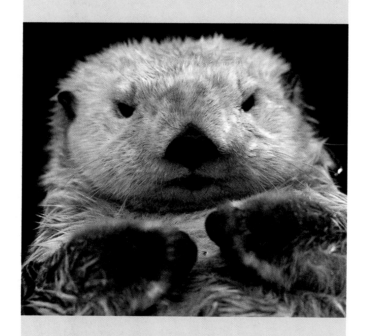

Sea otters were once hunted to the brink of extinction for their valuable fur. Tough protection laws and the regeneration of kelp beds that the sea otters inhabit have meant that populations are finally starting to recover in some areas.

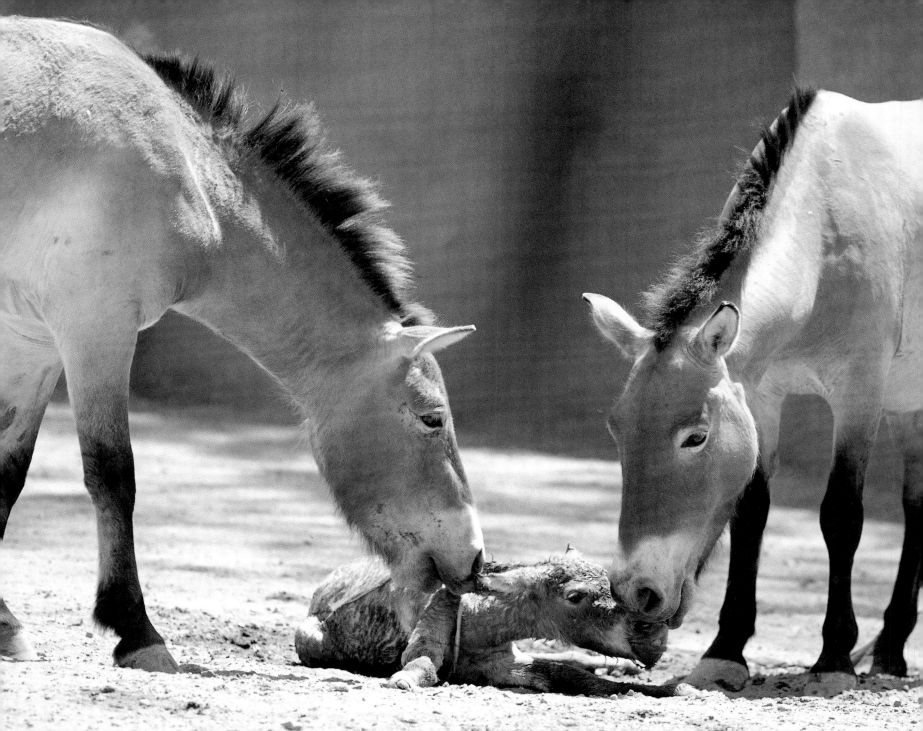

On an even more positive note, Mongolia's unique Przewalski's horse, once extinct in the wild, has been successfully bred on German and Dutch wildlife reserves as well as in a captive breeding program run by the Taronga Foundation in Australia and has now been reintroduced into its native land.

Small herds of these golden horses can now be found galloping across the Mongolian plains once more.

International cooperation has also saved the golden lion tamarin, a small flamboyant primate from the Atlantic forests of South America. Several of the world's leading zoos joined forces with the Brazilian government to breed up numbers of tamarins from a wide genetic pool and then reintroduce them into large protected reserves.

So far, this has been a big success.

These tremendous turnarounds have given many endangered animals and plants new hope. If we can just apply the same principles to the many other species at risk, with a sense of genuine urgency, then their future and ours will look much brighter.

Of course if we just lie back and do nothing, then countless lives will be lost. **Forever.**

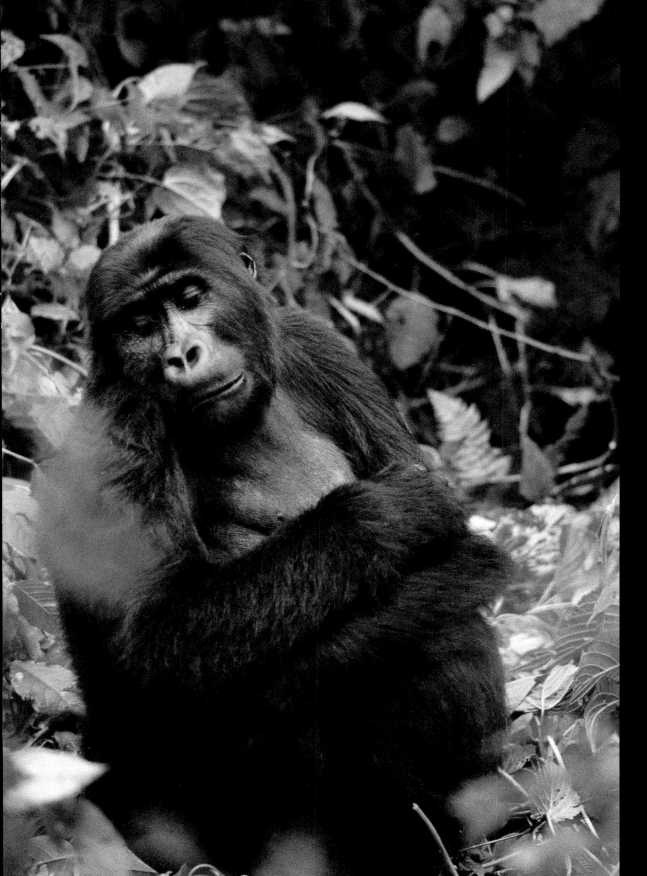

For endangered species we are both their greatest enemy and their only hope.

These wonderful creatures will not argue their case.

They will not put up a fight.

They will not beg for reprieve.

They will not say goodbye.

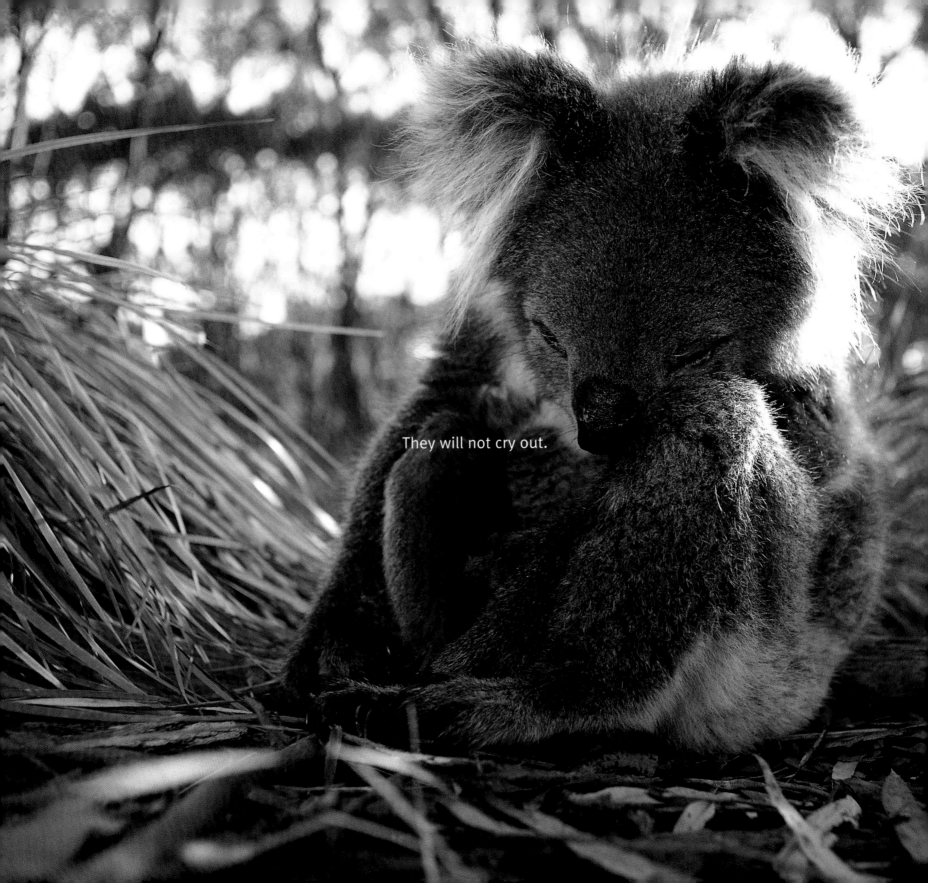

They will not cry out.

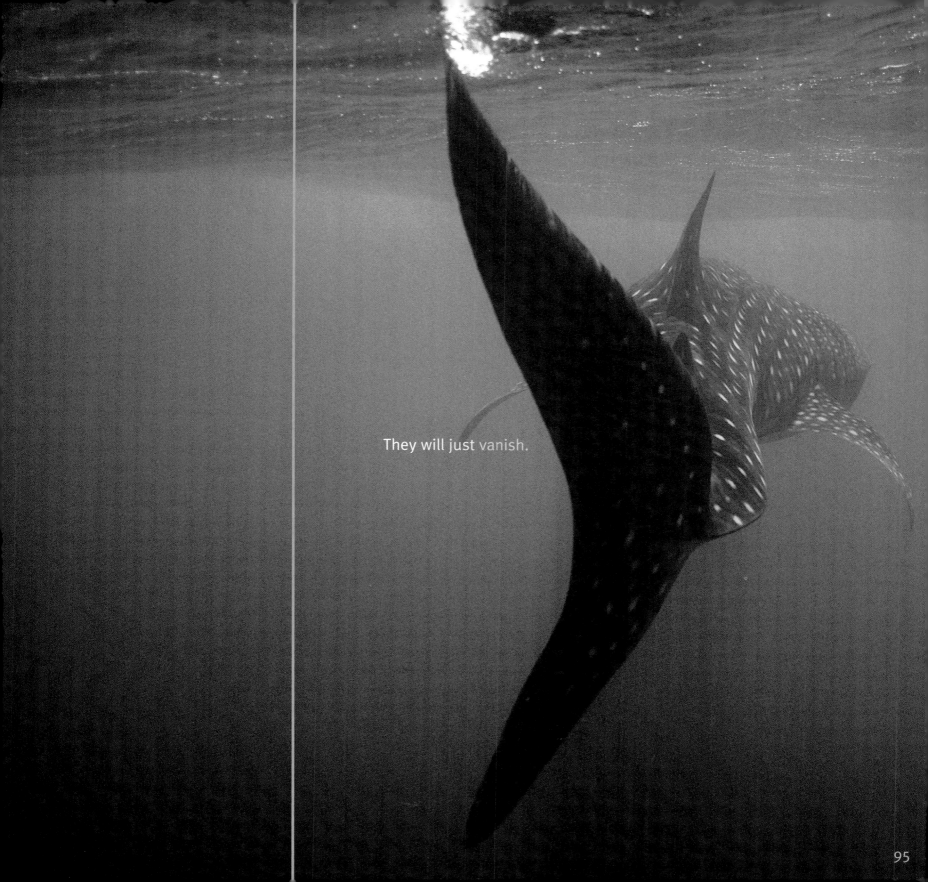

They will just vanish.

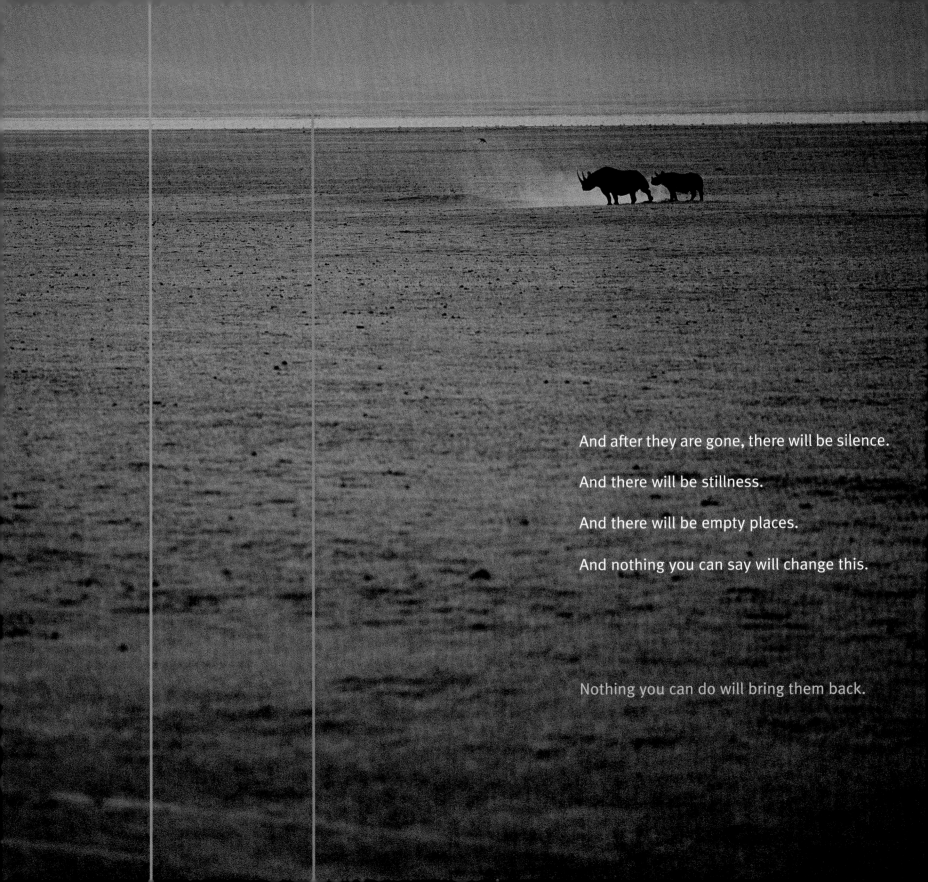

And after they are gone, there will be silence.

And there will be stillness.

And there will be empty places.

And nothing you can say will change this.

Nothing you can do will bring them back.

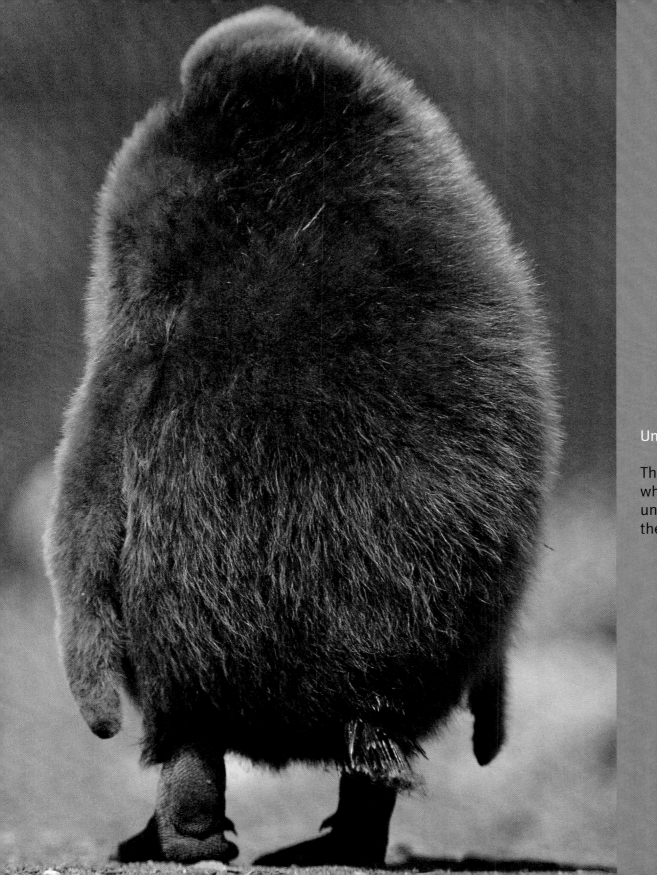

Uncertainty.

That is our only guarantee of
what tomorrow will bring,
unless we care enough to create
the tomorrow we really want.

97

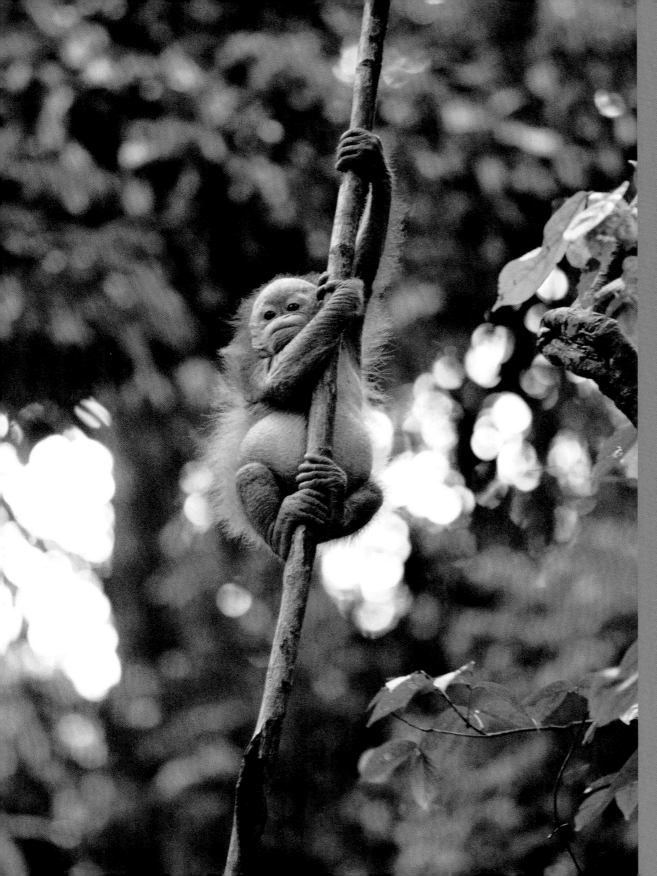

With so many lives hanging in the balance, the paths we choose today will decide the fate of the world.

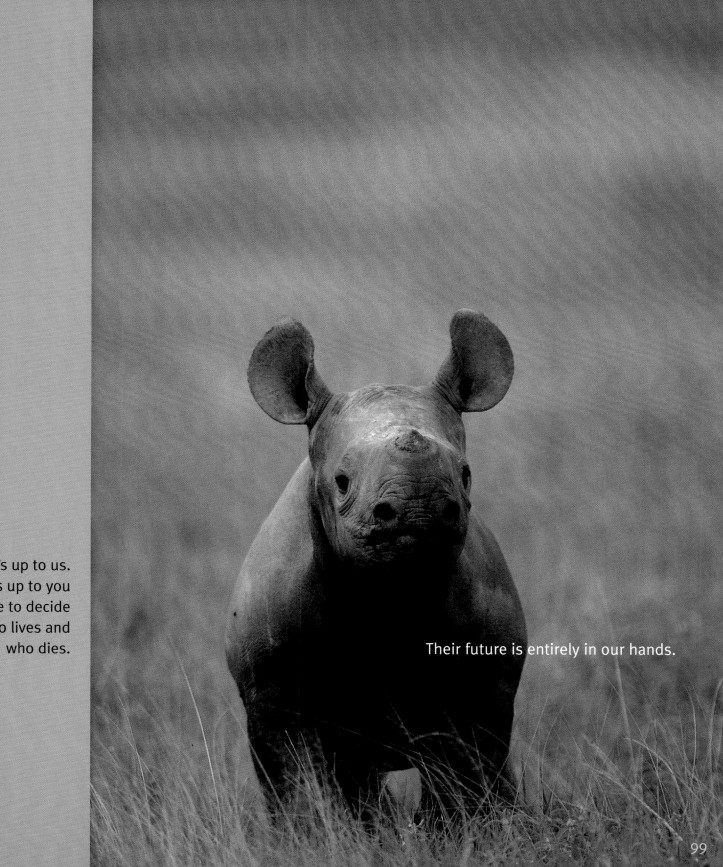

So it's up to us.
It's up to you
and me to decide
who lives and
who dies.

Their future is entirely in our hands.

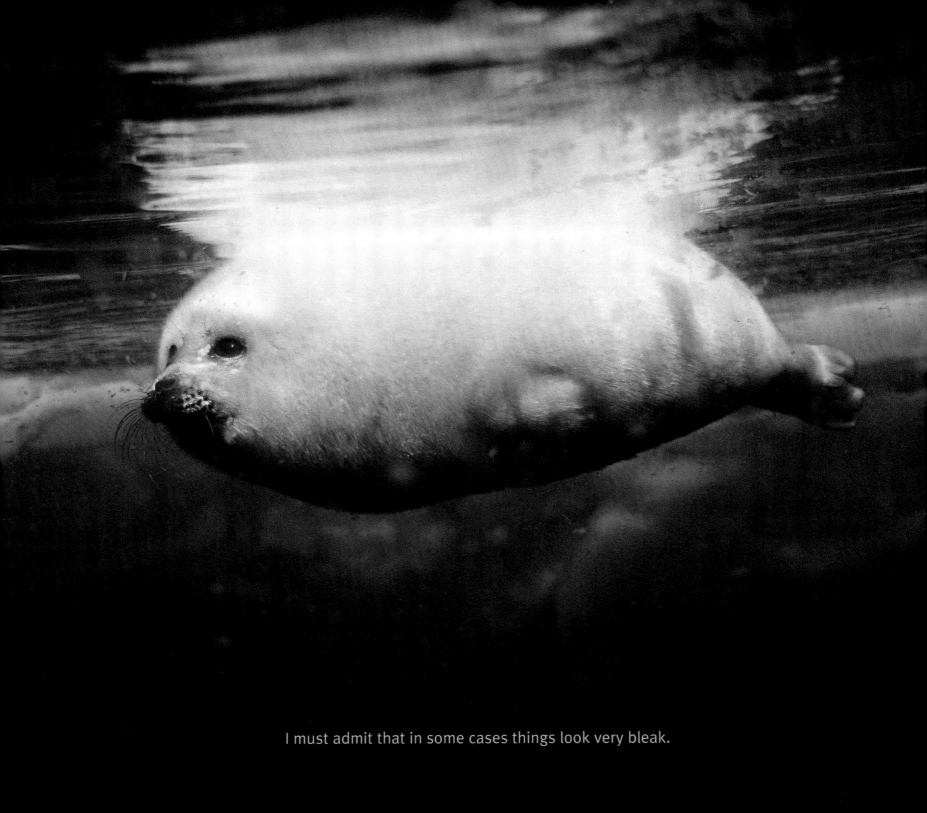

I must admit that in some cases things look very bleak.

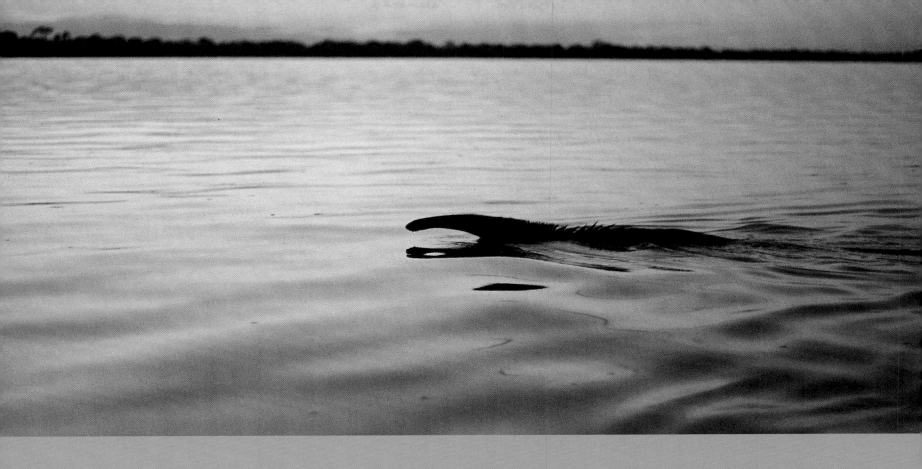

It appears as if there is too much to do,
that we have so far to go it seems an impossible journey.

It may feel as if the battle is already lost.

But it isn't.

Small changes can make huge differences.

Just as two raindrops falling an inch apart may hit a steep mountain ridge and flow down opposite slopes into different rivers and ultimately end up in two distant oceans, thousands of miles from each other, so too, in almost every aspect of life, a tiny difference, a subtle change, is often all that is required to set in motion irreversible new changes that compound upon themselves again and again until the possible outcomes are worlds apart.

In our relationship with the environment this has mainly been a negative phenomenon. We have made a number of small mistakes in the past that have ultimately proven to be very, very costly.

But the same can also be true of positive results.

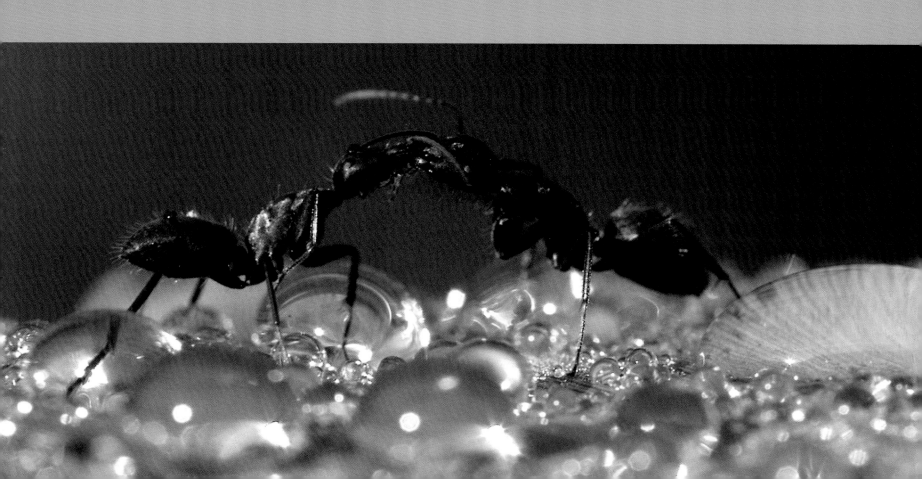

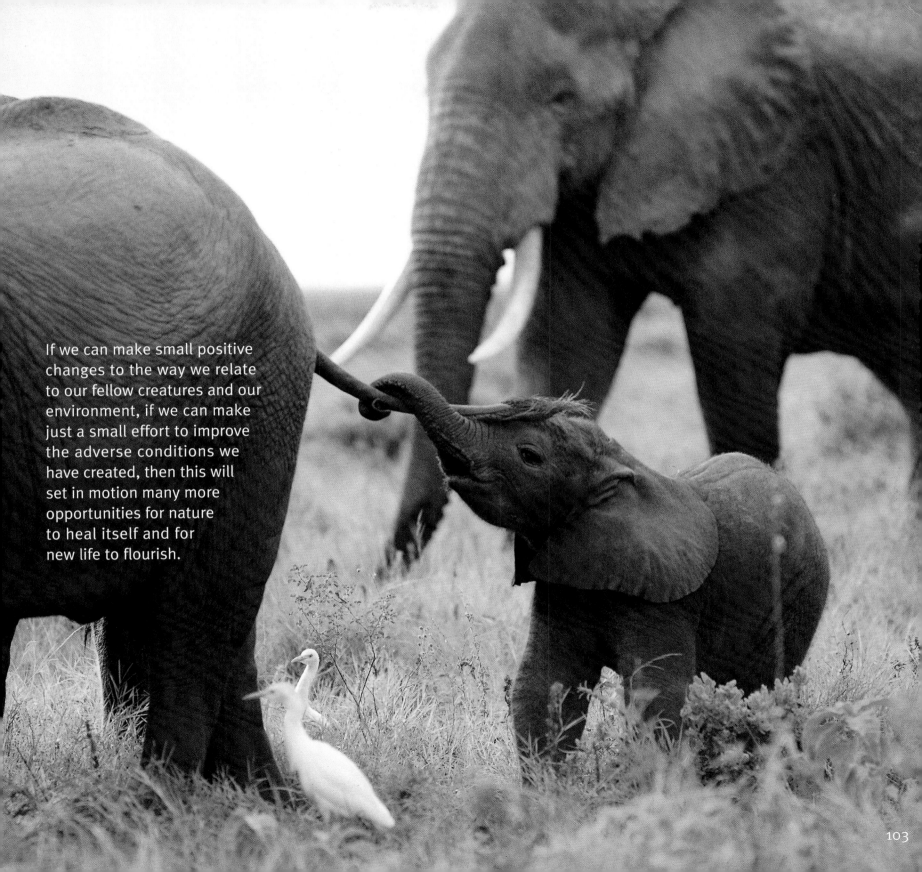

If we can make small positive changes to the way we relate to our fellow creatures and our environment, if we can make just a small effort to improve the adverse conditions we have created, then this will set in motion many more opportunities for nature to heal itself and for new life to flourish.

103

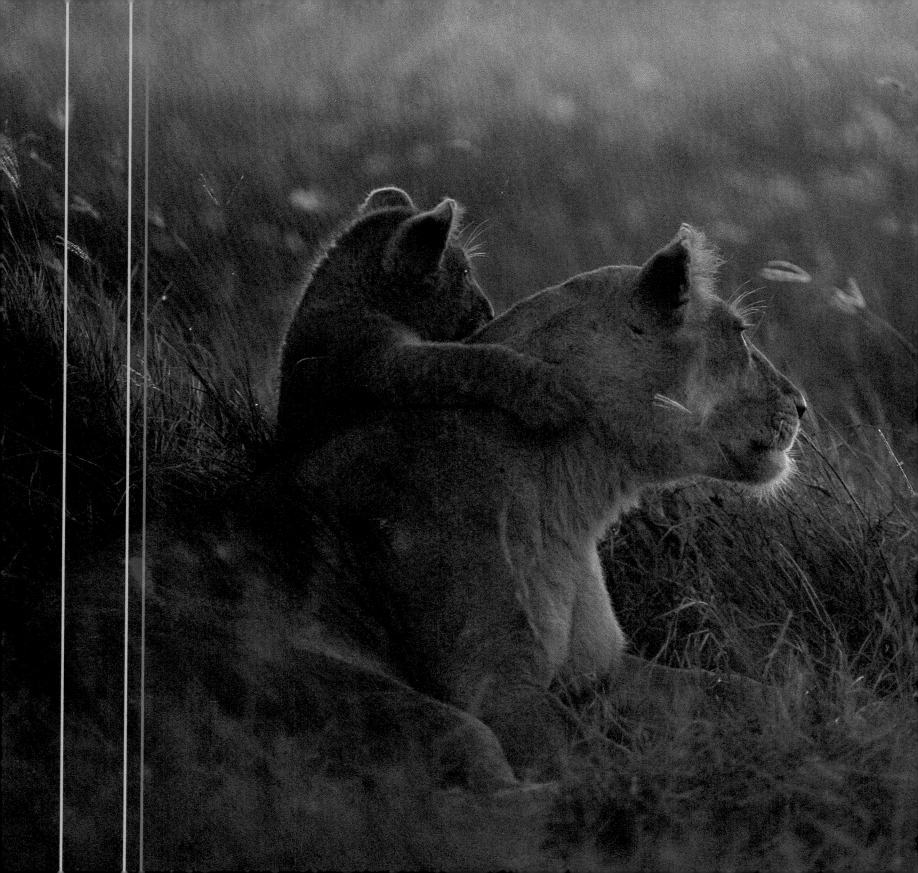

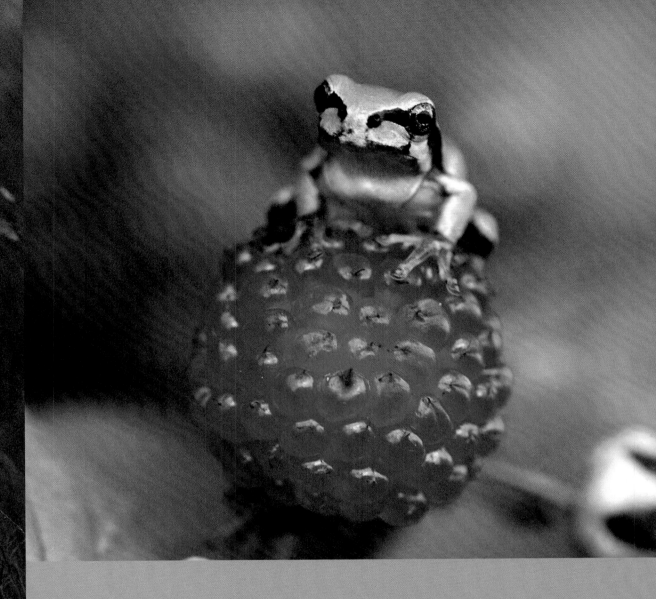

Anyone who has
seen a sunrise,
climbed a tree,
smelled a rose,
held a kitten or
listened to a whale's
haunting love song knows,
deep in their bones,
just how amazing
this planet really is.

To preserve our home and
the priceless creatures
that dwell within it
you need only see
the world as it is
and have a vision
of how it could be.

Then hold fast to this vision
and let it guide your steps,
your voice and your heart.

If you can do that then there will be hope

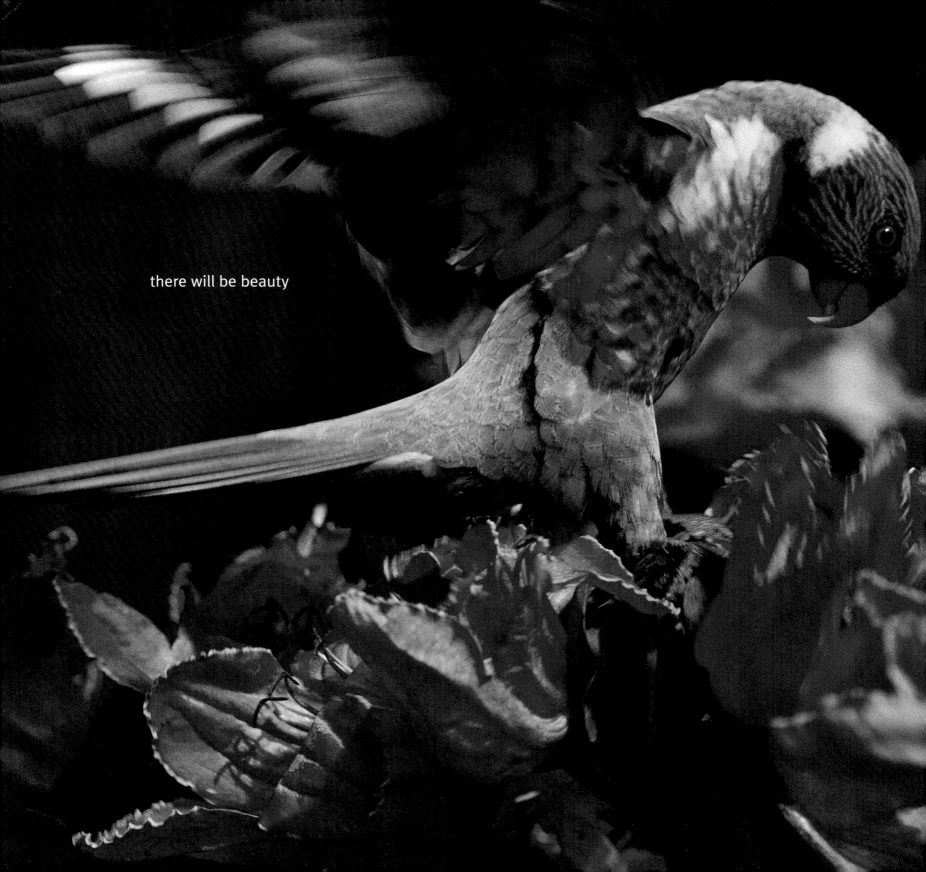

there will be beauty

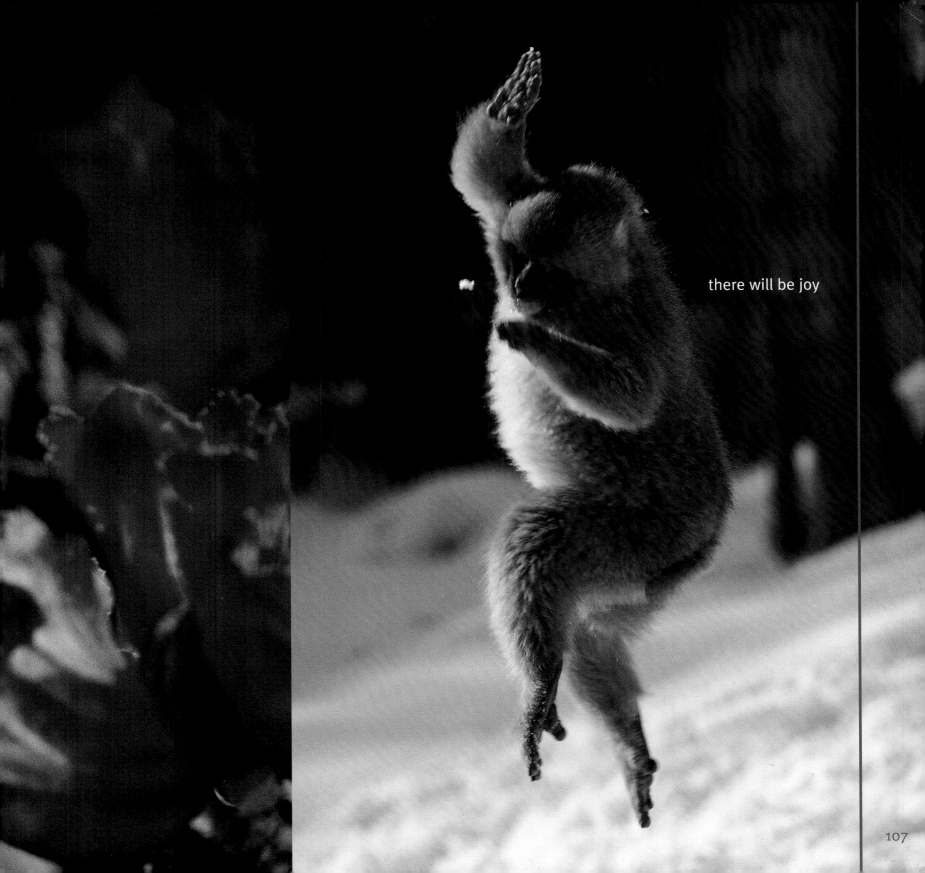

there will be joy

107

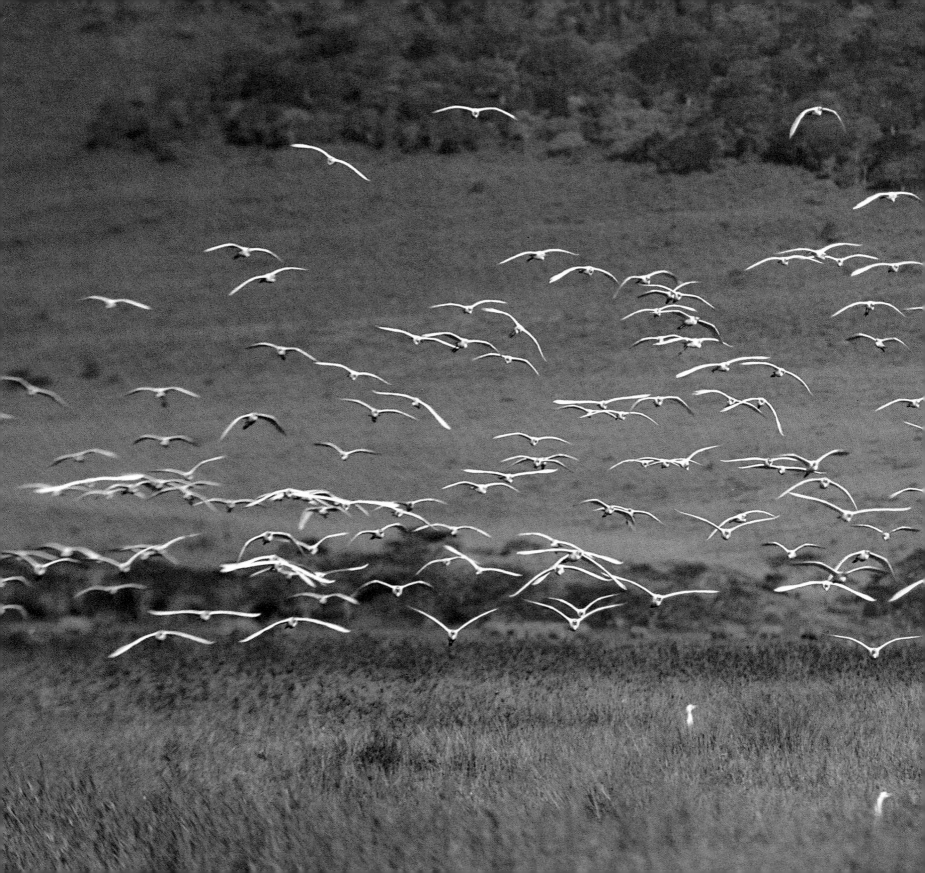

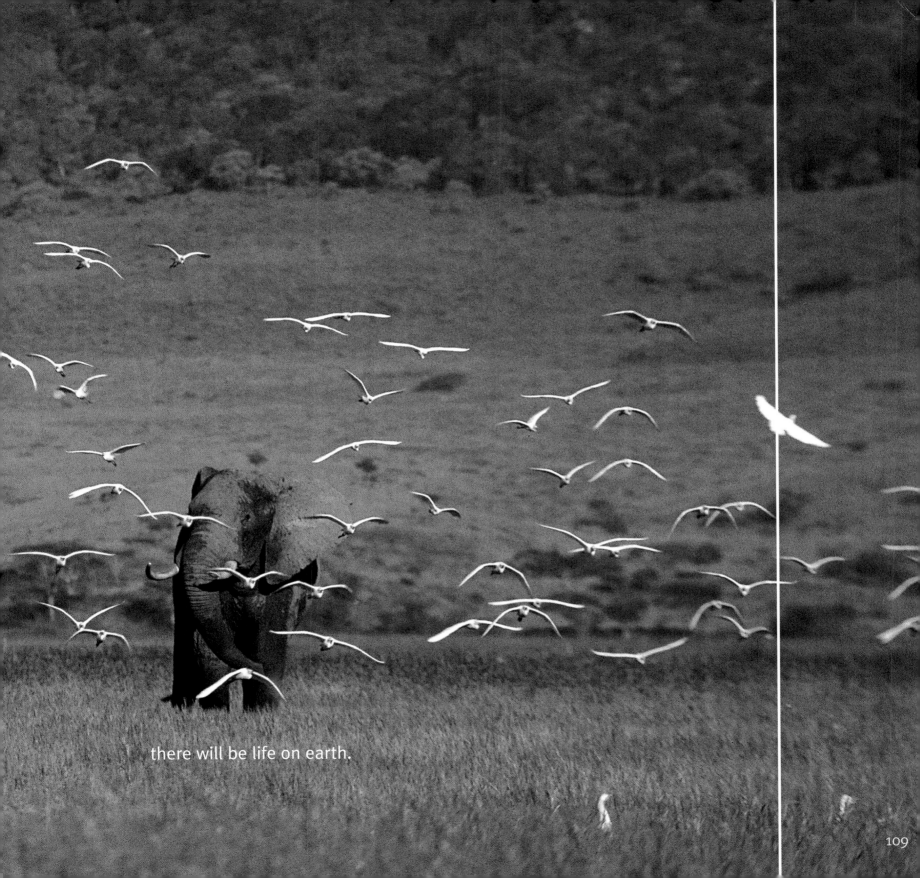

there will be life on earth.

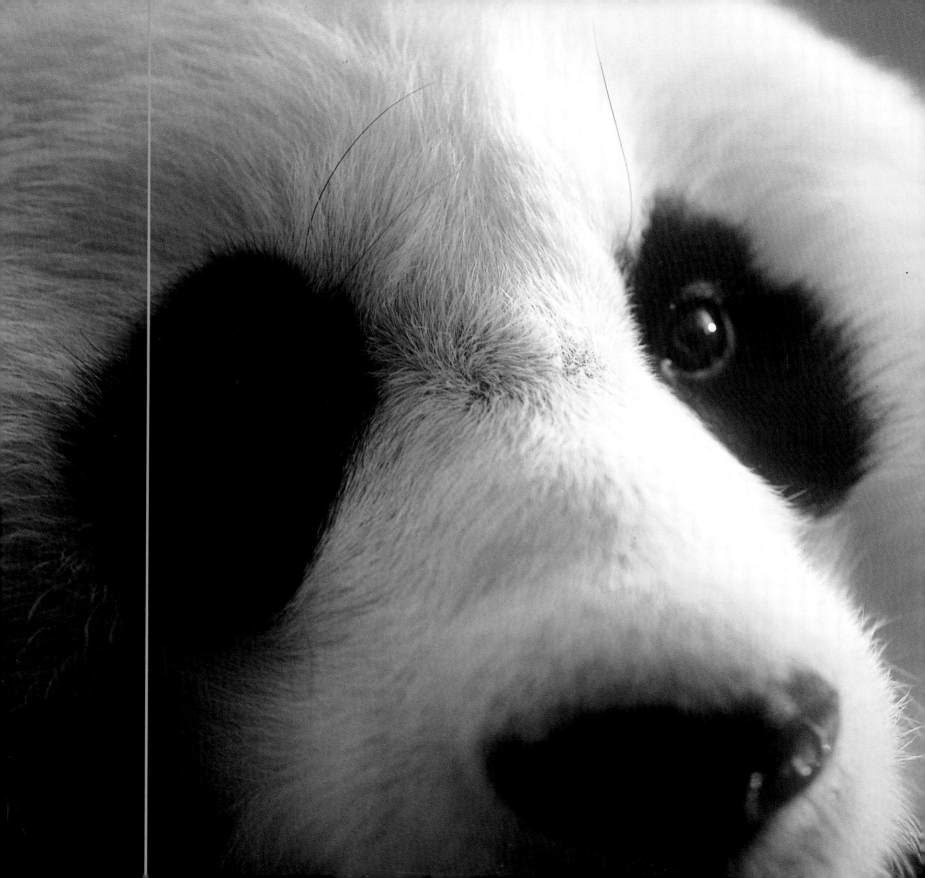

(and you will never have to live in a world without pandas)

Four things you can do to make a difference

1: Get out there and see the natural world for yourself. You can (and should) experience nature and all its wonderful creatures in the flesh, not through a 24-inch flat screen. Every single creature in this book can be reached by plane, car, train, boat and/or foot in less than 48 hours, from any location on earth. If a major adventure like this is not possible right now then visit your nearest wildlife sanctuary, your local zoo or even your neighborhood park. Do all of these things eventually. There is no better way to understand your place in the world and the role you play in securing this beauty for yourself and your children. And it's lots of fun!

2: Support research institutions, zoos, wildlife sanctuaries and conservation groups that are improving the world we live in. Donate whatever spare time or money you can afford to help their work progress. Get involved.

3: Vote with your wallet. Don't support companies that abuse animals or the environment. If you find a really great product or service that helps the environment, tell all your friends and colleagues about it. Conversely, if something is not how it should be, speak up! Make your feelings known about important issues like conservation, pollution and animal welfare. It's your planet too.

4: Think about the long-term results of what you do. Ask yourself what happens to things once they pass through your hands. Be honest about what you use and try to make small positive changes whenever you can.

Photograph by Peter Trenchard

"The world is as delicate and as complicated as a spider's web. If you touch one thread you send shudders running through all the other threads. We are not just touching the web, we are tearing great holes in it."

Gerald Durrell

from *Catch Me a Colobus*
(first published in 1972)

A few words about Gerald Durrell

Gerald Durrell was a true visionary in the field of wildlife conservation and, through his marvelous books and films, a celebrated champion for all living things. As a zoologist he possessed incredible knowledge and passion in quantities that turned the scientific community on its head and, as a nature writer and humorist, was blessed with such rare talent that he could literally make his audience laugh and cry at the same time (myself included).

Through the Jersey Wildlife Preservation Trust that he established in 1963 (renamed Durrell Wildlife Conservation Trust in 1999), he pioneered groundbreaking studies and zoo programs for endangered species that have led the way in guaranteeing a future for these rare creatures and, in truth, ourselves.

Although he passed away in 1995, his precious legacy remains intact and our love of him endures. His wonderful books and television programs about his unique life with animals continue to delight millions around the world and increase awareness of the serious issues facing our fellow earth residents. Gerry's life mission is still being fought daily by those close to him through his beloved Jersey Zoo in the Channel Islands, the headquarters of Durrell Wildlife, an institution that still sets the global benchmark for endangered species captive breeding programs and research. I was fortunate enough in 2001 to make the half-hour flight from London and spent two unforgettable days touring this tremendous zoo, learning about their many incredible conservation and training programs and thoroughly enjoyed meeting some remarkable (and very rare) creatures, including Andean bears, pink pigeons, silvery marmosets and even a "mountain chicken" that is actually a giant frog! I was so inspired by their efforts and had such a wonderful time that I became a Life Benefactor of the Durrell Wildlife Conservation Trust and promised to return to Jersey Zoo every year.

To learn more about Gerald Durrell I strongly suggest you read his superb books for yourself. Some of my favorites include *My Family and Other Animals, The Overloaded Ark* and *The Bafut Beagles* (the latter concerns a hilariously eventful animal-collecting expedition he undertook to the African nation of Cameroon in 1948). You should also take the opportunity to look up the Durrell Wildlife Conservation Trust website (www.durrell.org) and discover exactly what they are doing to make the world a better place.

A rather long personal message from Bradley Trevor Greive about the Taronga Foundation

Dear Reader,

It's no secret that I genuinely love animals, which is why I am such a proud supporter of the Taronga Foundation. Biodiversity is our planet's most valuable resource and it's my belief that the modern zoo is, at its best, the new cornerstone of effective conservation and preservation of endangered species.

It's my opinion that just as only the world's best museums and art galleries really have the expert staff, space and specialist resources necessary to preserve and display the beauty of priceless artworks for future generations to enjoy, so too the world's leading zoos now have the great bulk of specialist staff, scientific experts, technical resources, facilities, level of international cooperation and financial capacity needed to ensure that priceless animal species are preserved and displayed for the genuine benefit of all mankind. What's more, leading zoos also have the passionate desire to achieve this goal. I have never met a professional zookeeper who didn't want their animals to be happy and healthy and didn't also harbor a secret dream that one day there would be no reason to have zoos at all, because every animal would be able to be returned to a fully rehabilitated habitat allowing them to once again flourish in huge numbers within a safe, natural environment.

Of course, not all zoos are what they should be—some are still stuck back in the dark ages of zoo keeping when the animals were just amusing objects to be looked down upon—little more than disgusting freak shows, really, and sometimes not even that. I don't take kindly to those sorts of places and neither should you. Just as the leading zoos receive my full support, so too these appalling zoos receive my unmitigated wrath. Put simply, I have a personal mission to make good zoos great and bad zoos broke!

Sydney's famous Taronga Zoo (established in 1916) and its huge, open-range counterpart, Western Plains Zoo (established in 1977), are two of the world's best zoological parks. These celebrated institutions are at the forefront of zoo-based conservation and are working tirelessly in cooperation with other leading zoos, wildlife reserves, conservation groups and research facilities around the globe to educate and inspire the greater community to create a better world for wildlife and our children.

With global pressure on wildlife increasing, the Taronga Foundation was formally established in 2000 to raise the $225 million needed to expand their role as leaders in wildlife conservation, research-driven breeding programs, environmental education (including ecotourism) and the premium care of wildlife—all of which are linked to the inspirational presentation of animals, serviced by world-class facilities and amenities. And as if that were not enough, the long-term vision of the Taronga Foundation is to be recognized as a world leader in the development of philanthropic support for the conservation and presentation of wildlife.

Like so many frequent visitors over the years, I was delighted to see the huge range of endangered species that are cared for within the two zoos, including Asiatic elephants, black and white ruffed lemurs, Goodfellow's tree kangaroos, greater bilbys, Mueller's gibbons, Sumatran tigers, African elephants, cheetahs and bison, to name just a few.

As I got to know what was going on behind the scenes, I was even more impressed with their conservation achievements, including world-renowned captive breeding programs for such critically endangered species as the black rhino, Mongolia's Przewalski's horse, Fijian crested and rhinoceros iguanas, Australia's elusive platypus and the almost extinct hairy-nosed wombat. When I discovered that there were already plans underway to breed the western lowland gorilla and the greater one-horned rhino from northern India and Nepal, I was hooked.

Of course, the focus at these wonderful zoos is not only on working with animals but also, just as importantly, about working with people. Every year millions of visitors come face-to-face with the message of wildlife preservation. Furthermore, the zoos create positive, hands-on, educational opportunities for hundreds of thousands of school children annually. As if that weren't enough, they also run outreach programs such as the "Zoomobile," which visits children disadvantaged by disability, distance or economic circumstances. The bottom line is that they are always trying to find new and better ways to share their important message with as many people as possible.

After meeting the key staff members in person and seeing the results first-hand, I became totally committed to helping achieve the goals of the Taronga Foundation. A couple of years ago I started helping by becoming a Zoo Parent to some of my favorite animals, including two Malayan sun bears, a white rhinoceros, an Aldabra tortoise and a ring-tailed lemur. In 2001, I increased that support to assume the principal sponsor role for my beloved sun bears, Victoria and Mr. Hobbs. These charismatic little bears had been rescued from certain, painful death in a restaurant cage in Cambodia in 1997, where they were destined to have their paws cut off and eaten. Now they have grown into healthy adults and we hope they will breed in the future. Finally, in early 2002, I increased my level of support again by accepting a request to join the board of governors for the Taronga Foundation itself.

Now you know why I am donating all of my royalties from the sale of *Priceless* to the Taronga Foundation. Please don't get me wrong. I'm not a selfless philanthropist or an eccentric oil baron; I never took a vow of poverty nor am I an animal-obsessed tree-hugging nutcase who wants to dance around the rainforest in a hemp diaper—far from it. If given a chance, I'm sure I could develop a genuine affection for excessive wealth, so you'd better believe that I wouldn't be signing away my spare time plus my hard-earned and long-awaited author's royalties without a damn good reason.

And the reason is simply this—the money you and I donate to the Taronga Foundation is going to make a really, really, really big difference. This is an organization that truly knows how to maximize the value of your personal contribution to the environment.

Of course, by purchasing this book you have already made a significant contribution, but the donated proceeds from *Priceless* alone won't come close to meeting the needs of this important mission. I really need your help here, so I'm asking you to dig a little deeper. We have a signed commitment from the New South Wales state government to give the Foundation three dollars for every single dollar we raise, so if you were ever going to donate money to a leading wildlife charity, now is definitely the time!

If you enjoyed seeing and learning about the animals portrayed in this book and you want to do something to ensure that all the extraordinary creatures alive today will also be alive tomorrow and every tomorrow after that, please contact the Taronga Foundation as soon as possible by looking up their website (www.tarongafoundation.com).

For more information you can also contact Julie Brown,
the Taronga Foundation's Executive Officer, and her staff direct by calling:
(Your international access code followed by) 612 9978 4616.
For calls made within Australia, dial (02) 9978 4616.
If you like, you can send a fax by dialing:
(Your international access code followed by) 612 9969 7515.
For faxes sent within Australia, dial (02) 9969 7515.

If you prefer to get in touch the good old-fashioned way, please write to:
The Taronga Foundation
P.O.Box 20
MOSMAN
NSW 2088
Australia

There is so much to be done but, fortunately, there is so much you and I can actually do. Please give generously and encourage your like-minded friends and colleagues to do the same.

and now it's up to you

A few more words about the animals featured in this book

What follows are a series of brief fact sheets on the wonderful creatures that appear in *Priceless*. Please understand that these fact sheets are designed only to offer a basic introductory guide to these species and do not represent comprehensive studies of these animals, nor are they, despite our best efforts, free from error. In researching these animals and their habitats we were surprised to discover how many differences existed, in terms of both raw data and expert opinion, between the various established sources. Also, we were forced to accept that general wildlife data, particularly population sizes, are prone to continuous and sometimes rapid change. Sometimes this is because a major study is finally completed and the new knowledge corrects or updates previous findings. Sometimes this is because a new pocket of animals or plants has suddenly been discovered; however sadly, this is very rare. Mostly the changes are wrought by the continuous decline in wildlife habitat that continues to erode animal and plant populations throughout the globe. The bottom line is that we cannot assume that any wildlife we observed thriving a decade ago are still doing well today.

Just in case this book whets your appetite, we have provided a somewhat lengthy bibliography/recommended reading list at the back of this book that contains some very enjoyable and interesting material for every level of reader. If however, you seek more detailed and current information, there is simply no better place to start looking than the World Conservation Bookstore, which is easily accessible online throughout the globe (www.iucn.org.bookstore). For that matter, the updated "Red Book" listings of threatened animals and plants, plus a detailed explanation of IUCN codes and abbreviations, some of which we have included in the following pages, can also be quickly located via the same home-page (www.iucn.org/bookstore/Red-data-index.htm).

It should be noted that size/data measurements for each species generally indicate the dimensions and mass of the average, fully-grown, adult animal unless otherwise indicated. Also, I must stress that there are many more great parks and zoos around the world in which to see these creatures than just those locations we have listed. I encourage everyone to seek out their nearest wildlife park, nature reserve and zoological park to find out what wonderful creatures they have in their own backyard before wandering off to the ends of the earth (although I definitely recommend that too!).

I hope you enjoy browsing through the information we have provided and find it interesting enough to want to learn more about the fascinating animals that share our planet and—better still—feel inspired to get out there and meet them face-to-face in the wild while you still can.

JAPANESE MACAQUE [SNOW MONKEY] (PAGE 1, 107)
Cercopithecidae / Macaca fuscata

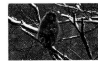

Size/Data
Height: 21 in.
Weight: 17–29 lbs.
Tail Length: 3–4 in.

General Description
The Japanese macaque has a hairless red face, calloused red rump and a short tail. Their dense gray body hair has two insulating layers that allow them to emerge wet from a hot spring and walk through the snow without suffering hypothermia. Their teeth are virtually the same as humans. They have very keen, three-dimensional sight and high-frequency hearing, although little is known about their sense of smell.

Location/Distribution
Scattered throughout the broadleaf forests of the Japanese archipelago.

Behavior
Snow monkeys are highly intelligent, social animals and live in troops that range from 10 to 100 members. They communicate very effectively utilizing physical display, grooming, facial expressions and vocal sounds. The social hierarchy for males is determined by age, size and personality, whereas female social status is determined by kin relationships. These monkeys are very active during the day and sleep in trees at night, embracing one another. The Japanese macaque diet is made up of many different plants, but they prefer new buds, young leaves and flowers (especially cherry blossoms), fruit, tree bark and seeds.

Breeding takes place between October and February. Single young are born after a 5 to 6-month gestation. The relationship between a mother and the infant is very strong; the young monkey matures after a long dependency period.

Did You Know?
- The Japanese macaque's habitat is covered with snow for more than half the year so they are accustomed to enduring temperatures of 14°F to 18°F for long periods of time.
- Snow monkeys wash their food.
- If you stare at a snow monkey they will regard it as a threat. If you stare at a monkey while sitting down at their own eye-line you may well get bitten.

Population Status
With population numbers falling and range areas dwindling, snow monkeys are definitely at risk.
IUCN Red Book Classification: Deficient Data (Formerly Endangered A2 cd)

Where Can You Find Them?
Japanese macaques are found in most zoos in Japan, Ueno Zoo being one of them. The author (BTG) also visited the Mount Takao Natural Park ("Monkey Mountain") 2 hours out of Tokyo, which is a small but delightful facility. However, the hot springs of Jigokudani, Nagano ("Hellish Valley") is the best place to see these fascinating monkeys and is the actual location the photographer (MI) chose for his award-winning book about them. Other famous sites include the natural playground of the Yokoyu River and Nikko, Kou-jima, where snow monkeys are known to wash and season food with sea water.

OKAPI [PAGE 2]
Giraffidae / Okapida johnstoni

Size/Data
Length: 6–7 ft.
Tail: 11–17 in.
Height: 4–6 ft.
Weight: 440–550 lbs.

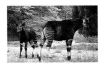

General Description
At first glance, okapis resemble something of a cross between a giraffe, a zebra and a tall horse. These shy animals have a dark chestnut coat with a light zebra-like striped camouflage pattern on their hindquarters and legs. With the exception that *only* male okapis have short horns, both sexes look very similar with white or cream mid-facial markings, long heads and necks, and large, rear-set ears.

Location/Distribution
Okapis are found only in the equatorial rainforest of the northern, central and eastern regions of the Democratic Republic of the Congo, near the Congo-Uganda border.

Behavior
Okapis are solitary and secretive creatures who are very difficult to spot in the dappled sunlight of their forest home, thanks to dark coloring and their unique face and hindquarter camouflage pattern, which effectively breaks up their outline. Okapis feed during the day on a diet of leaves, fruit and seeds. They are able to stand up on their hind legs and use their long blue tongues to secure fresh vegetation well out of reach of most other forest-grazing animals. Okapis have poor eyesight and rely heavily on their sense of hearing and sense of smell. Males have scent glands contained in their hooves that are used to mark their territory.

The 2 mating seasons take place from May to June and from November through December. At this time, rival males will neck-fight in the presence of a receptive female in order to secure her favor. After successful copulation, one young will be born after a gestation of 425 to 491 days.

Did You Know?
- The okapi is a fastidiously clean animal and it even uses its 14-inch tongue to reach up and wash its eyelids.
- Okapis were first kept in zoos in 1918 but it wasn't until the 1950s that they were bred successfully in captivity.
- The okapi's closest living relative is the giraffe.
- The longevity record for a captive okapi is 33 years.

Population Status
At Risk. It is estimated that there are only 30,000 okapis left on the planet.
IUCN Red Book Classification: LR/nt

Where Can You Find Them?
The Okapi Wildlife Reserve, which was established and sponsored by the White Oak Conservation Center, is believed to contain around 5,000 okapi and is certainly the best place to see this animal in its natural habitat. The reserve is located on the Epulu River and occupies about one-fifth of the Ituri Rainforest in a northeast region of the Democratic Republic of Congo. The Dallas Zoo, in Texas, and Yokohama Zoo, in Japan, have small, high-quality exhibits, while the Brookfield Zoo in Chicago and Bronx Zoo in New York both have superb Okapi facilities. The largest and most successful Okapi exhibit, however, is in Jacksonville, Florida, at the elite White Oak Conservation Center itself.

LEAF CHAFER BEETLE (PAGE 3)
Coleoptera / Scarabaeidae rutelinae

Size/Data
Leaf chafer beetles are generally between .8 and 2 in. in length, however beetle sizes range from .008 in. to 8 in.

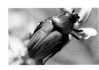

General Description
There are approximately 4,100 species of leaf chafer scarab beetles found worldwide, and no other group of animals exhibits such a wide array of sizes, colors, and shapes. Some leaf scarabs (like this one, which was photographed at Tanzania's Serengeti National Park) have a somewhat metallic appearance; a few even look as if they were made of pure silver or gold. Others have enlarged, horn-like mandibles or swollen-looking hind legs. The beetle family name, coleoptera, literally means "sheath wing" and describes the one thing that almost all beetles have in common: a second set of hardened outer-wings (called "elytra") that act as a strong, protective covering (or "sheath") for the soft hind wings, which the beetles actually use for flying.

Location/Distribution
Beetles are found practically everywhere in the world except Antarctica and the open sea.

Behavior
Adult leaf chafers feed mostly on the pollen, nectar and fibrous tissues of flowers and leaves, while the larvae, which live in the ground, generally feed on the roots of the same plants. In more general terms, beetles are nature's miniature recycling machines. They are the ultimate omnivores, consuming all manner of plants and animals and/or their remains. In other words, for every possible kind of food, there is probably a beetle species that eats it. They live in and upon plants, soil and deposits of organic waste; by consuming and reprocessing this organic waste they prevent a major infestation of pests and parasites from spawning and taking over the world. Furthermore, when beetles have eaten and disposed of this organic rubbish (remember that in polite company beetle poop is referred to as "frass"), it is returned to the soil making the nutrients available again for use by plants and other animals.

Some beetles have awesome defense capabilities. The bombardier beetle mixes chemicals at the rear of its abdomen to produce a jet-blast of hot liquid reaching temperatures of around 212°F. The blister beetles, when threatened, oozes a liquid from its knees that causes animal (and human) skin to break out in painful blisters. Most beetles, however, do not have these sort of personal arsenals and rely on their hard shells, spiky legs or horns, camouflage, proportional strength and rapid foot or wing speed to escape predation by birds, spiders, fish, smaller mammals, ungulates, reptiles, large amphibians and cruel little kids armed with magnifying glasses.

All beetles have four main life stages: egg, larvae, pupa and adult. Each stage has distinctive characteristics, but it is only the last stage, the fully grown adult, that most people ever see. This final stage is usually not the longest stage of these animals' lives. Some beetles may spend many years as larvae and only emerge for a few weeks to breed after a long and productive life out of sight.

Did You Know?
- Beetles are *the* dominant form of life on earth, as one of every 5 living species *is* a beetle!
- Beetles appeared on this planet long before dinosaurs existed, and they will probably still be here long after all other present-day species have died out.
- Beetles themselves are an important food source to many people throughout the world.
- Beetles are very attractive animals and have often been depicted in vase paintings, porcelain statuary, precious stones, glass paintings sculptures, jewelry, coins and illustrated manuscripts.
- Many of the large horned beetles, such as Goliath beetles of Africa and Hercules beetles of South America, are used as toys by children. They attach one end of a string to a stick and the other end to a beetle's body or horn. The beetle then walks about like a small dog on a lead or flies around at the end of the string, making a loud whirring sound.
- The heaviest insect in the world is the Goliath beetle from Africa. A big male can weigh up to 3.5 oz.

Population Status
Lower Risk. While it is generally accepted that there are 350,000 to 400,000 known beetle species on this earth, some experts believe there may ultimately be as many as 8,000,000 to 10,000,000 species in existence. Keep in mind if you discover a new beetle you get to name it after yourself, unless it's a stink bug in which case you can always name it after someone else. That being said, many of these species do not have large populations or large range areas and many important beetle species are put in grave danger as a result of habitat destruction and pesticides intended for other insects. Beetles perform a far greater role in maintaining the health and liveability of our environment than we ever could—anything that affects their population numbers will certainly have an impact on our own.

Where Can You Find Them?
Beetles live in virtually any place imaginable. If you can't find a beetle within five minutes of

looking you are either at the South Pole or on the moon, or some other extreme environment that is completely unfit for human inhabitation. The Natural History Museum of Los Angeles has a discovery center and insect zoo where people can view live exotic and local arthropods, including tarantulas, praying mantids, stick insects and scorpions. The Macleay Museum (housed within the History of Science Museum at the University of Sydney) holds more than half a million beetle specimens and is one of the oldest and historically most significant collections in Australia. The Natural History Museum of Maastrich in the Netherlands and the Transvaal Museum in South Africa also house a large number of beetles, but the grandfather of all beetle exhibits is contained in the entomology department of the legendary Smithsonian in Washington, D.C. This awesome museum houses the world's largest collection of coleoptera, consisting of more than 7,000,000 specimens!

HUMPBACK WHALE [PAGE 4, 80]
Balaenopteridae / Megaptera novaeangliae

Size/Data
Length: 46–63 ft.
Weight: 66,000–143,000 lbs.

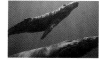

General Description
Humpback whales are blue-black in color across most of their bodies with some irregular paler areas across parts of their undersides. The humpback has prominent knobs on its snout. Its blowhole, located on the top of the head, can spray mist up to 10 feet in the air when it exhales. Its broad tail has large flukes that can be slapped hard on the water to give a loud report. Its white-edged flippers are long, powerful and serrated and are used in surface displays and to protect calves. The whale's prominent hump, from which it gets its name, is actually a raised platform upon which sits a small dorsal fin located about two-thirds of the way toward its tail. This hump area is often visible above the water's surface when the whale rises to breathe.

Location/Distribution
Worldwide except for the Mediterranean Sea, Baltic Sea, Red Sea and the Arabian Gulf.

Behavior
Humpback whales are generally found in social groups, called pods, frequenting cold and polar seas for most of the year and moving to subtropical and tropical seas in winter. A few populations are residents in the tropics. These ocean giants feed on krill, fish and squid, diving to depths as great as 650 feet below the surface and staying submerged for 30 minutes while they hunt down their prey. These whales are very intelligent and have a wide array of food gathering methods. One of the more common involves the cooperation of several whales who condense schools of fish by circling below them while exhaling a continuous curtain of bubbles. The group makes the bubble curtain circle tighter and tighter like a net, rising to the surface alongside the bubbles before rushing through the dense fish school with their mouths open.

Mating season takes place between October and March. Females breed only every 2 to 3 years. As the breeding season commences, humpback whales increase their communication via their evocative songs. Most singers are solitary males who are perhaps trying to find a partner. Their songs feature a complex sequence of calls that can be heard from at least 18 miles away. These songs vary from one whale to the next and can last up to 35 minutes at a time. Humpback whales tend to return to the same breeding ground every year. During copulation, the male and female embrace with their flippers and rise upward, half emerging from the water. They may hold this embrace at the surface for up to 30 seconds before breaking away.

After a gestation of 330 to 345 days, the mother will give birth to one calf that will be 13 to 16 feet long. The bond between mother and calf is strong. The newborn calf requires 10 gallons of milk every day for the first 5 months. It will remain close to its mother for a full year.

Did You Know?
- An adult humpback whale consumes about 2,200 pounds of food per day.
- Humpback whales have a cruising speed of up to 9 miles per hour but are capable of speeds up to 17 miles per hour if required.

Population Status
Vulnerable. Hunting has reduced the global population of humpback whales from 150,000 to only 9,000 or 10,000. Commercial hunting (officially) ended in 1966, but the population is still vulnerable.
IUCN Red Book Classification: VU A1 ad.

Where Can You Find Them?
Cape Byron, the most easterly point of the Australian mainland, is a popular whale-watching location, as is the more northerly seaside town of Hervey Bay. There are numerous whale-watching sites on a humpback migration route that runs right along the West Coast of North America: it starts at Alaska's Prince William Sound and heads south past Canada and the United States, and concludes at the Islas Marias off western Mexico. The Hawaiian Islands are definitely a preferred place to see these whales during the winter months, as are the Bonin Islands of Japan.

HIPPOPOTAMUS [PAGE 5]
Hippopotamidae / Hippopotamus amphibious

Size/Data
Length: 9–11 ft.
Tail: 22 in.
Height: 5 ft.
Weight
Male: 3,307–7,055 lbs.
Female: up to 3,307 lbs.

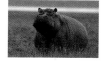

General Description
The hippopotamus is the second heaviest land animal (after the elephant) and has a long, solid body with proportionally short, insubstantial-looking legs. The hippo's head shape is adapted to a life in the water, with eyes, ears and nose set

along the top so it can breathe and see easily. The hippo's jaws can open up to 150 degrees wide, displaying enormous teeth. The canines in the lower jaw may be 20 inches long! These teeth are as intimidating as they are deadly. Hippos are usually dark gray-brown in color but after they get hot from lying in the sun their skin can become reddish pink.

Location/Distribution
Found in wetland regions of western, central and southern Africa with the highest concentrations in the Great Rift Valley of eastern and central Africa.

Behavior
Hippos are quite social and live in groups of 15 to 20 animals that are under the control of a single, dominant male. They spend most of their time, up to 18 hours a day, in water to keep cool and support their huge frame. After sunset, hippos begin foraging for food, feeding mainly on grasses and aquatic plants. Despite its large bulk, the hippo swims and walks under water with graceful efficiency.

When a female is ready to mate, she will seek out a desirable adult male. A successful copulation will result in a single young (twins are very rare) after a gestation of 240 days. Within the first 5 minutes of birth, the baby hippo is able to swim and walk. The mother is fiercely protective of her calf and very few large predatory animals, including huge estuarine crocodiles, would attempt to attack it.

Did You Know?
- The hippopotamus' scientific name literally means "water horse" or "river horse."
- Hippos can be very territorial and quite "moody" and should be treated with great respect during an encounter. More people are killed by hippos each year than by any other wild animal.
- Adult hippos eat about 88 pounds of vegetation each day.
- Almost half (up to 45%) of all hippos die in their first year.

Population Status
Vulnerable. Hippo numbers are steadily declining throughout its range.
IUCN Red Book Classification: VU A1 a

Where Can You Find Them?
Africa's Lower Zambezi National Park has a substantial population of hippos, as does the picturesque Okavango Delta in Botswana. The San Diego Zoo in California (USA) has one of the best hippo exhibits in the world. Western Plains Zoo (Australia) and Auckland Zoo (NZ) also have high standard, albeit more modest, hippo facilities.

PYGMY-POSSUM (LITTLE) [PAGE 6]
Burramyidae / Cercartetus lepidus

Size/Data
Length
Body: 2–3 in.
Tail: 2–3 in.
Weight: .2–.3 oz.

General Description
When fully grown a little pygmy-possum is roughly the same size as a human thumb. Its relatively large head features black whiskers, a pink nose, large dark eyes and prominent, erect ears. They have well-developed forward-facing pouches for their young. The prehensile tail cannot only support the animal's entire weight but it also expands at its base to store excess food as fat. The pygmy-possum has opposable big toes perfect for climbing and clinging. In terms of coloration, the little pygmy-possum is fawn or brown over its upper body and is the only pygmy-possum with gray fur on its underside.

Location/Distribution
The southeastern Australian states of Victoria and Tasmania, and Kangaroo Island, South Australia.

Behavior
These tiny nocturnal marsupials are usually found individually except when breeding. All pygmy possum species are adept climbers and can leap (proportionally great distances) from branch to branch with considerable ease. Their diet is quite diverse and includes insects, fruits, seeds, pollen, nectar and sometimes even small reptiles.

Breeding occurs throughout the year in Victoria, although species in Tasmania breed only during the warmer months in the spring and summer. A female will give birth to up to 4 young, each of which secures one of her 4 teats located inside her pouch, where they will stay for about 6 weeks.

Did You Know?
- Little pygmy-possums are the smallest of all the possum species.
- Unlike most Australian animals, the little pygmy-possum has the ability to enter torpor, which means during the cold of winter it is able to reduce energy expenditure by lowering its metabolism. Its body temperature can drop to near that of its surroundings. Unlike true hibernation, torpidity generally lasts only a few days at a time.

Population Status
Lower Risk. Although numbers are affected by habitat loss and human encroachment, this species, while not common, still maintains an adequate population size within its range.

Where Can You Find Them?
While they are certainly in the trees within their range of Australian bushland, their nocturnal habits and limited fluffy dimensions mean you would be very unlikely to see little pygmy-possums in the wild without making serious night-viewing preparations.

Sadly, no reserve, park, zoo or sanctuary in Australia has an exhibit of little pygmy-possums for public viewing at present. The most common sightings in recent times have been on Kangaroo Island, located off South Australia. The best advice would be to contact a National Parks and Wildlife office in these regions and seek their advice or assistance to locate these tiny marsupials.

JAPANESE SQUIRREL [PAGE 7]
Sciuridae / Sciurus lis

Size/Data
Total Length: (max)
19 in.
Body: 9 in.
Tail: 7 in.
Weight: 10–14 oz.

General Description
Japanese squirrels are somewhat like classic European squirrels, although they are quite small in stature. They have a grayish-brown coat with white chests and underparts. They have long whiskers and very bushy, well-haired tails. Their ears are quite long, stand straight up and have relatively long tufts at the tips.

Location/Distribution
Found only in Japan on the Hon Shu mainland.

Behavior
The Japanese squirrel feeds on nuts, acorns and buds, leaves, insects and mushrooms. These animals are very dexterous and, while they lack opposable thumbs, they use their paws in a manner similar to monkeys, raccoons and humans. In the autumn, they bury nuts and acorns in the ground to store them as a food supply for the winter months.

Japanese squirrels are not territorial and the home ranges of individual squirrels may overlap considerably. However, they are not particularly social in nature and are not normally found in groups except when males gather within a female's home range to compete for the opportunity to mate with her. After mating, female squirrels usually give birth to 2 to 5 young. Like kittens and puppies, squirrel babies are born blind. The infants will be nursed by their mother, within her tree hole nest, for 2 to 3 months, by which time they are ready to leave the nest and become courageous, independent young squirrels of Japan!

Did You Know?
• Squirrels bury more seeds, such as acorns, than they actually eat. They always forget where they buried much of their winter store and some of these forgotten seeds end up sprouting and growing into large seed-producing trees. In this way, these little squirrels help their forest habitat regenerate and inadvertently guarantee the future of their own food source.

Population Status
Lower Risk. Although their range is not very big, Japanese squirrels are abundant breeders and their population numbers are steady.

Where Can You Find Them?
Easily found in parks and reserves on the Hon Shu mainland.

UAKARI (RED) [PAGE 8]
Cebidae / c. rubicundus

Size/Data
Body Length: 14–22 in.
Weight: 6–9 lbs.
(note: females are generally larger.)

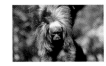

General Description
Red uakaris are immediately identifiable by their bald, reddish-pink faces and nasal spectrums so broad that the nostrils actually point sideways. Their striking reddish-brown hair is long and coarse, with bright orange highlights around their underparts. The uakari's muscularity is remarkable and, despite not having tails, they are very athletic and agile leapers. Their thumbs are not markedly opposable to their fingers and thus uakaris tend to grip objects between their forefingers and third fingers as humans do between their thumbs and forefingers.

Location/Distribution
Uakaris are found almost entirely in rainforests and the upper Amazon swamps of Central and South America. The actual range of these creatures is poorly known; however, it was once believed to extend through Brazil, Colombia and Peru.

Behavior
These New World primates live in small territorial groups (troops) high up in the rainforest canopy. They are fairly omnivorous and forage by day in the trees for seeds, fruits, flowers and small animals.

Uakaris do not breed rapidly; a female gives birth to no more than one infant every 2 years.

Did You Know?
• While a uakari troop will fiercely protect its territory from other uakaris, they often mix with other primate species and squirrels when feeding.

Population Status
Uakaris are endangered due to hunting as well as habitat disturbance from logging. With their slow rate of reproduction, their numbers are rapidly declining. They are now extinct in the wild within Peru.
IUCN Red Book Classification: ENB1+2abcde

Where Can You Find Them?
The Reserva Comunal Tamshiyacu-Tahuayo is the only protected area in Peru inhabited by red uakari. Los Angeles Zoo (USA) is one of a handful of quality institutions to house red uakaris. They also have a number of other unusual primates that are breeding successfully and are certainly worth visiting.

JAPANESE CRANES (RED-CROWNED CRANE) [PAGE 9]
Gruidae / Grus japonensis

Size/Data
Length: 39–59 in.
Height: 67 in.
Wingspan: 7 ft.
Weight: 15–27 lbs.

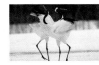

General Description
The red-crowned crane is the largest and heaviest crane species and one of the most beautiful. These stunning birds have predominantly white plumage with black necks, faces and wing tips. One of their most striking features is their bright red, featherless crowns from which they get one of their common names.

Location/Distribution
Once spread from Siberia to Japan. Today, apart from Japan, these cranes can only be seen in Russia's Amur Basin and a small area of north-east China.

Behavior
Japanese cranes are, like most cranes, primarily wading birds, feeding mostly on mud-fishes, frogs, water reptiles and various vegetable matter. Japanese cranes are usually found in breeding pairs. They are very territorial birds and will actively defend a large breeding area if encroached upon. They will often publicize their ownership of this territory by calling loudly to other cranes, warning them to keep well away. When they become sexually mature, the cranes perform spectacular courtship dances to find a mate. The dance performance can involve leaping, bowing and flapping their wings. They may even throw feathers or stones up into the air. This elaborate behavior helps the pair to form a strong partnership; in fact, cranes usually stay with the same mate their entire lives. Interestingly, Japanese cranes rarely dance once they have selected and settled with their life partner. Does this sound familiar, ladies?

During the breeding season, a nest is made of grass and reeds. The mother will lay 2 eggs that weigh 8.8 ounces each and take about one month to hatch. During this period, both parents take turns incubating the eggs, switching places 2 to 10 times a day. Both parents will then care for and raise the hatchlings. Crane families stay together as a unit for 9 months, at which point the fully grown young are chased away from the parents' territory.

Did You Know?
• Red crowned cranes can live for over 80 years. They have historically been a symbol of long life and good luck in the Orient and feature prominently in Oriental art and folktales.
• One captive Siberian crane died at the age of 83, having successfully fathered chicks in his 78th year!

Population Status
Endangered. The current global population of red crowned cranes is only 1700 birds. The population in Hokkaido, Japan, where most cranes spend the winter months, is gradually rebuilding its numbers, which, in 1952, fell as low as 33 birds. The good news is that a Japanese crane survey completed on January 25, 2001, found 798 cranes in Hokkaido. This positive result is thanks largely to Asian nations working together to preserve the crane's habitat and implementing effective breeding programs through their "Captive Propagation Centers for Cranes." Naturally, this great work must continue for this species to survive.
IUCN Red Book Classification: EN C1

Where Can You Find Them?
Kushiro, Japan, is a great place to see cranes for 2 reasons: firstly, it is the home of the Japanese Crane Reserve, which, having been established in 1958 with only 5 cranes, now hosts around 20 of these stunning birds. Secondly, the Kushiro Zoo, in the same neck of the woods, also plays an important part in securing the future of the red crowned crane through the Tanacho Protection and Propagation Center, located within the zoo itself.

You can also find these elegant birds in the Zhalong Nature Reserve in China and the Choelwon Bird Reserve in South Korea. There are about 63 cranes spread over 21 zoos in the United States including those held at the International Crane Foundation in Wisconsin.

WOMA PYTHON [PAGE 10]
Pythonidae / Aspidites ramsayi

Size/Data
Length: (max) 7 ft.

General Description
The woma has dark eyes and a stout body with slender banding. Its head markings, the width of its bands, body color and the degree of contrast are all highly variable, ranging from sandy-brown to dark bronze and black-brown, depending on family bloodlines and the individual animal.

Location/Distribution
Found in the arid desert regions of central Australia.

Behavior
The woma spends the day underground in burrows, emerging at night on cruises across the sandy plains searching for prey such as lizards, small mammals and even other snakes. A woma will sometimes agitate the tip of its tail to lure small animals close enough for a strike. After biting their prey, the python will then suffocate it as quickly as possible by applying ever-increasing pressure around the victim's body. All meals are swallowed whole.

During the breeding season, a female will lay 8 to 16 eggs. Unlike many snakes, woma young are quite large when hatched.

Did You Know?
• Womas are not only incredibly beautiful snakes but also possess an endearingly calm disposition. They are strong feeders and thus are highly prized as pets among authorized reptile owners (in Australia you must have a permit to own a captive reptile).
• Australian Aboriginals (indigenous Australians) have traditionally considered womas to be good eating and actively seek them out by tracking them to their burrows.

Population Status
Endangered. These beautiful desert-dwelling pythons have been wiped out from south-western Australia as huge tracts of land have been cleared for intensive wheat farming.
IUCN Red Book Classification: EN A1c

Where Can You Find Them?
Unless you possess the Australian Aboriginal hunters' high-level game-tracking skills, finding snakes in the middle of the Australian desert at night will prove no mean feat. The Alice Springs Desert Park in central Australia contains a number of protected womas, but they are still difficult to find within the park's boundaries.

A far easier option would be to visit the Adelaide Zoo in South Australia, Darwin Zoo in the Northern Territory, or Perth Zoo in Western Australia. Perth Zoo houses the most womas in the world, which thankfully have been bred in captivity with prolific success.

PUFFIN (TUFTED) [PAGE 11]
Alcidae / Lunda cirrhata

Size/Data
Length: 10–11 in.
Wingspan: 19–25 in.
Weight: 11–19 oz.

General Description
The tufted puffin is a stocky seabird that is related to the auk family. It has a white chest and face with a black body, wings and crown. The bill sheath, which is shed after each breeding season, is brightly colored, but the tufted puffin's most distinctive feature and its namesake, is its long, swept-back tuft of light blonde plumes.

Location/Distribution
The North Atlantic and Arctic Oceans.

Behavior
After penguins, puffins are the most highly adapted aquatic birds on earth. Although they are capable of flight, their small wings work much better under water than in the air, propelling them through the ocean at tremendous speed. Not surprisingly, their diet is primarily composed of small fish and sand eels, especially during the summer months. When near the Arctic, puffins use their strong beaks to consume crustaceans as well.

Puffins tend to pair for life, although remarkably they split up after mating and then reunite annually at the mating ground during the breeding season, which occurs between April and August. Puffin pairs initially display to each other on the water by rubbing their bills and cooing before mating. Only then do they come ashore. A young pair may dig a new burrow, but they prefer to use a pre-existing burrow, like an abandoned rabbit hole, to which they will return every year. The female lays one egg inside the burrow that hatches after an incubation period of 36 to 45 days. The fledgling is then raised by its parents for 34 to 83 days, after which it will face the world on its own.

Did You Know?
• The puffin keeps its feathers waterproof as it preens by applying oil from a gland near its tail.

• Although the puffin is more adept at swimming, it can actually fly very fast. The only catch is that its legs are located so far back on its stubby body that most flights end with a dramatic crash landing. March is an ideal time to observe this phenomenon as puffins can be seen undertaking what appears to be high-speed joy flights that conclude with them dive-bombing their colony's nesting cliffs.

Population Status
Lower Risk. Although many puffins died in the 1960's due to unchecked chemical and oil pollution of the sea, the numbers have since stabilized somewhat and this colorful species is once again quite common within its range. It should be noted that these small seabirds are still at risk to ocean pollution, as well as overfishing and changing sea temperatures, which reduce the populations of sand eels and whitebait that puffins rely on for food.

Where Can You Find Them?
In the North Atlantic there are several established puffin colonies around the British Isles. Tufted puffins can be observed on islands such as Skomer in South Wales and on remote Scottish islands such as St. Kilda.

SERVAL [PAGE 12]
Felidae / Felis serval

Size/Data
Length: 26–39 in.
Tail: 9–18 in.
Height: 21–24 in.
Weight: 17–40 lbs.

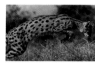

General Description
The serval resembles a small cheetah in that it has a long narrow head, a slender build, prominent ears and a spotted coat (black on tawny-gold). They have explosive power and can leap up to 10 feet into the air from a static position. Their hearing is so good that they can actually hear rodents tunneling underground.

Location/Distribution
They were formerly found throughout Sub-Saharan Africa, but now they are very uncommon in the African grasslands and are completely missing from the rainforest and desert regions altogether.

Behavior
Servals are solitary, territorial animals that are most active at dusk. They are basically everything your pet pussycat wishes it could be: sleek, intelligent, graceful and versatile predators that prey successfully upon birds, rodents, hares, lizards and even fish.

The breeding season for servals varies with the climate of its region. When the female is ready to mate she will emit a unique call that attracts a suitable male to her hidden den. A successful union of mature servals will generally result in a litter of one to 4 young after a gestation of 74 days.

Did You Know?
• It is widespread but very uncommon over most of its range. Hunting and loss of habitat have

driven the serval from many areas, but it is still one of the few spotted cats not on the critically endangered list.
• The serval longevity record is currently 19 years (in captivity).

Population Status
Endangered in North Africa but still lower risk over the rest of its range.
IUCN Red Book Classification: EN D1 (North Africa)

Where Can You Find Them?
It is virtually impossible to find a serval in the wild and only someone like Mitsuaki Iwago could come up with a photo like the image in this book. However you will be able to see one easily because currently there are more servals in zoos than can really be accommodated effectively in captivity. The International Species Information Service (I.S.I.S.) lists 292 servals in zoos worldwide, with almost half that number (130) in the United States alone. Sierra Safari Zoo in Nevada (USA) is one such institution with a breeding pair of servals.

BLACK LEMUR [PAGE 13]
Lemuridae / Lemur macaco

Size/Data
Length
Body: 16 in.
Tail: 22 in.
Weight: 5 lbs.

General Description
Black lemurs are a slim, middle-sized lemur species, roughly the size of a house cat. They are sexually dimorphic (the male and female are different colors), thus the name black lemur is slightly misleading, as only the male is entirely covered in soft black fur. The female is usually brown or russet with lighter underparts and ear tufts. Both sexes have brown eyes, long tails, moderately ruffed necks and long ear tufts.

Location/Distribution
Black lemurs are found in the few pockets of undisturbed tropical rainforest in the northwest corner of Madagascar. They have also been reported in secondary forests, as well as in coffee and cashew plantations. However, this is almost certainly a result of their forest home being destroyed.

Behavior
Although they will happily take to the ground and walk, black lemurs are primarily treetop dwellers. They are quite social animals and live in family groups of 7 to 10 related individuals. Females are dominant to males. Their social bonds are reinforced by grooming with their 6 unique lower teeth that stick straight out, forming a dental comb used to clean their own fur and that of other members of the group. Black lemurs seem to be very relaxed about territorial matters and can cohabit a region with other lemur species without any great animosity. Black lemurs feed primarily on ripe fruit, leaves, flowers, insects and sometimes small vertebrates such as tiny lizards. Although most feeding and mating activity takes place during the day, black lemurs are also occasionally active at night.

In the wild, females give birth to one offspring in autumn (March to May) after a gestation period of 126 days. The infant clings tightly to its mother's belly for the first 3 weeks and will then stay quite close until it is weaned at about 5 to 6 months.

Did You Know?
• Due to large amounts of fruit in their diet, black lemurs are important in the dispersion of fruit seeds in Madagascar. In other words, they replant the trees from which they get their fruit by dropping seeds onto the ground as they eat or in their droppings.
• The black lemurs at the Duke Primate Center are named after Greek gods and mythological figures such as Hesperus, Latona, and Daphine.
• Lemur comes from the Latin word meaning "ghosts." This is actually the perfect name for them because as tree dwellers they often seem invisible high up in the dense foliage, even though their calls and movements are readily heard from the ground It can sometimes appear as if the trees are actually haunted!

Population Status
Vulnerable. It is estimated that there are about 10,000 black lemurs surviving in the wild. However, these are increasingly at risk due to the unrestrained exploitation of Madagascar's rainforests. Many experts currently believe the rich biodiversity of Madagascar is under such threat the numerous unique species of plants and animals will vanish entirely before they have been studied at all (not to mention those hundreds of species that have yet to be identified). In addition to the shrinking wild population, there are currently 275 black lemurs housed in over 50 zoological institutions worldwide.
IUCN Red Book Classification: VU B1+2bc

Where Can You Find Them?
Although you will almost certainly need a local guide (brush up on your French!), black lemurs can most easily be found in the tropical rainforest havens in the northwest corner of Madagascar, including Nosy Be ("Be" is pronounced "Bay") and Nosy Komba. The celebrated Duke Primate Center in North Carolina houses a healthy breeding group of black lemurs, but the best public exhibit I have seen to date is the superbly designed, brand-new facility at the San Francisco Zoo that not only displays this and other lemur species in a positive and comfortable way, but also actively promotes awareness of their plight and raises funds for conservation in Madagascar.

GREEN SEA TURTLE [PAGE 14–15]
Cheloniidae / Chelonia mydas

Size/Data
Length: 5 ft.
Weight: 600 lbs.

General Description
The green sea turtle is equipped with powerful flipper-like forelimbs which, when "flying" at full speed, make it the fastest swimming sea turtle in the world (there are 7 other related species). Its protection from larger predators is a thick, heavy, bony shell, which is usually olive or dark brown in color. After hatching,

male green sea turtles spend their entire lives in the ocean while females will only come ashore to lay eggs. To adapt to a life spent in the sea, these turtles have a special gland near their eyes through which they excrete excess salt from their system.

Location/Distribution
Presently found in decreasing numbers throughout many warm oceans, including the Pacific, the Mediterranean and some parts of the North Atlantic coast of the United States and Europe.

Behavior
Green sea turtles are solitary animals and prefer to spend most of their lives in warm, shallow coastal waters, although are known to carry out incredible migration journeys across the world's largest oceans. While young these turtles have been known to feed on seaweed, jelly fish, crustaceans and fish; however adults focus almost exclusively on a selection of marine plants.

Although capable of breeding year-round, green sea turtle nest sightings are increasingly rare, thanks largely to illegal hunters who kill huge numbers of these turtles for their meat and shell. 7 to 10 weeks after mating successfully, females will come ashore at night and dig a nesting pit in the sand. They will then lay and bury 75 to 200 eggs, which will hatch in 2 to 3 months, depending on temperature. A female will repeat this exhausting exercise up to 5 times during her nesting season. Sadly, turtle infant mortality rates are incredibly high; from 1000 eggs only one or 2 hatchlings will survive their first year.

Did You Know?
- The green sea turtle was actually named for the green color of its fat.
- The sex of hatching sea turtles depends on the incubation temperature. At 86°F the sex ratio of males to females is 1:1, at 82.4°F the hatchlings are all male, and at 89.6°F they are all female.
- If they can survive the ocean's many predators (especially illegal hunters) green sea turtles can live for as long as 50 years.
- The author (BTG) once split his head open in a dramatic collision with a stainless-steel dive boat while foolishly chasing after a speeding green sea turtle while skin diving off Kirra Reef in north-eastern Australia.

Population Status
Endangered. We may well lose all green sea turtles soon if more is not done to protect them and their environment.
IUCN Red Book Classification: A1 abd

Where Can You Find Them?
The most important rookeries or nesting beaches are Tortuguero in Costa Rica, Aves Island in the Caribbean, Ascension Island on the Mid-Atlantic and the numerous Coral Islands off Australia's Great Barrier Reef.

THORNY DEVIL [PAGE 16]
Agamidae / Moloch horridus

Size/Data
Length: (max) 8 in.
Weight: (max) 3 oz.
(Note: females are generally larger than males)

General Description
These exotic reptiles are members of the dragon lizard family. Despite its aggressive appearances, the thorny devil is actually a slow-moving, harmless reptile. About the size of a human hand, it is covered in savage-looking spines that provide protection against predators and camouflage against the harsh Australian desert. The colors of this species range from sandy-yellow to reddish brown with some black areas, depending on the region it inhabits.

Location/Distribution
Western and central arid regions of Australia.

Behavior
Like most other reptiles, the cold-blooded thorny devil is active during the day, moving in open arid areas in search of a meal. At night they rest, partly digging into the sandy soil among spiky triodia grasses to hide from predators. They feed almost exclusively on small black ants, which they eat in huge numbers—between 600 and 3,000 in one meal. They catch the ants one at a time by accurately flicking out their sticky tongues at a steady rate of 45 ants per minute.

The thorny devil mates between September and January, during the hottest months of the year. Sometime in January the mother will lay between 3 and 10 eggs, leaving them buried underground to hatch 2 or 3 months later.

Did You Know?
- Thorny devils have a unique way of drinking. If they stand in a shallow puddle of water or if raindrops fall directly onto their bodies, the precious fluid will naturally run along thousands of tiny grooves up and along their legs and backs and then straight into the corner of their mouths. The water moves along these tiny grooves by a capillary action that thorny devils set in motion simply by gulping. It's as if their entire skin was just one giant "crazy-straw."
- Thorny devils have a lifespan of 20 years.

Population Status
Thorny devils are considered lower risk because their population numbers seem to be quite steady. That being said, these extraordinary lizards are not commonly seen and are residents of one of the most extreme and fragile ecosystems on earth.

Where Can You Find Them?
Found throughout many of Australia's interior deserts, including the Gibson Desert, the Great Sandy Desert and the Tanami Desert. One of the best places to see these exotic lizards, and many

other desert-dwelling creatures, is Uluru-Kata Tjuta National Park in central Australia, about 186 miles from Alice Springs. This wonderful national park is managed superbly by the original owners and contains 2 of Australia's most famous landmarks, Uluru (aka Ayers Rock) and Kata Tjuta (aka the Olgas). The author (BTG) visited Uluru-Kata Tjuta National Park some years ago and, although he didn't find a thorny devil, it totally changed his life.

The only enclosed reserve or sanctuary in Australia to see thorny devils is the open range-style Alice Springs Desert Park in the Northern Territory. There are no zoos or reptile parks that hold thorny devils, because they only eat the live ants found in the central deserts and it is difficult to maintain a large enough supply of ants to keep them healthy. Sydney's Taronga Zoo did house thorny devils a few years ago, but had to phase them out because of the desert ant-supply problems. In future years Taronga Zoo, funded by the Taronga Foundation, is hoping to establish a large colony of these particular black desert ants so they can safely house thorny devils again and display these unusual Australian lizards to the general public.

THREE-TOED SLOTH [PAGE 17]
Bradypodidae / Bradypus tridactylus, torquatus & variegates

Size/Data
Length: 16–28 in.
Tail: .8–3.5 in.
Weight: 5–12 lbs.

General Description
The three-toed sloth is one of the world's strangest mammals, completely adapted to a life hanging upside down in trees. Typical of all sloths, its head is small and its eyes and ears are tiny; its tail is small and hidden in its fur. It has a large body and slender but powerful limbs. As its name suggests, there are 3 toes on each fore and hind foot. These are closely bound together with tissue and covered with skin and hair. A strong, curved claw extends from each toe. Its claws, along with its leathery palms, give the sloth a vice-like grip around branches. Its arms (forelimbs) are considerably longer than its hind limbs. The sloth uses these to pull itself through the trees. The three-toed sloth's sight and hearing are poor, but its sense of smell and touch are well developed. The sloth's coarse outer coat is long, dark, and mane-like around its head, neck and shoulders while the under-fur is fine, dense and pale. The three-toed sloth's fur is usually host to algae, mites, ticks, beetles and even moths. This organic infestation, while completely harmless to the sloth, can give its coat a greenish appearance, which provides some level of camouflage.

Location/Distribution
The brown-throated sloth (*B. variegates*) occurs from Honduras to northern Argentina. The maned sloth (*B. torquatus*) lives in coastal forests of eastern Brazil, and the pale-throated sloth (*B. tridactylus*) is found in southern Venezuela, the Guianas and northern Brazil.

Behavior
Three-toed sloths are solitary animals and are considered the most tree-dwelling of all South American forest mammals. A sloth may spend as many as 18 hours a day (or three quarters of its life) sleeping and dozing. It is so inactive it requires little energy and so processes food very slowly. During the most active part of their day, three-toed sloths search for and feed on the leaves, buds and soft twigs of a few specific rainforest trees.

The breeding season for these slow-motion mammals runs throughout March and April. Sloths show little outward signs of enthusiasm leading up to, during and after mating, although their characteristic "ai-ai" call is increased during this time of year. Following just such an unspectacular union and a gestation period of 120 to 180 days, the mother will give birth to one infant.

Did You Know?
- The three-toed sloth comes to the ground only to defecate or to move to another tree as it cannot swing or leap between trees. When on the ground it has to crawl and is very vulnerable.
- The grip of the three-toed sloth on a tree branch is so strong that even if it is shot and killed, it will remain hanging in place until it decomposes.
- After a meal the contents of a sloth's stomach can compose up to a third of its body weight.

Population Status
Endangered. Due to the rigidity of their diet and inflexibility in habitat range, sloths are particularly susceptible to deforestation and human encroachment. Put simply, the three-toed sloth may spend its entire life in one tree, so it's easy to understand why this species has been so dramatically affected by the ongoing destruction of its habitat.
IUCN Red Book Classification: EN A1 cd

Where Can You Find Them?
The Aviarios Caribe on the Caribbean coast near Cahuita in Costa Rica is a sloth refuge of note. Costa Rica also plays host to other sloth reserves, such as Manual Antonio Park and the biological reserves of Corrego de Veado, Sooretama and Nova Lombardia. Brazil is also home to sloth facilities, the easiest of which to visit is probably Serra dos Orgaos National Park near Rio de Janeiro. Not too many zoos house sloths. The Dallas World Aquarium, in the United States, has a sloth exhibit as does the Vancouver Aquarium in Canada.

GIANT TORTOISE [PAGE 18]
Estudinidae / Geochelone gigantea & elephantopus

Size/Data
Length: 55 in.
Weight: 550 lbs.

General Description
As its name implies, the giant tortoise is the largest tortoise in existence

and, in truth, one of the wonders of the animal world. It has a huge carapace, proportionally massive limbs, a long neck and a broad, strong head. Its shell is high and convex, providing excellent defense against predators. For additional protection, all of its limbs have a tough scale covering and can be withdrawn into the hard outer casing, as can its neck and head. Its broad feet are somewhat splayed to give greater purchase on the ground and, unlike a turtle's feet, are not webbed or clawed but have thick toes and strong nails.

Location/Distribution
The Pacific species (*Geochelone elephantopus*), lives on several islands of the Galápagos. The Indian Ocean species (*G. gigantea*), is now restricted to the island of Aldabra, near Madagascar.

Behavior
A gentle, lumbering monster from remote islands, the giant tortoise actually looks quite prehistoric. Outside of the breeding season these solitary animals feed on grasses, leaves, flowers, cactus, lichen and some carrion.

During February and March, the hormones start to surge and males will start to bellow loudly as they attempt to seduce a mate. If the female accepts his head-bobbing advances he will mount her from behind. This awkward feat is only possible because his under-shell is actually hollowed out to accommodate her domed carapace, so he doesn't slide off. The female will then lay and bury 10 to 20 eggs, which have an incubation period of 120 to 216 days. The hatchling giant tortoises are tiny—less than 3 inches in length and have soft shells, making them very vulnerable. Those that survive their first few years may go on to live for more than a century.

Did You Know?
- The 2 species of giant tortoise are not directly related to each other but to a smaller species in Africa and America.
- Despite its robust appearance, the shell of a giant tortoise is relatively fragile. Its bony foundation is greatly reduced to save weight, and the shell itself can be quite easily damaged.
- The giant tortoise is the longest living creature on earth, living to well over 100 years. Some experts believe it can live well over 200 years.
- Steve Irwin's Australia Zoo, located near Brisbane in Queensland, has a delightful old Galápagos tortoise named Harriet, who it is believed, was collected from the Galápagos Islands by Charles Darwin himself during his epic voyage (1831-6). If this is correct, then Harriet would be over 260 years old today, making her the oldest (recorded) tortoise in history! Harriet's official birthday is celebrated in fine style at the zoo every year on November 15th.
- Apart from being slaughtered for their meat and shell, giant tortoises, who can survive without eating for months at a time, were once captured by sailors to be used as living ballast in the hulls of their sailing ships.

Population Status
Vulnerable. While the Aldabran population seems to be flourishing and its future seems secure,

other species aren't so fortunate, and some have disappeared entirely. The Galápagos population has struggled to compete with introduced species and is now endangered with only 15,000 animals left on the planet.

Since 1965, the Charles Darwin Research Station has been running a breeding and repatriation program to boost the dwindling population of the Galápagos tortoises. By March 2000 they had, after 35 years of concentrated effort, released 1,000 tortoises.
IUCN Red Book Classification: VU D2

Where Can You Find Them?
The Galápagos Islands have some very respected ecotour operators with whom you can visit this extraordinary sanctuary. Giant tortoises are also popular exhibits in major zoos and reptile parks around the world.

CHEETAH [PAGE 19, 45]
Felidae / Acinonyx jubatus

Size/Data
Length
Head & Body: 3–5 ft.
Tail: 23–35 in.
Height: (at shoulder) 27–35 in.
Weight: 75–160 lbs.

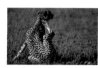

General Description
The cheetah has a lithe build, a small head and extra long legs. The coat is tan or buff-colored with black spots; there are no spots on its white belly and the tail spots merge to form 4 to 6 dark rings at the end. The cheetah's face has distinguishing teardrop-shaped lines on each side of its nose, from the corner of its eyes to its mouth. Its long, muscular tail, which usually ends in a bushy white tuft, acts as a stabilizer and rudder for balance, preventing it from rolling over and spinning out in fast turns during high-speed pursuits of game.

Location/Distribution
Found mainly in southern and eastern Africa.

Behavior
The cheetah is the fastest of all land animals, sprinting at speeds in excess of 60 miles per hour after its prey, which includes antelope, hares, rodents and even young zebras. Its specially widened nostrils take in great amounts of oxygen for explosive running and also quick recovery times after it captures its meal. Cheetahs are not strong enough to tear their prey apart, like lions and leopards do, so they usually suffocate their victims with a choke-hold on their throats.

Males and females live separate lives; the females are solitary except for their cubs while the males live in small groups. Cheetahs can breed year-round. After mating, a female will give birth to 2 to 5 (sometimes even 8) cubs following a gestation of 90-95 days. Sadly, cheetah cubs have a shocking mortality rate of 90% in the wild due to predation from lions, leopards, hyenas and so on.

Did You Know?
- The cheetah was trained for hunting with humans as long ago as 3000 B.C. A leashed cheetah with a hood on its head is depicted on an official Sumerian seal from that period.
- Cheetahs were revered as a symbol of royalty in early Lower Egypt. In later centuries (14th, 15th and 16th), royalty from Europe to China kept cheetahs as status symbols.
- A cheetah can reach its top speed in just 3 seconds.
- Cheetahs were once raced against greyhounds as a sport. Can you guess who won?
- A cheetah does not have sharp retractable claws like a cat but instead has feet like a dog.

Population Status
Vulnerable. The cheetah was once widely killed for its fur and now suffers from loss of habitat and prey. Once numerous in India, it became extinct there in the 1950's. It has been estimated that in 1900 there were more than 100,000 cheetahs found in 44 countries throughout Africa and Asia. Today the species is extinct from over 20 countries and only 9,000 to 12,000 animals remain. Almost all of these are found in small, pocketed populations in 24 to 26 countries within the African continent. As few as 200 wild cheetahs (a Eurasian sub-species) are believed to remain in tiny pockets of the Middle East, a region where they once thrived.
IUCN Red Book Classification: VU A1d+2d C1

Where Can You Find Them?
Cheetahs do not survive well in protected wildlife reserves due to increased competition from larger predators. A large percentage of the remaining cheetah populations are outside protected reserves, placing them at greater conflict with humans. 2 remaining population strongholds are within Namibia, in southern Africa, and the bordering nations of Kenya and Tanzania in eastern Africa. With the world's largest resident cheetah population (approximately 2,500), Namibia is the greatest hope of survival for this amazing animal.

The Cheetah Conservation Fund has been set up to help research the cheetah. In April 2001 it enabled the President of Namibia to send 10 cheetahs to captive breeding programs at the Cincinnati Zoo in Ohio and the White Oak Conservation Center outside of Jacksonville, Florida. Australia's Western Plains Zoo is also taking part in the international captive breeding program.

MALAYAN TAPIR [PAGE 20 AND PAGE 25]
Tapiridae / T. indicus

Size/Data
Length: 6–8 ft.
Tail: 2–4 in.
Weight: 550–1,200 lbs.

General Description
At first glance, this strikingly marked animal looks like an extremely large pig with an extended flexible trunk-like snout. It has a unique saddle-blanket pattern composed of a white mid-section with a dark front and rear quarters for camouflage

which, surprisingly enough, works incredibly well in a rainforest at night, when it is most likely to be on the move. The young are also black and white; however, they are covered in irregular stripes and spots that make them almost invisible among the dappled light falling on the rainforest floor.

Location/Distribution
Thinly spread throughout the remaining forests of Indonesia, Laos, Malaysia, Myanmar, Thailand and Vietnam.

Behavior
Tapirs are very solitary animals. The male tapir has an average range of 5 square miles, which is quite large by rainforest standards, that overlaps the home ranges of several females. The male will join these females only briefly to breed before returning to his own area, leaving the mother to raise the young. Being strictly nocturnal, tapirs spend the day resting and sleeping in dense thickets, emerging only at night to bathe and forage in rivers and marshes. Their diet is composed primarily of leaves and forest fruit along with other plant matter.

Did You Know?
- The Malayan tapir is the only tapir in Asia and is substantially bigger than its New World relative, the Brazilian tapir.
- Interestingly, the tapir has 4 stubby-hoofed toes on the front feet and 3 hoofed toes on the back feet.

Population Status
Vulnerable. Malayan tapirs are at risk of extinction. Nobody knows how many still exist in the wild, but with human encroachment and the rapid destruction of their forest home their future is very uncertain.
IUCN Red Book Classification VU A1c+2c,B2cd+3a,C1+2b

Where Can You Find Them?
Taman Negara National Park of Peninsula Malaysia has been a major study point for tapirs particularly in the 1980's. Tamen Negara is a stunning primary rainforest haven that, when the author (BTG) visited in the late 1970's wearing elastic-waisted shorts, could only be reached by a 4 hour trip in a motorized long-canoe. Huai Kha Khaeng Wildlife Sanctuary in Thailand is also worth visiting, and there are also a number of major zoos around the world who keep Malayan tapirs including Woodland Park Zoo in Seattle; San Diego Zoo; Amsterdam Zoo; Tobe Zoo, in Japan; Bangkok Zoo; Rotterdam Zoo; and Taronga Zoo in Sydney, Australia.

ECHIDNA [PAGE 21]
Tachyglossidae / Tachyglossus aculeatus

Size/Data
Length: 14–20 in.
Weight: 5–15 lbs.
(Note: males are generally 25% bigger than females)

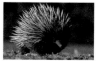

General Description

The echidna, or spiny anteater, has short legs and a small head with tiny eyes and a cylindrical beak. Its sharp, sand-colored, protective spines are up to 2.5 inches long and protrude though a coat of dark, dense fur. These spines are very stiff and strong, they cannot be dislodged or removed, and cover the entire back and sides of its body. Its forefeet have powerful claws for digging. On the hind feet the second toe has a special long curved claw for scratching the skin between the spines. Its snout is quite soft and hairless with the small nostrils and mouth at the tip. It contains a long, sticky tongue for licking up ants and termites.

Location/Distribution

Throughout many parts of Australia, including Tasmania, with another, much larger, subspecies found in the lowlands of New Guinea.

Behavior

These nocturnal burrowing animals are very shy and will quickly burrow out of sight if disturbed in the open. At night they wander in search of a variety of ants, termites, grubs and worms to eat, which they detect by using their advanced sense of smell.

Echidnas are solitary animals, only coming together for breeding during the Australian winter months of June through August. When a female is ready to mate she will leave a scent trail for a male to follow. Trains of up to 10 excited males will trudge nose-to-tail along this scented trail. They will repeatedly push one another out of the way until one secures the female's attention. The male will then proceed with a courtship that can last for 36 days. During this time, the male will repeatedly dig a trench around the female. When she is ready, she will roll into it and lie on her back. The male will then climb on top so they are belly-to-belly and copulation will take place. 14 days after mating, the female will lay one white egg, which should hatch about 10 days later. The infant echidna will then stay in the nest for around 55 days before it is ready to leave.

Did You Know?

- Echidnas are one of only 2 examples of monotremes (mammals that lay eggs). The other member of this special group is the platypus. Both species are found only in Australasia.
- An echidna's lifespan can be as long as 50 years.
- The echidna sub-species found in Papua New Guinea has a longer beak, more hair, is much larger and far more endangered than its Australian relatives.

Population Status

Lower Risk. Echidnas have very few natural enemies except for dingos and humans (especially those in trucks and cars) and seem able to survive in a variety of habitats.
IUCN Red Book Classification: LR/nt

Where Can You Find Them?

Widely found throughout the less barren parts of mainland Australia and is featured in most Australian zoos and wildlife parks.

ORANGE SULPHUR OR ALFALFA SULPHUR BUTTERFLY [PAGE 22–23]
Pieridae / Colias eurytheme

Size/Data

Wingspan: .8–3 in.

General Description

The wings of these very common butterflies are usually white, yellow or orange and feature black or gray markings.

Location/Distribution

There are 1,200 subspecies of sulphur butterflies distributed throughout the world except for the polar regions.

Behavior

Sulphur butterflies commonly inhabit grassy, open areas and cultivated land. The adult butterfly feeds on the nectar of flowers as well as on other less pleasant liquids, including animal urine.

During the breeding season, the female will lay 20 to 100 eggs singly or in small groups on host plants. Caterpillars feed voraciously on clover and alfalfa; in sufficient numbers they can represent a genuine threat to farmers. The pupa, which has a distinctive, spiny projection on its head, is held upright on the host plant by a silk belt. After emerging from their cramped chrysalis, the butterfly's wings are folded up in a compact ball. It takes an hour or more for the new wings to inflate with fluid, expand to full size, and then dry and harden in the sun before they can fly away.

Did You Know?

- What appears to be colored dust particles on butterfly wings are in fact thousands of microscopic feathers known as wing scales.
- The colors in the wing scales are derived from the food eaten during the caterpillar phase.
- Butterflies get their name from the yellow brimstone butterfly of Europe, which is first seen in the early spring or "butter" season.
- Female Queen Alexandra butterflies, from Papua New Guinea, are the largest in the world, some with wingspans larger than 10 in.
- Butterflies are found on all land masses except Antarctica.

Population Status

Lower Risk. Sulphur butterflies, while highly vulnerable to airborne pollutants, such as pesticides and exhaust emissions, are still showing very healthy population numbers.

Where Can You Find Them?

On sunny days sulphur butterflies can be seen hovering over alfalfa and clover fields. They are also commonly found gathered in groups around fresh bird droppings, animal urine and shallow rain puddles. Commercial butterfly farms and exhibits are becoming more popular in some parts of the world, but sulphur butterflies are not one of the more common species featured as they are pushed aside in favor of the more colorful varieties. Other than in the wild, the best place to see a broad range of butterflies is in a museum such as the Natural History Museum in Fribourg,

Switzerland, which houses a large collection of butterflies, as does the Natural History Museum of Maastrich, the Netherlands and the Provincial Museum of Alberta, Canada.

India's Sanjay Gandhi National Park in Borivali, Mumbai, is famous for its high number of butterflies, as is Papua New Guinea's Baiyer River Wildlife Sanctuary, which hosts 80 different butterfly species.

GIRAFFE [PAGES 24, 34–35, 46]
Giraffidae / Giraffa camelopardalis

Size/Data

Height
Male: 12–15 ft.
Female: 10–13 ft.
Weight
Male: 1,800–4,300 lbs.
Female: 1,200–2,600 lbs.
Tail: 30–40 in.

General Description

Giraffe are the tallest animals on earth. They have long sturdy legs (the front legs are quite a bit longer than the back), and incredibly long and flexible necks. They have large eyes and ears and small horns on the top of their heads. Their short-haired coat features a variety of patterns of semi-regular chestnut-brown blocks often separated by white lines and interspersed with lighter tan areas or the reverse.

Location/Distribution

Giraffe are distributed throughout many parts of Africa's open woodland areas, as well as on the southern edge of the Sahara desert.

Behavior

The giraffe is a browsing animal that feeds almost exclusively on trees, often acacias, using its 18-inch long tongue to gather in the leaves and fresh shoots. To drink, it must splay its legs and lower its neck right down to the ground—this is a giraffe's most vulnerable position. Giraffe are not defenseless however; they often keep watch for each other and when necessary can deliver a powerful kick that can kill a fully grown lion. They have a very keen sense of vision which, in conjunction with their great height, is why numerous other species of grazing animals seek out the company of giraffe so as to take advantage of their ability to spot and give warning of approaching predators.

When the female cow comes into season, which can happen at any time, she gathers all the bulls around her but mates only with the dominant bull. He drives off all the subordinate bulls by simply threatening them; actual fighting, which involves the bulls striking their heavy necks against their rivals' necks with great force, is rarely necessary. After a gestation of 453 to 464 days, the cow will give birth to one young. During the birth the baby giraffe will fall from its mother almost 7 feet to the ground but, thanks to its rubbery bones and joints, will not be harmed at all.

Did You Know?

- No 2 giraffe have the same dapple.
- Giraffe can reach speeds of over 31 miles per hour.

- The giraffe's long neck contains elastic blood vessels with special valves that prevent a sudden rush of blood to the giraffe's head when it's lowered to drink.
- The giraffe actually has quite a large voice box but almost never makes any noise.

Population Status

Lower risk, but still conservation dependent.
IUCN Red Book Classification: LR/cd

Where Can You Find Them?

The best place to see giraffe in their natural habitat is within Tanzania's famous Serengeti National Park where numbers are increasing by 5% each year. Numerous zoos around the world have high-quality giraffe exhibits, including Auckland Zoo (NZ) which has included other African species such as ostrich, zebra and Grant's gazelle in the same enclosure. Australia's famous Taronga Zoo has several well cared for giraffe while its sister facility, Western Plains Zoo, has a tremendous open-range exhibit in Dubbo, a 5 hour drive northwest of Sydney.

CHINSTRAP PENGUIN [PAGE 26]
Sphenisciformes / Pygoscelis antarctica

Size/Data

Weight: 10 lbs.
Height: 28–30 in.

General Description

Chinstrap penguins are highly specialized, social, flightless pelagic seabirds. They are medium-sized penguins and may spend up to three quarters of their life in the sea, which is why their wings have evolved into stiffened, flattened, paddle-like flippers to make them supreme swimmers. Their adaptation to their environment is remarkable, and some scientists believe they have remained unchanged for at least 45 million years. They are well suited for extremely cold weather, with insulating feathers extending well down onto their bills. These black-and-white birds have an alert, upright stance and are classically monomorphic as penguins go (i.e., they all look the same); however, they are easily distinguished from other penguin species by the thin black markings under their beaks that resemble a chinstrap on a hat or bonnet.

Location/Distribution

Circumpolar around Antarctica.

Behavior

Chinstrap penguins nest during the spring and summer months and then take to the open water in winter. They hunt alone, zipping through the icy water like beaked torpedoes, catching fish and small shoaling animals like krill. In turn, they often fall victim to aquatic super-predators such as killer whales and leopard seals.

The breeding season for chinstrap penguins occurs between October and February during the warmest months of the year. The female generally lays 2 eggs that are then incubated on top of the adults' feet and covered by their warm abdominal skin.

Population Status

Lower Risk. Thanks largely to the harsh nature and extreme isolation of their Antarctic home, these

penguins have, to date, avoided human interference and presently enjoy a stable population of about 7.5 million breeding pairs.

Where Can You Find Them?
Chinstrap penguins are found in the Scotia Arc, extending from the tip of the Antarctic Peninsula and including the South Shetland, South Orkney and South Sandwich Islands, and South Georgia. Make sure you dress warmly!

GORILLA (WESTERN LOWLAND) [PAGE 27]
Hominidae / Gorilla gorilla gorilla

Size/Data
Height
Male: 5–6 ft.
Female: 4–5 ft.
Arm-span: 6–9 ft.
Weight
Male: 300–600 lbs. Female: 150–300 lbs.

General Description
The gorilla is the largest of all primates. The big silverback (mature male) easily outweighs the world's heaviest Sumo wrestler by a great margin. The western lowland gorilla has a broad chest, a muscular neck and strong hands and feet. Short, thin, gray-black to brown-black hair covers its entire body except the face. It has a thick ridge of bone that juts out above its eyes and flared nostrils. Strikingly human in appearance, the hands are broad with thumbs larger than the fingers. This helps the animal grasp foliage.

In comparison to the mountain gorilla, the western lowland has a wider and larger skull. Also, the big toe of the western lowland is further apart from the alignment of his other 4 toes compared to the alignment in the mountain gorilla.

Location/Distribution
The western lowland gorilla is found in the tropical forests of western Africa, from southern Nigeria to the Congo River.

Behavior
These gigantic apes are both peaceable and sociable. Gorillas live in groups composed of one fully adult male and several females, along with their respective young. They play, sleep and eat within this structured family group. The dominant silverback regulates what time they wake up, eat and go to sleep. They are herbivores, feeding primarily on fruit, shoots, bulbs, leaves and occasionally a little tree bark.

Only the dominant silverback will mate with the mature females in his group. The frequency and duration of sexual activity in gorillas is quite low compared to other great apes, but they make up for this in some ways by being unusually loud during copulation.

The western lowland gorilla has a gestation period of 8 to 9 months and produces one young per confinement. Newborns are totally helpless at first and are carried everywhere in their mother's arms. They grow at twice the rate of a human baby and become robust and adventurous very quickly. Young gorillas have a very close bond with their mothers and continue to ride on their mothers' backs until they are 4 or 5 years old.

Did You Know?
- Gorillas have a lifespan of up to 37 years.
- Gorillas never attack unless surprised, threatened or provoked. Even then, an adult male protecting his group will first try to intimidate his aggressor by displaying his sheer size, escalating his performance to include standing on his legs and slapping his chest while roaring and screaming. Only as a last resort will a gorilla engage in a violent physical confrontation, the results of which are predictably devastating.
- The western lowland gorilla is an important animal for detailed scientific study because its intelligence and body structure are closer to that of humans than any other primate, except for the bonobo and the chimpanzee.

Population Status
Endangered. The western lowland gorilla has no real enemies except for humans, who have been threatening their livelihood for over a century. They have caused them to become endangered through the degradation of their tropical rainforest habitat, illegal hunting for meat and over-collection and subsequent sale of live adults and young gorillas by private animal dealers, poorly run zoos and small-minded research institutions. Their last chance of survival may now be a few gorilla sanctuaries in Africa, zoos and other captive environments around the world. The wild population has recently fallen below 100,000 individuals. At the present rate, these animals could well vanish from the wild entirely in little more than a decade.
IUCN Red Book Classification: EN A2cd

Where Can You Find Them?
To find these immense primates in the wild you should visit Nouabable-Ndoki National Park in the Congo and the Lope Reserve in Gabon.

In December 2001, the governments of Japan, Switzerland and the United States pledged funding to the International Tropical Timber Organization (ITTO) to create one of the world's largest sanctuaries for lowland gorillas. This sanctuary will be known as the Minkebe/Mengame Transboundary Conservation Reserve and will cover 501.9 square miles of wilderness on the border between Cameroon and Gabon.

The western lowland gorilla is the gorilla species commonly found in zoos all over the world. Some of the better zoos housing these gentle giants include Jersey Zoo (UK), Utah's Hugal Zoo (USA), Ueno Zoo (Japan), Taronga Zoo in Sydney and Melbourne Zoo (Australia).

CRABEATER SEAL [PAGE 28]
Phocidae Lobodon carcinophagus

Size/Data
Length: 7–9 ft.
Weight: 485 lbs.

Location/Distribution
Circumpolar.

General Description
Long and lithe, the crabeater seal has oar-shaped, pointed front flippers and a silver-gray to yellow-brown coat with irregular darker spots and rings. Crabeaters are "true seals" and therefore do not have external ears and their hind limbs are directed backwards, which are perfect for swimming but little or no use on land.

Behavior
The irony is that crabeater seals do not actually eat crabs at all. Instead they feed on shrimp-like krill by using their many-cusped cheek teeth as a sieve to filter the small crustaceans from the sea water as they swim through concentrations of these tiny marine animals at speed.

Crabeaters are not gregarious and therefore don't live in colonies. They are usually found on their own (except for during the breeding season) and tend to come singly to breathing holes in the ice. After successful mating has taken place, a female crabeater will produce a single pup in spring or summer, which it will raise and feed for 12 days up to 2 months. After this, the mother stops lactating and the pup must be ready to look after itself.

Did You Know?
- The crabeater is the fastest sprinter on land (usually ice) of all the true seals.
- 12% of a crabeater seal's body weight is blood. This enables them to retain large amounts of oxygen to assist in diving, allowing them to stay submerged for very long periods of time.

Population Status
Low Risk. The crabeater seal is presently the most abundant seal in the world.

Where Can You Find Them?
Crabeaters can be found swimming in the open sea within the circumpolar region and are often sighted drifting on pack ice looking rather smug.

IMPALA [PAGE 29]
Bovidae / Aepyceros melampus

Size/Data
Length
Head & Body: 3–5 ft.
Tail: 10–16 in.
Horns: up to 30 in.
Height at shoulder:
30–40 in.
Weight
Male: 130–140 lbs. Female: 80–100 lbs.

General Description
Although the impala is somewhat gazelle-like in build and is widely regarded as the definitive grazing antelope, its classification remains uncertain. It was originally grouped with the gazelles, but many authorities now consider it most closely related to the gnus and hartebeest. In any case, the impala is a slender, agile creature. Its glossy reddish-brown or golden-tan back contrasts with its lighter flanks and white underside. Both sexes have black vertical stripes on the tail and thighs; however, horns are present on the adult males only. The horns are lyre-shaped, evenly ringed with ridges and quite long.

Location/Distribution
The impala's range extends across most of southern and eastern Africa.

Behavior
Impala are very social animals and, like all antelope, are much safer living in herds and thus are rarely seen on their own. Impala have an acute sense of hearing, sight and smell. They scatter swiftly in all directions when predators come too close. They are primarily grazing animals, but in addition to the African grasses, they also feed on a variety of leaves, fruits and seeds.

During the mating season, which varies according to the annual pattern of rainfall, the male roars and the female grunts to communicate their interest. The adult male impala fights to establish a small territory or stamping ground where he seeks to mate with passing females. If this enterprise is successful, the female will produce one young after a gestation period of 180 to 210 days.

Did You Know?
- Most young impala are born around midday. This is the safest time to give birth, since most potential predators (such as lions and leopards) are resting.
- The male's horns take many years to reach full length, which is why young animals are unlikely to establish a dominant position and breeding territory.
- Impala are perhaps the most athletic antelope. Not only can they run at speeds faster than 35 miles per hour but they are also able to jump up and down with side twists and turns and leap forward great distances to clear formidable obstacles and evade capture.
- Impalas live up to 12 years in the wild and 17 years in captivity.

Population Status
Lower Risk.

Where Can You Find Them?
Impala can be found in numerous African parks and reserves including the Nairobi Park and Masai Mara Nature Reserve in Kenya; Serengeti, Tarangire and Manyara National Parks in Tanzania; Hwange National Park in Zimbabwe; Chobe National Park in Botswana; and Kruger National Park and Umfolozi Game Reserve in South Africa.

JACKAL (GOLDEN) [PAGE 30]
Canidae / Canis aureus

Size/Data
Length
Head & Body: 25–41 in.
Tail: 8–16 in.
Height: 14–20 in.
Weight: 15–38 lbs.

General Description
The golden jackal, which resembles a cross between a fox and an alert, medium-sized dog, is built for speed with a light body and long, well-muscled legs. The coat is mainly pale yellow, golden

or light brown. It is somewhat grayer and darker on the back and gingery on the belly. It is also ginger-colored around the nose and ears. Its face is small and angular and its ears are quite large and pointed.

Location/Distribution
Primarily eastern and northern Africa, south-western Europe, including the Balkan Peninsula, and southern Asia spreading east to Myanmar (formerly Burma).

Behavior
In the northern range, the golden jackal may group into large packs with one dominant male, who relies on ritual behavior to retain his dominance. In the southern range, jackal pairs tend to live in territories of .2 to 1 square miles. Jackals are competent hunters, nimble opportunists and committed scavengers. Their diet consists of small mammals, birds, reptiles, amphibians, young deer, antelope and carrion.

Breeding season varies from location to location. Successful mating results in a litter of up to 9 pups after a gestation of 63 days. Golden jackals pair for life. The newborn pups are so dependent on both parents that if one should die the pups may also perish. The mother has sole charge of the nursery and at the first sign of disturbance she may move the den to another location. Poor den preparation or location selection means that many newborn pups die because of the den being flooded.

Did You Know?
- A jackal can drive off predators many times its own weight if its den is being threatened.
- One or 2 immature jackals always stay behind with their parents to assist in rearing the next litter. These helpers guard the den and bring food.

Population Status
Lower Risk. The golden jackal, along with the black-backed jackal and the side-striped jackal, are relatively common in their range and are in no immediate danger.

The simian jackal of Ethiopia, however, is highly endangered. As few as 500 pairs still exist.

Where Can You Find Them?
Tanzania's famous Serengeti is a major range area for the golden jackal.

OLIVE BABOON [PAGE 31]
Cercopithecidae / Papio anubis

Size/Data
Length
Head & Body: 23–34 in.
Tail: 16–23 in.
Weight: 49–82 lbs.
(Note: the male may be twice the female's weight)

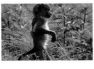

General Description
Olive baboons are one of the largest baboon species. They are ground-dwelling monkeys with dog-like faces, sharp teeth and deep-set, dark brown eyes. When born, olive baboons have darker baby fur but, when mature, both sexes have

a thick gray ruff around their cheeks and are speckled olive-green with black faces and rumps.

Location/Distribution
West to east Africa.

Behavior
The olive baboon lives in highly rigid social groups under the control of one dominant male. These family groups, called troops, usually comprise about 20 to 50 baboons, but may even be as large as 100. During the day, the entire troop will forage together for fruit, leaves, insects, lizards and sometimes much larger prey, such as gazelle fawns. During times of scarcity, more dominant animals get priority over available food and water. At night the entire troop sleeps together in trees.

Young olive baboons of both sexes are tolerated while their baby fur remains, but as they gain mature coloration females will take their place at the bottom of the troop hierarchy and all males will be driven off. The young males must then try to battle their way into another troop of females.

Did You Know?
- An olive baboon can live for more than 30 years.

Population Status
Olive baboon numbers are pretty stable but these animals are still at risk.
IUCN Red Book Classification: LR/nt

Where Can You Find Them?
Tanzania's Manyara National Park has the highest baboon density of any park in Africa. The Lower Zambezi National Park on the banks of the Zambezi River opposite Mana Pools National Park in Zimbabwe is also a focal point for baboons. Amboseli National Park in southern Kenya has a large population of savannah-dwelling baboons.

KANGAROO (RED) [PAGE 32, 38 , 92]
Macropodidae / Macropus rufus

Size/Data
Weight: 200 lbs. or more
Height: 6 ft. or more
(sitting on haunches)
Tail: 30–48 in.
(Note: males may be double the size of females)

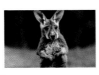

General Description
Red kangaroos are the largest of the kangaroos; in fact, they are the largest living marsupial species. They derive their name from the strong orange-red color of the male coat. Females have blue-gray fur and, while still large and powerful animals, are significantly smaller in size than the males. Red kangaroos have distinctive black, drooping, moustache-like marks along a broad white patch on either side of their muzzles. Their "forearms" and underside are generally off-white, and their chests are often stained pink-red by bacteria-rich secretions from skin glands. They have long, strong tails, short forelegs ("arms") and huge muscular hind legs that enable them to bound swiftly, easily clearing the width of a main road in a single leap and reaching top speeds in excess of 31 miles per hour.

Location/Distribution
Red kangaroos are found only in the arid and semi-arid zones of interior Australia. They survive easily in harsh habitats vegetated only with tough native grasses and shrubs; however, they thrive in pastoral grasslands (much to the annoyance of farmers) and prefer scrub lands mixed with mulga woodlands with creeks that provide billabongs (waterholes) throughout the dry months.

Behavior
Red kangaroos are social in nature and travel in large groups, called mobs, under the direction of a dominant male. The size of these mobs varies depending on the availability of food and water but, when these vital resources are plentiful, they may contain as many as 100 individuals. The mob will forage in the early morning and evening to avoid high temperatures and then, during the middle of the day, seek out shaded areas to rest.

The harsh conditions of the world's driest continent dictate the breeding cycle of these animals. Red kangaroos are capable of breeding year-round. In optimum conditions, females mate only days after giving birth; however, females will conceive only if there has been enough rainfall for vegetation. Males do not produce sperm at all during a prolonged drought. After birth the tiny, blind, pink, unformed baby (called a "joey") crawls from the mother's vulva up the front of her body before climbing into her pouch and fastening onto a teat. The joey then stays in the mother's pouch for several months until it is too large to fit inside. After leaving the pouch, a joey will continue to drink from the mother's teat for a while before being fully weaned one to 5 months later.

Kangaroos are generally quiet and gentle in nature; however the dominant male will fight off any challenge to supremacy from other males. To warn of potential danger, a kangaroo will thump its foot or tail on the ground and stretch up to its full height while rocking back on its tail. When play-fighting among themselves or duelling for dominance, kangaroos may stand up and spar with their forelegs ("arms"), hence the legend of the "boxing kangaroo," but their normal defense or attack is to deliver an extremely powerful front kick that would certainly disable (and in extreme cases even disembowel) a grown man.

Did You Know?
- Red kangaroos are also known as boomers. This name is a reference to the thunderous noise produced by a large kangaroo or mob of kangaroos bounding at speed.
- "Macropod" comes from the Greek, meaning "big footed."
- Female red kangaroos are called blue-fliers.

Population Status
Central Australia is a harsh place and so the population varies greatly from year to year, depending on rainfall. Although increased human presence in the region is having a greater and greater impact on all animals, red kangaroos are still low risk with a population believed to be between 5 and 12 million and at times, especially during drought, they are even considered a pest

by farmers as they compete with livestock for food.

Where Can You Find Them?
Throughout most vegetated zones of central Australia. Red kangaroos are popular residents at many zoos and wildlife parks in all Australian cities.

SPOTTED HYENA [PAGE 33, 47]
Hyaenidae / Crocuta crocuta

Size/Data
Length
Head & Body: 37–65 in.
Tail: 10–14 in.
Height: 31–36 in.
Weight: 88–190 lbs.
(Note: females are generally larger than males)

General Description
The spotted hyena is the largest of the hyenas. Their short coat is short, reddish sandy-brown in color, with dark spots on their bodies and legs. They have short, rounded ears and a reversed mane where the hairs slope forward rather than back. The mane stands erect when the hyena is excited. Spotted hyenas have dark paws, muzzles and tails, with pale bellies. Like all hyenas, they have relatively long front legs.

Location/Distribution
Found throughout west, east and southern Africa.

Behavior
Contrary to their scavenger reputation, spotted hyenas are powerful hunting animals whose prey includes large animals such as zebras and antelopes. They also feed on smaller animals and rotting carrion. They hunt efficiently at dusk or during the night, more commonly in a pack, but also alone if need be. Spotted hyenas live in clans and have a complicated social system. They communicate with each other through a series of calls, squeals and howls, their trademark "wicked laugh" and through scent marking using a creamy paste from a special anal pouch.

During the mating season, smaller males are driven away from the receptive female by a dominant male. After a gestation period of 99 to 110 days the mother will give birth to 2 to 3 young.

Did You Know?
- A single spotted hyena is capable of chasing and killing prey that is three times its own weight.
- The spotted hyena coughs up undigested waste matter, such as zebra hooves and antelope horns, in the form of pellets.
- Because the genital organs of males and females look almost identical (superficially), many people used to believe that every spotted hyena was both male and female.
- The spotted hyena howls toward the ground and not toward the sky like a wolf or a dog does.

Population Status
Lower Risk. Spotted hyenas are still widespread in Africa and although they have been systematically persecuted some regions are not currently threatened.

Spotted hyenas can be seen in the wild, especially in open grasslands (including most major wildlife parks and reserves) throughout most of Sub-Saharan Africa, excluding the most southern parts of South Africa, the Congo basin and some areas of western Africa.

TOPI [PAGE 35]
Bovidae / Damaliscus lunatus

Size/Data
Length
Head & Body: 4–8 ft.
Tail: 7–24 in.
Height: 35–47 in.
Weight: 250–300 lbs.

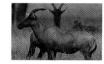

General Description
One of the largest of the antelopes, the topi has a glossy, red-brown coat, high shoulders, a sloping back and long tufted tail. Both sexes have angular horns up to 20 inches long that are curved backward with regular ridges. The topi has a distinctive convex forehead, an elongated muzzle and a dark blaze down the center of its face.

Location/Distribution
Found in numerous regions throughout Sub-Saharan Africa.

Behavior
Topi graze on clover and various grasses in small herds, with a dominant bull at the helm. A quite gregarious animal, these antelope are often found in the numerical safety umbrella of other grazing animals such as giraffe and zebra.

Male topi mark out and defend a territory so that they will have exclusive "mating rights." This means they will try to keep as many females as possible (up to 20) inside the territory in order to mate with all of them. During the mating season, which varies according to region, a female usually produces one calf after a gestation of 225 to 275 days.

Did You Know?
- When alarmed, panicking topi will jump over each other's backs in their haste to flee.
- Topi can reach speeds of up to 43.5 miles per hour.
- The generic name, "Antelope," is derived from a Greek word meaning "brightness of eye."

Population Status
Lower Risk. Although subjected to considerable hunting over the years, the topi still flourishes and is not yet one of the many antelope species threatened with extinction. That being said, it is still conservation dependent.
IUCN Red Book Classification: LR/cd

Where Can You Find Them?
Found in seasonally flooded grasslands and open savannah from Senegal to western Sudan and from eastern Africa through to South Africa. South Africa's world-famous Kruger National Park and the Hluhluwe Game Reserve both have large resident populations of topi.

WHITE-HANDED GIBBON [PAGE 36]
Hylobatidae / Hylobates lar

Size/Data
Length: 16–25 in.
Weight: 10–17 lbs.

General Description
Gibbons are the smallest of the apes. They are slender and have extraordinarily long arms as well as long, narrow hands in which the thumb is deeply cleft from the palm as far as the wrist. Their shaggy, medium-length fur can be any of several uniform colors from black, dark or red-brown to pale fawn, off-white, and even silver-gray. Whatever their fur color, all white-handed gibbons have black skin and feature a short fringe of white fur around their face and covering the upper sides of their hands and feet.

Location/Distribution
White-handed gibbons were once widespread in Southern Asia. However, they have gradually become extinct in many key areas, including China. Their present range includes Indo-China and Thailand, west of the Mekong River, Tenasserim, Malay Peninsula and Northern Sumatra.

Behavior
White-handed gibbons are social primates that live in family groups of about 6 members. These are usually composed of one adult male, one or more females and several young. They are the most active of the gibbons and, being mainly diurnal, spend most of their days moving easily and rapidly through the trees within their deciduous monsoon and montane evergreen forest habitats in search of fruit (especially figs), young plant shoots, flowers, leaves, bird's eggs and insects.

White-handed gibbons are very vocal in their communication, and from early morning they launch into loud duets, with the female taking the major part. This song is primarily a spacing call, although by requiring the male and female to interweave their different contributions, it reinforces the pair's bond. Their is no particular breeding season, and white-handed gibbons generally breed slowly with only a single young produced every 2 to 4 years. Gestation is 7 to 8 months in duration, and it takes 18 months for the infant to be fully weaned. The baby gibbon is initially hairless except for a crown of fur on its head, and it must shelter between the mother's thighs and belly to stay warm. Later the infant will develop a coat of completely white fur until it is 2 to 4 years of age, by which time its final coloration will be evident. The juvenile gibbon will stay with its parents for 6 to 8 years before finally being pushed out of the family "home" to start its own group.

Did You Know?
- Gibbons drink by licking their wet fur after dipping their hands into water or rubbing them against wet foliage.
- The lifespan of white-handed gibbons in the wild is 25 to 30 years.
- White-handed gibbons are generally considered to be the fastest moving of all the primates and can easily leap 33 feet between trees.

- A gibbon's arms are 40% longer than its legs.
- Gibbons have a sound-amplifying throat sac that makes it possible for their loud calls to be heard half a mile away.
- White-handed gibbons mate for life.
- Gibbons cannot swim at all and are afraid of rivers and other large bodies of water.

Population Status
Endangered. Extensive military activity within its range has had a detrimental effect on population numbers. The white-handed gibbon is also increasingly threatened by loss of habitat and is still being hunted illegally for food and for use in traditional Oriental medicines.
IUCN Red Book Classification: EN

Where Can You Find Them?
There are a number of wildlife reserves and less populated areas in southeast Asia where white-handed gibbons might possibly be found, but at the time of this writing, no specific location could be recommended (sorry). There are, however, numerous zoos around the world that have healthy gibbons in residence; two of them are the Hogle Zoo in Utah and the Santa Barbara Zoo in California.

PRAYING MANTID [PAGE 39]
Mantidae / Mantis religiosa etc.

Size/Data
Length: .6–12 in.
(depending on species)

General Description
The praying mantid gets its name from the way it holds its forelegs; it sometimes looks as if this dramatic insect has its "hands" raised in prayer. The abdomen and wings usually have camouflaging colors so the mantid blends in perfectly with its surroundings. While most of these micro-predators are green or brown, some look exactly like bright exotic flowers and other varieties of colorful, tropical foliage. Their long antennae have sensitive feelers to detect airborne scents. The eyes are large to provide almost 360 degree vision. The forelegs have sharp spines with which the mantid grips its prey. Many species have no wings, while others have 2 sets.

Location/Distribution
The 1,800 or so mantid species are distributed widely throughout the tropical, sub-tropical and warm temperate regions of the world.

Behavior
Mantids have serious cannibalistic habits, so it's no surprise they are generally solitary creatures that live well apart from their own kind. The praying mantid does not actively hunt down its prey but plays a waiting game, poised unmoving and virtually invisible on a leaf or stem, ready to ambush its victims with a sudden and savage attack. The mantids are clinical killers who chew off their victims' heads immediately to ensure there is no further struggle.

The breeding season occurs during summer in temperate areas, year-round in the tropics and

during the "wet" season elsewhere. The mating habits of the female mantid are notorious: after securing a breeding partner, she chews off the head of the male while he mates with her. After mating with, and eating, her "husband," the female lays 10 to 400 eggs in batches fully enclosed in a frothy mass produced by glands at the tip of her abdomen. On contact with the air, the froth hardens to form a tough, spongy envelope that protects the eggs from harm. For further protection of their precious eggs, some female species stand guard over their ootheca (egg batch capsule) until they hatch 3 to 6 weeks later.

Did You Know?
- The largest mantids are strong enough to kill and eat small frogs and nesting birds.
- Praying mantids are among the few insects that can rotate their heads to literally look over their shoulders, making them extremely effective predators.

Population Status
The only real threat to the mantids comes from man's destruction of their habitat. Tropical rainforests and some arid environments are particularly at risk as are regions near areas where pesticides and other airborne pollutants are used.

Where Can You Find Them?
In the gardens and forested areas of warmer regions around the world. The entomology department of the Smithsonian in Washington, D.C., has an incredible display of insects, including mantids. Other prominent collections can be found in the New Walk Museum in Leicestershire, England, the Provincial Museum of Alberta, Canada, and the Australian National Insect Collection in Canberra.

BURCHELL'S ZEBRA [PAGE 34, 40]
Equidae / E. burchelli

Size/Data
Height: 47–55 in.
Length: 7–8 ft.
Tail: 18–22 in.
Weight: 385–850 lbs.

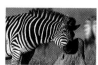

General Description
Burchell's zebra is the most common zebra species and closely resembles a short, stocky horse covered in alternating black and white stripes. It has a black muzzle and hooves. Its forelock-free mane, which runs from its shoulder to the top of its head, continues the same striped pattern from the torso and is composed of stiff, upstanding bristles. Although they all may look alike at a glance, every single zebra has a distinctively different stripe pattern—not unlike a human's fingerprint.

Location/Distribution
Central, eastern and southern Africa.

Behavior
Burchell's zebras are strongly gregarious animals living in family groups of one to 6 mares (along with their foals) under the leadership and protection of a stallion. Surplus stallions live singly, or in bachelor groups of up to 15 members, often making attempts to woo a young mare away

from her family group to start a new one. Burchell's zebras can appear to be rather tame but have a dramatic barking call that ends with a whinny when alarmed. If confronted or cornered, they are capable of vicious kicks and bites. Zebras are grazing animals that prefer to feed on the coarser stem sections of grasses rather than the softer leafier parts.

During courtship the stallion nips at the mare's legs, kneeling down in front of her in an invitation to wrestle. If a mare falls for this playful gesture, roughly 370 days later she will probably give birth to a small, striped foal. The newborn zebra is up on its feet within one hour of birth and ready to move with the herd only a few hours later. During those first hours of its life, the mother, with the assistance of the stallion who patrols a "no-go" zone around her, will ensure that the foal sees no other zebras at all. It is vital that the young zebra imprints only on the mother's unique pattern or it will not know who to feed from and will soon get lost in the herd and die of starvation.

Did You Know?
- There are a total of 3 zebra species, but they are no more closely related to each other than the other members of the family Equidae, horses and asses.
- The Burchell's zebra is named after the British naturalist William John Burchell.
- As most predators see only in black and white, the zebra's bold striped pattern actually camouflages it quite well in long grass and shadowy scrub by breaking up its outline. Furthermore, when zebra are standing together as a group in the open, the confusing array of stripes disguises the overall numbers from predators and makes it hard for them to distinguish individual zebra that might be sick, old, or very young.

Population Status
Lower Risk. Burchell's zebra are abundant and widespread within their African range. Sadly the same cannot be said for all other zebra sub-species. For example the cape zebra (aka mountain zebra) had a population of only 47 back in 1937; this group was transferred to a reserve many years ago and have since slowly increased to 200.

Where Can You Find Them?
Burchell's zebra are the most common zebra to be found in many major zoos, wildlife reserves and safari parks around the world. They can also be found in large herds throughout Kenya's Masai Mara National Reserve. Masai Mara is located just to the north of the Serengeti National Park in Tanzania, from where wildebeest and zebra migrate annually. If you visit the Serengeti you will also probably see another zebra sub-species, Grant's zebra.

AUSTRALIAN PELICAN [PAGE 41]
Pelecanidae / Pelecanus conspicillatus

Size/Data
Weight: 8–15 lbs.
Length: 5–6 ft.
Wingspan: 7–8 ft.

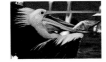

General Description
The most characteristic feature of these large aquatic birds is the elongated bill with its massive throat pouch. There are 7 pelican species in the world, all of which are similar in shape and, with one exception, the brown pelican (*Pelecanus Accidentalis*) of Central and South America, are primarily white in color.

Location/Distribution
The Australian pelican (*Pelecanus conspicillatus*) is found throughout Australia, Papua New Guinea and western Indonesia, with occasional reported sightings in New Zealand and various western Pacific islands.

Behavior
Pelicans are highly mobile, searching out suitable areas of water and adequate food supplies. They eat mostly fish, but are opportunistic feeders and consume a variety of aquatic animals. The Australian pelican may feed alone, but more often feeds as a cooperative group, herding fish into shallow water by beating their wings. During periods of starvation pelicans have been reported to capture, drown and eat seagulls and ducklings. Pelicans will also rob other aquatic birds of their prey.

Breeding may occur at any time of year depending on environmental conditions. Breeding begins with courtship, the female leading 2 to 8 males around on a walk while they threaten each other. Finally, after pursuits on land, water or in the air, only a single male is left and the female leads him to a potential nest site. One to 3 eggs are laid and then incubated on the parents' feet.

Did You Know?
- Despite the pelican's large size, its skeleton is actually very light, making up only 10% of its total body weight.
- Pelicans are excellent soarers and can stay in the air for up to 24 hours.
- The pelican's pouch and bill, which grow to 15 to 20 inches long, play an important role in feeding. The bill is very sensitive to help locate fish in murky water. The pouch is quite strong and can serve as a fish collecting/holding device for a short time. It is also used to collect rainwater for drinking and to dissipate heat in hot weather.
- The brown pelican (*Pelecanus accidentalis*), which is mainly silver-gray and brown with a white-yellow head and chestnut mane, is the only pelican that plunge-dives for fish rather than swimming on the surface.

Population Status
Low Risk.

Where Can You Find Them?
Because of their low risk status and huge range-area requirements, pelicans are rarely held in captivity. They can often be found in fresh water, estuarine and marine wetlands and waterways including lakes, swamps, rivers, coastal islands and foreshores. Australian boating piers are usually a great place to find pelicans, especially if you are trying to quietly eat some fish and chips on your own.

MOOSE [PAGE 42]
Cervidae / Alces alces

Size/Data
Length: 8–10 ft.
Height: 5–8 ft.
Weight: 880–1,800 lbs.
(Note: females are generally 25% smaller than males)

General Description
The moose is the largest surviving species of deer. It has a dense blackish-brown coat with lighter gray underparts, long limbs and splayed hooves. Its head is broad with a pendulous muzzle, a long snout and an overhanging top lip. Hanging beneath its throat is a unique growth of skin and hair known as the "bell." Males have large antlers that are branched, flattened and very wide spreading.

Location/Distribution
Northern America, particularly in Alaska and Canada. The smaller elk, as it is called in Europe, is an almost identical subspecies found in Scandinavia and some parts of north-eastern Europe and Asia.

Behavior
Moose are generally solitary animals or found in small groups. Their diet is composed of leaves, branches, small twigs, water plants and sedges. Because of its large size an adult moose needs to consume up to 11,000 pounds of vegetation each year to survive. As a result, many die of starvation during the winter.

Mating season takes place between September and October, during which the bulls become very aggressive. To secure the available cows, the older bulls drive the younger ones away while rivals of roughly equal size fight in ritualized a test of strength. A dominant bull will mate with more than one cow. A successful union will produce one or 2 young calves after a gestation of 240 to 250 days.

Did You Know?
- The moose can trot at speeds of up to 35 miles per hour. It is also a strong swimmer and can stay under water for a full minute.
- Professional and amateur hunters (legal and illegal) seeking moose antlers as trophies often use a "moose call" to lure a mature bull moose into view. The "moose call" is in fact an imitation of a female moose's call and is therefore most effective in breeding season.
- Out of a population of 150,000 in Alaska, 10,000 are killed annually by hunters.

Population Status
Low Risk. Although hunting and human encroachment have affected moose population numbers, they are still quite abundant in most key areas. It should be noted, though, that one severe winter can cause the population to fluctuate considerably.

Where Can You Find Them?
The best places to see moose are major North American national parks such as Jasper National Park and Banff National Park in Canada and North Cascades National Park, Rocky Mountain National Park, Kenai Fjords National Park, and the Appalachian National Scenic Trail in the United States. To the far north, Alaska, one of the world's last true frontiers, is certainly a great place to visit for wildlife, with Denali National Park and then of course there's Wrangell-St. Elias, the largest park in United States, with over 13 million acres of untouched wilderness (and one or 2 moose, I'll bet).

COQUEREL'S SIFAKA [PAGE 43]
Indriidae / Propithecus verreauxi coquereli

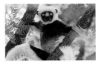

Size/Data
Length
Head & Body: 17–20 in.
Tail: 20–24 in.
Weight: 8–9 lbs.

General Description
Coquerel's sifaka is a slim, somewhat lanky primate with a thick, silky coat of predominantly white or yellowish-white fur around the head, body and tail with distinctive maroon patches on he thighs and arms and across the chest. This unusual tree-dwelling creature has a small patch of short white fur extending from its forehead down its nose to its muzzle on an otherwise naked black face. It has prominent black ears and vivid yellow eyes that, should you be fortunate enough to stare into them, are quite hypnotic. The hands and feet are very narrow and feature naked black palms and soles. The second toes on its hind feet are elongated for grooming.

Location/Distribution
Confined to small forest reserves in northwestern Madagascar, with a general range extending from Ambato-Boeni and Betsiboka River north to around Antsohihy in the northwest and Befandriana Nord in the northeast.

Behavior
Coquerel's sifakas are highly athletic and agile, and thus they are perfectly adapted to arboreal life. They can easily leap across 30-foot gaps between tree branches, but if they are forced onto the ground, which is most unusual, they are decidedly clumsy. Their hands, feet and limbs, while ideal for swinging from treetop to treetop, don't allow them to walk easily on terra firma, and so they tend to skip or dance in a very amusing fashion to the base of their next leafy haven. Coquerel's sifakas are most active during the day as they forage among the trees in groups of 3 to 10 looking for the leaves, fruit, flowers and bark that make up the great bulk of their diet. They eat up to 100 different plant species, although they are heavily reliant on only 12 of these that form 60% of their diet.

The breeding season for Coquerel's sifaka runs from January through March. Females are only receptive to mating for 2 days, so rivalry between males can be quite intense, especially since the female mates only with the dominant male. After mating successfully, the mother will produce only one young in June or July after gestation of 160 days. The infant will cling tightly to its mother's chest and belly for 3 to 4 weeks, whereupon it transfers to riding her back until fully weaned 6 months later.

Did You Know?

- Coquerel's sifakas greet each other by rubbing noses.
- Although hunting still occurs in some areas, the Coquerel's sifaka is actually protected by local taboo (which is known as "fady").
- The Coquerel's sifaka is quite vocal in its communication. It emits a soft cooing sound as a contact call and harsh rattling or grunting sounds as alarm calls.

Population Status

Vulnerable. Accurate population figures are not available although experts are unanimous in their opinion that numbers are declining due to human encroachment and especially the deliberate setting of fires to clear forest and promote the growth of new grass. The last general survey of the Ankaranfantsika Nature Reserve (figures were published in 1999) estimated a population density of approximately 150 animals per square mile. It should be noted that this reserve is relatively tiny and is virtually the only protected area where the Coquerel's sifaka lives.
IUCN Red Book Classification: VU A2cd

Where Can You Find Them?

Coquerel's sifakas have been reduced to small isolated populations as human settlement has rapidly spread throughout Madagascar's forests. There are a total of 10 strict nature reserves in Madagascar (Coquerel's sifaka is found in only 2) along with 23 special reserves. However, the combined area of all these reserves covers a mere 2% of the island. The best place to view Coquerel's sifaka today in (what remains of) its natural environment is at the Ampijoroa Forestry Station (which is part of the Ankarafantsika Nature Reserve). Not only do the well-marked trails provide great viewing opportunities, but several groups of these spectacular lemurs actually live within close proximity to the campsite itself, so seeing them is guaranteed (perhaps even from the comfort of your sleeping bag!). If you can't make it to Madagascar (which would be a great shame), then there is also a small breeding group at the Los Angeles Zoo that is well worth a quick visit.

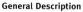

MANDRILL [PAGE 44]
Cercopithecidae / Mandrillus sphinx

Size/Data
Length: (max) 30 in.
Weight: 55–99 lbs.

General Description
These striking baboons have vivid red and blue, dog-like faces, large sharp teeth, short stubby tails and bluish, naked rumps. Their coats are quite long and generally dark olive-brown in color with pale underbelly fur.

Location/Distribution
Mandrills can be found in the African nations of Cameroon, Congo and Equatorial Guinea and also within the small patches of rainforest and mountain forest remaining in Gabon.

Behavior
Mandrills are very social and live in highly organized family troops. During the day they spend a lot of time searching for food such as fruit,

seeds, fungi, roots, insects and even small vertebrates such as lizards. At night they climb up into the trees and sleep as a group. Their brilliantly colored faces and rear ends help mandrills recognize each other on the dark forest floor. Males also use these dramatic features to warn other males to keep away from their territory. Mandrills also communicate through a complex set of social signals; vocal and visual greetings, social grooming, threatening displays and submissive postures are in their repertoire.

Males possess scent glands in the middle of their sternums that produce a waxy, odorous substance, which they rub against trees to mark their territory and attract mates. After successful mating takes place, a female will give birth to a single young after a gestation period of 220 to 270 days. The baby mandrill will be born up in the trees where the troop sleeps and the mother and young will share an extremely strong bond that lasts for many years.

Did You Know?

- In Equatorial Guinea, mandrills are a popular food source for locals and are not protected by law.
- In Gabon, mandrills are hunted for meat and also threatened by timber companies.
- Congo's capital, Brazzaville, has a thriving illegal "bush-meat" trade. In fact, to the Congolese, bush-meat (including mandrill) is their most important source of protein after fish.
- The North Carolina Zoo participates in a survival plan for the mandrill.
- The author of this book (BTG) sponsors a female mandrill called "Oprah" at Australia's beautiful Melbourne Zoo. Oprah was born at the Columbia Zoo (USA) in 1987 and moved to Melbourne in 1996, where she is now the dominant female and is part of a regional breeding program.

Population Status

Vulnerable. The illegal "bush-meat" trade and the rapid habitat conversion of tropical forests into farmland are the primary threats to this species. These factors are compounded by the mandrills' slow reproduction rate. With the surviving population on the African mainland now as small as 3,000 individuals and declining, it is not expected that this species will be around for much more than one generation (30 or 40 years).
IUCN Red Book Classification: VU A2cd

Where Can You Find Them?

Mandrills can still be found in Gabon in the Wonga-Wongue Reserve and 5 other wildlife parks, including Lope Okande Reserve. The largest population of protected mandrills is found in the Korup National Park in northern Cameroon.

ROCK HYRAX [PAGE 48]
Procaviidae / Procavia capensis

Size/Data
Length: 12–22 in.
Height: 7–12 in.
Weight: 7–9 lbs.
(Note: females weigh slightly less than males)

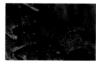

General Description
Furry, compact animals, hyraxes are proportionally very muscular with massive short necks and stubby legs. Their teeth are very sharp; the incisors are used as a means of defense against predators as well as feeding. The front feet have 4 toes; the back have only 3. All feet, however, have soles that are covered with a rubbery pad that secretes a sticky sweat enabling the hyrax to grip smooth rock surfaces.

Location/Distribution
Primarily southern and eastern Africa and, to a lesser degree, the western edge of Asia.

Behavior
The hyrax is a social animal and lives in family groups usually based around small rocky outcrops on the African plains, known as "kopje." They cannot regulate their body temperatures so they warm themselves by basking in the sun and then conserve heat by huddling together. Hyraxes are most active by day alternatively feeding, primarily on grasses and shrubs, and keeping close watch out for predators. The hyrax has very sharp eyesight. Its iris bulges above the pupil, reducing the light from above its head. This enables it to look directly into the sun and keep watch for potential strikes by fast-moving birds of prey.

Breeding seasons vary from region to region, however all hyrax have litters of one to 6 babies after a gestation of 202 to 245 days.

Did You Know?

- The hyrax is a very vocal communicator with 21 distinctly different calls recorded.
- The hyrax has an unusual bone structure that makes scientists believe it is closely related to elephants!

Population Status

Lower Risk. Despite its slow breeding rate and the numerous threats to its habitat, hyrax numbers have, against all odds, remained relatively stable.

Where Can You Find Them?

Hyrax family groups can be found around rocky outcrops throughout Sub-Saharan Africa, except for the densely forested areas in the western and central regions. They can also be seen in similar conditions in the Middle East, particularly the southern Arabian Peninsula.

RING-TAIL LEMUR [PAGE 49]
Lemuridae / Lemur catta

Size/Data
Length
Head & Body: 15–18 in.
Tail: 22–25 in.
Weight: 5–8 lbs.

General Description
Ring-tail lemurs are immediately identified by their long, bushy, black-and-white striped tails, which are significantly longer than their gray bodies. The tail is usually held aloft like a flag, as a recognition signal for other lemurs. The ring-tail has a white snout, which is pointed and somewhat fox-like, and its

brilliant yellow eyes are large and forward facing. Its eyes have black mask-like markings. Its muzzle is also black with sensitive whiskers. The hands and feet have leather-like palms and soles, providing excellent grip on rocky surfaces and its opposable thumbs mean it can grasp any object with the ease of a human being. Both males and females have lower arm scent glands and long second toes on each hind foot, which are used for grooming.

Location/Distribution
Found in rocky and scrubby pockets of Madagascar in the south-west regions of the island.

Behavior
Ring-tail lemurs are gentle, affectionate primates who live in social groups of 15 to 20 members. They are herbivores and feed mainly on fruit and leaves.

Mating season is from April to June, at which time males will have "stink battles" in order to secure a receptive female. This is generally quite a non-violent contest where the males simply smear a strong-smelling substance from their lower arm scent glands onto their tails, which they then wave at each other in a menacing way. Bizarrely enough, this usually works wonders and, once they secure a female's interest, earnest copulation begins. After a gestation of 136 days, one or 2 baby lemurs will make their world debut. As testimony to their social nature, newborn lemurs are suckled by any milk-producing females in the social group.

Did You Know?

- Their long tails act as an effective counter-balance when the lemurs leap or run.
- The celebrated British comic actor and writer, John Cleese, is a Life Benefactor of Jersey Zoo and a massive fan of lemurs. The former *Monty Python* star fell in love with these animals after working closely with them during the production of his successful film, *Fierce Creatures*. He has since visited Madagascar to produce a documentary about the release of captive bred black-and-white ruffed lemurs into Betnampona reserve.
- Young ring-tail lemurs are born with blue eyes that will gradually change color as they mature.

Population Status
Vulnerable. All lemurs are threatened because of habitat destruction. The ring-tailed lemur is more abundant than most, presently inhabiting at least 6 protected areas; however, it is not certain whether these remaining lemur habitats can be preserved for much longer.
IUCN Red Book Classification: VU A1 c

Where Can You Find Them?
Berenty Reserve in Madagascar is considered to be the premier location for viewing and interacting with ring-tail lemurs. One of the largest reserves in Madagascar is Tsingy de Bemaraha, an area of about 375,600 acres, where experts have already recorded 53 different species of birds, 8 reptile species and 6 lemur species living there so far. This great reserve lies 35 to 50 miles inland from the west coast in the northern sector of the

Antsingy region of the Bemaraha Plateau, north of the Manambolo River.

The ring-tail lemur breeds well in captivity and over 1,000 can be found at approximately 140 zoos around the world. The Duke Primate Center in Durham, North Carolina (USA), is one of the world's most respected primate institutions and currently houses a breeding group of around 40 ring-tail lemurs.

RACCOON [PAGE 50]
Procyonidae / Procyon lotor

Size/Data
Length
Head & Body: 17–30 in.
Tail: 8–15 in.
Height: 9–12 in.
Weight: 13–18 lbs.

General Description
The raccoon is roughly the size of a large cat. Its coat is very thick, mostly gray in color, and it has a distinctive black face-mask that is accentuated by lighter bars above and below the eyes. The raccoon's fluffy tail is long with black and gray rings. The raccoon's hind feet are longer than its forefeet. Each has 5 toes, which are quite dexterous and are armed with powerful claws.

Location/Distribution
The raccoon range extends south from Canada through to Central America.

Behavior
Raccoons are generally solitary animals although they can be found in groups at a feeding site where food is plentiful. They are mostly active at night, when they will search for food such as fruit, nuts, insects, reptiles, and amphibians. In rural and urban areas, raccoons will also consume household waste and agricultural crops.

Raccoons usually mate during the winter and produce a litter of between 2 to 7 young after a gestation of 60 to 73 days.

Did You Know?
- The raccoon has very nimble fingers and can twist open a variety of handles and knobs. They have even been known to open refrigerators.
- The raccoon's name means "the one who washes," a reference to its habit of washing its food.

Population Status
Low Risk. Although hunted extensively the raccoon is one of the few animals whose population numbers are not declining. Its broad-ranging diet, high level of intelligence and extremely high ability to adapt to change in its environment, including human encroachment, mean that the raccoon has thrived in pest-like numbers where other species would have disappeared.

Where Can You Find Them?
The raccoon is found over most of the United States, southern and central Canada, and as far south as Costa Rica. It has been introduced into parts of central Europe and Asia. Although not usually kept in zoos, it can be seen in forest reserves and found rummaging through rubbish bins in parks all over the United States.

SLENDER LORIS [PAGE 51, COVER]
Lorisidae / Loris tardigradus

Size/Data
Length
Head & Body: 6–10 in.
Tail: .2–.3 in.
Weight: 9–10 oz.

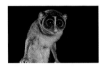

General Description
The slender loris is a primitive monkey about the same size as a chipmunk. They are gray-brown to red-brown in color with light, silvery-gray underparts. Their round faces are dominated by their huge, brown, forward-facing eyes, which provide excellent night vision and precise depth judgement. These eyes are fringed by a dark fur face-mask and separated by a pale central stripe that runs down to a small, pointed nose. Slender lorises have small round ears and extremely thin limbs. Their index fingers are vestigial (in that they are fairly useless-looking stumps), however they still provide greater purchase on vertical branches.

Location/Distribution
Scattered in small numbers throughout the area once known as the Indochina peninsula, including Vietnam, Laos, Cambodia and Malaysia, as well as China and Hainin Island.

Behavior
Slender lorises have strictly arboreal and nocturnal habits which are really their only protection from predatory animals. They sleep during the day, usually rolled up in a hollow, and then emerge at night to feed on the insects that land on flowers and buds. They approach their prey with the utmost caution. Their movements through the trees are deliberate and slow, gripping twigs and branches with all 4 feet where possible. At the last second they snatch their meals with surprising speed.

The female slender loris reaches sexual maturity at 10 months and is receptive to the male twice a year thereafter. After a successful union and a gestation period of 166 to 169 days, a mother will produce one or 2 young, which she will then suckle for 6 to 7 months.

Did You Know?
- Thanks to its big toe on each foot, which opposes the other 4 toes to produce a strong pincer-like grip, the slender loris can actually sleep soundly and safely while holding onto branches.

Population Status
Vulnerable. In the wild the population is unknown.
IUCN Red Book Classification: VU A1cd

Where Can You Find Them?
The celebrated Duke Primate Center in North Carolina (USA), houses a colony of 11 slender lorises, of which 10 were successfully bred in captivity.

PRONGHORN [PAGE 54]
Antilocapridae / Antilocapra Americana

Size/Data
Length
Head & Body: 3–5 ft.
Tail: 3–7 in.
Height: 32–41 in.
Weight: 80–150 lbs.

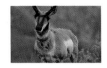

General Description
The pronghorn antelope is red-brown to tan in color, with a white underside, face, rump, and neck bands. The male has a black neck patch and horns that are longer than its ears, with a forward-facing "prong" half-way up its front side. The female's horns are shorter than the ears.

Location/Distribution
Found throughout western parts of North America from southern Canada to northern Mexico.

Behavior
Pronghorns are social, herd-living, territorial grazers. Their diet is composed of shrubs, grass and cacti. When alarmed, the pronghorn raises and splays long white hairs from its rump, which act as a warning sign to other herd members. It also secretes a powerful scent from glands at the base of its rump hairs.

Breeding takes place between July and October when the males confront each other over the available females. The contest begins with a steady stare and a challenging bellow, and then they charge at each other. The weaker male often backs off quickly, but sometimes bloody battles are fought over a herd of females. Successful mating results in a single infant after a gestation of 252 days. After her first pregnancy, a female will often have twins. The newborn fawn's coat is grayish in color but then changes to the same pale tan as the adults after about 3 weeks.

Did You Know?
- The pronghorn is the fastest land mammal in the Americas.
- At just 2 days old, a young pronghorn can out-run the world's fastest man and at 4 days can outrun a horse.
- When galloping at full speed, a pronghorn can take strides of up to 26 feet in length.

Population Status
Lower Risk. From a population of 35 million, the pronghorn was hunted to fewer than 20,000 animals by the 1920's. Conservation measures have increased its numbers to between 750,000 and one million today, but some sub-species remain endangered.

Where Can You Find Them?
The Pierre Hills rangeland of northwest Nebraska contains the United State's highest population of pronghorns.

EMPEROR PENGUIN [PAGE 55, 97]
Spheniscidae / Aptenodytes forsteri

Size/Data
Height: 3–4 ft.
Weight: 44–88 lbs.

General Description
Emperor penguins are by far the largest of all the penguins and, with their vivid orange-yellow chest and head markings, also the most colorful. They have large heads, short thick necks, streamlined body shape, short wedge tails and tiny flipper-like wings. They have white chests with black wings and backs, meaning that they are counter-shaded (having lighter color on the belly and are darker on the back). This makes them hard to see in the water from above or below. Emperor penguins are the only penguins that solely inhabit the Antarctic continent. They are well equipped for the extreme cold, with 3 layers of protection: outer feathers, a dense layer of down and insulating blubber.

Location/Distribution
Antarctica.

Behavior
Emperor penguins live in large social colonies on the ice sheets of the Antarctic. Despite their size, they are incredibly mobile in the water, where they are very fast swimmers, and also on land, where they often lie on their bellies and toboggan swiftly across ice and packed snow with ease. All of their dietary needs are met by the sea, feeding primarily on fish, crustaceans and squid.

Emperor penguins breed during the Antarctic summer (between December and March). Before mating the couple will perform a courting display that features their bright orange ear patches. After successful copulation, the female will lay one white egg in a nest made of grass, feathers, or pebbles. At this point, the female will leave to go fishing and the male will take over all responsibility for the egg, keeping it incubated on his feet under a pouch of feathery belly skin for 64 days. During this time, the male will not eat or drink at all and, as his blubber layer decreases, he will protect the egg and himself from the bitter cold by huddling close with other incubating males to keep warm. When the egg hatches, the female returns and both parents care for the young. In ideal conditions, emperor penguins should live for around 20 years.

Did You Know?
- Emperor penguins can dive to depths of 870 feet and stay submerged for almost 20 minutes.

Population Status
As the present population of emperor penguins contains an estimated 220,000 breeding pairs, and also as they have very few natural enemies,

emperor penguins are generally regarded as a low risk species. It is important to note, though, that the population has started declining and that this species, especially as it is found in concentrated coastal populations on only one continent, is highly vulnerable to any marine-related environmental accident, particularly oil or chemical spills.

Where Can You Find Them?
There are about two dozen recorded emperor penguin colonies in Antarctica ranging in size from less than 200 pairs (Dion Island) to over 50,000 pairs (Coulman Island). The Ross Sea is considered the best area to find large emperor penguin colonies, although it's not somewhere you would set out for with an owl and a pussy-cat in a pea-green boat as you will need to be on board an icebreaker if you hope to survive the voyage.

Emperor penguins are large seabirds with special diet, exercise and climatic needs. They almost never do well in captivity. The only known places that hold emperor penguins at this time are the highly regarded Sea World theme park in San Diego, California, and the Six Flags Worlds of Adventure theme park in Ohio (USA).

AFRICAN LION [PAGE 56–57, 104]
Felidae / Panthera leo

Size/Data
Length
Body: 8–11 ft.
Tail: 2–3 ft.
Weight: 250–525 lbs.

General Description
The lion is the largest and most powerful of the African big cats. It has a lithe, muscular body, acute senses, highly evolved teeth and claws, and effective camouflage coloration. They are model hunters. Males have long, tawny manes, which darken considerably with age, while females have uniform tawny coats.

Location/Distribution
African lions are distributed in limited numbers throughout game reserves in Sub-Saharan Africa.

Behavior
Lions are social and territorial, living in extended family groups called prides that are controlled by a dominant male. A lion's territory and the size of the pride are directly related to the availability of prey and water. Young males are forced to leave the pride when they become mature enough to threaten the dominant male. They may then live alone or with small groups of other young males until they are able to take control of their own pride by fighting off an older lion.

Lions hunt game only when they are hungry. They do not store up food for later consumption or kill for amusement like some other predators. It is always the lionesses who undertake the hunting duties for the pride. They can be very organized, often hunting in groups to perform high-speed coordinated attacks that flush the intended prey,

usually a wildebeest, zebra, impala, antelope, or gazelle, into an ambush that is lying in wait downwind.

Lions can mate most times of the year, however a lioness will only breed once every 2 years. The gestation period for lions is 102 to 112 days after which a litter of 2 to 5 cubs is born. Cubs will spend around 2 months living on their mother's milk before being weaned onto a purely carnivorous diet. Male lions take no interest in rearing their young.

Did You Know?
- When fresh game has been killed by the lionesses the male will eat before the rest of the pride. This is the origin of the expression taking "the lion's share."
- Lion cubs are born blind with spotted coats.
- Lions have a very vocal form of communication involving roars, grunts, and growls.
- If a young male lion fights off an older lion and takes over his pride he will immediately kill (and sometimes eat) all the cubs in the pride. This act forces the lionesses to go back into season and they soon mate with him and have his cubs.

Population Status
African lions are vulnerable. The 10,000 wild African lions that remain today survive only in protected reserves. A small population was thought to exist in remote parts of Iran but is now believed to be extinct. The Asiatic lion (*Panthera leo persica*), which is another slightly smaller sub-species, is also highly endangered and found only in India's Gir Forest.
IUCN Red Book Classification: VU A1cd

Where Can You Find Them?
African game reserves and national parks are the best hope for the lion's survival and also the best place to see them. The Lower Zambezi National Park is considered one of the better locations for viewing lions and the following South African parks are worth visiting as they are involved in lion reintroduction programs: Hluhluwe-Umfolozi, Madikwe, Phinda, Pilansberg and Makalali. The Serengeti Reserve in Tanzania has 15 known lion prides and there are also established prides living in the picturesque Ngorongoro Crater.

Lions are also popular exhibits at many zoos. The Melbourne Zoo, Sydney's Taronga Zoo and the North Carolina Zoo all participate in an international survival plan for lions.

TIGER SWALLOWTAIL BUTTERFLY [PAGE 58–59]
Papilionidae / Papilio glaucus

Size/Data
Wingspan: 2–11 in. (This family includes the bird-wings, the largest butterflies in the world, now protected by law).

General Description
Swallowtail butterfly species typically have elongated tails on their hind wings. Their scalloped-shaped wings are often dark with scalloped-shaped markings or lighter bands, spots or patches of white, yellow, orange, red, green or blue.

Location/Distribution
There are 600 sub-species of swallowtail butterflies distributed worldwide except for the polar regions.

Behavior
Swallowtail butterflies are herbivorous, feeding on nectar and other liquids from a specific family of plants.

During the breeding cycle, a female swallowtail will lay single round eggs on specific host plants, usually deciduous trees (trees that shed their leaves seasonally). After hatching, the caterpillars feed among the highest foliage in the same shrub or tree. The swallowtail caterpillars have forked, fleshy scent glands that emit an odor to protect them from predators. After feeding voraciously for some time, they undergo pupation on the same plant, later emerging from their chrysalis as a fully formed butterfly.

Did You Know?
- Some butterflies, like the famous monarch butterfly of North and Central America, are left alone by birds because they taste awful. This is because of the toxic sap contained in the leaves eaten by the butterflies during their caterpillar phase. The caterpillar is immune to the natural toxins and the elements stay inside its body even after it goes through pupation and becomes a butterfly. As these butterflies always return to the same plant species to reproduce, predatory birds learn to leave them well alone.

Population Status
Lower Risk. Like all flying insects, butterflies are particularly vulnerable to airborne pesticides. Species within a heavily sprayed region can be wiped out fairly quickly. As many are specialist feeders, they are also affected greatly by introduced plant species that compete with or dominate their own food plants, and when their food plants are destroyed by human encroachment. Nevertheless, at present most butterfly populations are fairly stable.

Where Can You Find Them?
Swallowtail butterflies prefer the world's warmer regions. They are most likely to be found in open or shaded flower-rich areas. Commercial butterfly farms and exhibits are becoming popular in some parts of the world. The largest exhibits are in museums such as the Natural History Museum, Fribourg, Switzerland, the Natural History Museum of Maastrich, The Netherlands and the Provincial Museum of Alberta, Canada.

India's Sanjay Gandhi National Park in Borivali, Mumbai, is famous for its high number of butterflies, as is Papua New Guinea's Baiyer River

Wildlife Sanctuary, which hosts 80 different butterfly species.

AFRICAN SPOONBILL [PAGE 60]
Threskiornithidae / Platalea alba

Size/Data
Height: 35 in.
Bill Length: 14–16 in.

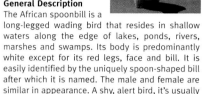

General Description
The African spoonbill is a long-legged wading bird that resides in shallow waters along the edge of lakes, ponds, rivers, marshes and swamps. Its body is predominantly white except for its red legs, face and bill. It is easily identified by the uniquely spoon-shaped bill after which it is named. The male and female are similar in appearance. A shy, alert bird, it's usually found singly but can also be found in groups or pairs.

Location/Distribution
Botswana, Kenya, Madagascar, Mozambique, Namibia, South Africa and Zimbabwe.

Behavior
It feeds on fish, small amphibians and aquatic invertebrates by wading through the shallows, swinging its bill from side to side through the water and snapping it shut when its prey is positioned within the spoon shaped portion.

Spoonbills breed in colonies. Mating season begins in the winter and continues through the spring. Having built a nest of sticks and reeds in the trees close to the water's edge, the female then lays 3 to 5 white eggs that are spotted with red, brown and blue dots. The male and female take turns incubating the eggs for about 29 days, at which time the chicks make their egg-shattering debut. The baby chicks are then raised by both parents until they are ready to fly about 4 weeks later.

Did You Know?
- At birth the African spoonbill's bill does not resemble a spoon at all. It hatches with a short beak that gradually develops its spoon shape later on.
- The African spoonbill is one of only 3 remaining large birds (the other 2 being the cassowary and the jabiru stork) that have not attacked the author (BTG) at some point in his life. Surprisingly, the most severe injuries he has received from enraged birds, to date, were inflicted by blue penguins (aka "fairy penguins"), the world's smallest penguin species.

Population Status
Lower Risk. Spoonbills are still a fairly common sight on the African waterways within its range, especially in South Africa.

Where Can You Find Them?
You can see spoonbills in their natural environment in Kruger National Park in South Africa, Namibrand Nature Reserve in Namibia and Hwange National Park in Zimbabwe.

BAT-EARED FOX [PAGE 61]
Canidae / Otocyon megalotis

Size/Data
Length: 18–26 in.
Height: 12–16 in.
Weight: 6–11 lbs.
Tail: 9–10 in.
Ears: 4–5 in.
(Note: females are slightly larger than males)

General Description
Bat-eared foxes are a most unusual member of the dog family. These smallish canines are slight in build with bushy tails and long legs. They are mostly grayish-yellow with dark brown areas around their eyes, ears and forelegs. Their muzzles are short and pointed and, of course, they possess disproportionately large oval-shaped ears from which they get their name.

Location/Distribution
From southern Sudan to south-western Tanzania in the north and from Namibia to central South Africa in the south.

Behavior
Bat-eared foxes are burrow-dwelling animals that live in Africa's arid grasslands. They are not strictly nocturnal or diurnal as they are active in the night during summer and during the day in winter. When searching for food (including termites, beetles, reptiles, bird's eggs, fruit and small mammals), they continually move their head from side to side in order to triangulate and pinpoint the location of any sounds with their radar dish-like ears.

Bat-eared foxes are quite social in nature and share their burrows with small family groups. Bat-eared foxes appear to mate for life and form strong bonds. After successful copulation, female foxes give birth to a litter of 2 to 5 young after a gestation period of around 70 days.

Did You Know?
- Bat-eared foxes regularly eat scorpions, swallowing both the stingers and poison sacs with no apparent side effects.
- Unlike those of other fox species, its teeth are adapted for crushing as opposed to tearing and chewing.

Population Status
Bat-eared foxes are considered a low risk species. Their population fluctuates greatly, however, as they are particularly vulnerable to outbreaks of rabies, which can occur as often as twice a year.

Where Can You Find Them?
The Serengeti National Park in Tanzania and Botswana's Chobe National Park both have regular sightings of bat-eared foxes.

(UNIDENTIFIED) DRAGONFLY [PAGE 62]
Odonata

Size/Data
Size varies from species to species, however these insects are typically 1 in. long.

General Description
Dragonflies are large, powerful flyers with 2 pairs of glassy, membranous wings and long, almost thread-like, abdomens. They have 6 strong, spiny, forwardly directed legs and well-developed mouth parts. Their 2 eyes are proportionally very large while their antennae are small and quite inconspicuous. Dragonfly coloration is often very bright and ranges from yellows and reds (like this specimen photographed in Japan) through to green and even electric blue; few species are subdued in color or camouflaged in any way. Their wings, while generally transparent, can also feature strong patches of color.

Location/Distribution
There are about 5,500 dragonfly species, divided into roughly 30 families, and these are distributed throughout the globe except for the polar regions; the greatest varieties occur in the tropics.

Behavior
Dragonflies are carnivores and have strongly developed predatory habits. They feed on smaller insects, attacking them in flight by swooping into them and applying a vice-like grip with their spiky forelegs. They may further disable their victims by biting them, but they will generally head for a secure site where they can chew away at their leisure.

Adult dragonflies mate in flight. The male flies ahead of the female and grips her head with his special claspers, located at the very tip of his abdomen. The female then bends her abdomen forward and receives the spermatozoa from a special copulatory organ that lies at the front of the male abdomen. After mating, the female lays her eggs in a body of still water. To do this, she either attaches the eggs to aquatic plants on the water's surface or washes the eggs off her abdomen so that they sink to the bottom of the pool or adhere to submerged vegetation.

Did You Know?
- The fastest known insect is a dragonfly that was clocked at 36 miles per hour.
- Dragonflies are commonly called "horse stingers" and "devil's darning needles."
- Unlike other insects, dragonflies rest with their wings held out.
- Each eye on a dragonfly is made up of up to 28,000 lenses!
- The smallest dragonfly, found in Malaysia, is only .6 inches in length, while the largest, found in South America, is over 10 times that size.

Population Status
Lower Risk. Dragonfly populations in most areas are generally very stable except for those species in regions affected by airborne and especially waterborne pollutants. As all dragonflies start life as aquatic nymphs, an excessive amount of toxic material in their breeding water can wipe out almost an entire family of these insects in just one egg-laying season.

Where Can You Find Them?
Dragonflies are commonly found near still water with nearby vegetation, such as large puddles, ponds and swamps—unfortunately so are mosquitoes. The author (BTG) once observed gigantic swarms of bright dragonflies in the countryside around Baguio City, located within the mountainous Philippine province of Benguet, about 60 miles north of the capital Manila, on the island of Luzon.

NINE-BANDED ARMADILLO [PAGE 63]
Dasypodidae / Dasypus novemcinctus

Size/Data
Length: 15–22 in.
Tail: 11–18 in.
Weight: 6–9 lbs.

General Description
The nine-banded armadillo is a medium-sized armadillo species that derives its name from the 9 distinctive bands of armored plates that run across the middle of its back. In addition to these 9 bands, the armored plates, which are attached to flexible skin and are hard and bony, extend the entire length of the head and body to provide protection against attack. The armadillo's short limbs are very strong and its feet are equipped with sharp, curved claws for rapid burrowing and digging for food. The underside has no armor, so when attacked by larger predators, the armadillo protects itself by lying flat on the ground with its legs tucked underneath over its vulnerable regions.

Location/Distribution
The armadillo's range extends through the southern United States, Mexico, the Caribbean, Central America and South America.

Behavior
Armadillos are generally nocturnal scavengers by nature, usually being most active at night, when they emerge from their burrows to consume insects, small animals, fruit, roots, bird eggs and even carrion (dead animals).

The breeding season commences with mating during the summer months which, if successful, then results in a litter of identical quadruplets after a 70 day gestation. If desired, a female can delay the implantation and become pregnant some time after being inseminated by the male.

Did You Know?
- The nine-banded armadillo is the only species of armadillo that can swim. It does this by inflating its stomach and intestines with air to keep buoyant, like an internal life-preserver, and then paddling ferociously like a dog.
- The name "armadillo" comes from the Spanish word "armado" meaning "one that is armed." This refers to the suit of natural armor it wears, which was supposedly similar (at least in principle) to the metal armor that a Spanish soldier of the 15th century would wear for battle.

Population Status
Lower Risk. In some areas it is quite common, even reaching "pest status" in some agricultural regions, although it does help keep insect numbers in check.

Where Can You Find Them?
On the American continent this animal can be found in a range stretching from Kansas and Missouri in the United States, through Mexico and Central America to Argentina and Uruguay in the south.

KING BIRD OF PARADISE [PAGE 64]
Paradisaeidae / Cicinnurus regius

Size/Data
Length
Body: 6–7 in.
Tail Plumes: 5.5 in.

General Description
Birds of paradise are stout, colorful, flamboyant birds. The king bird of paradise is the smallest member of this species. It has vivid red plumage, bright blue feet, a vertical black "eyebrow" and long green tail streamers. Unlike most bird species, in which males and females have markedly different plumage, both sexes of the king bird of paradise are almost identical (monomorphic).

Location/Distribution
Papua New Guinea.

Behavior
The king bird of paradise is mostly solitary outside of the breeding season. Its diet consists of fruit, leaves, buds, flowers, insects, spiders and even small vertebrates like frogs or mice.

When the breeding season begins, the male will try to attract a partner by performing elaborate displays accompanied by his colorful plumage accompanied by loud vocal calls. After mating, the female will lay between one and 3 beautifully colored eggs in a nest within a hollow tree. The chicks hatch after an incubation period of 17 to 21 days. The male and female share all nesting duties.

Did You Know?
- The hunting of birds of paradise for their plumage was made illegal in 1924. However, sadly, this practice still continues today. This is a major problem in Indonesia's Papua province (formerly Irian Jaya) where numerous corrupt Indonesian military personnel actively trade in live birds and their plumage on the Javanese black market.
- Birds of paradise are important symbols to the people of Papua New Guinea. Their feathers feature prominently on traditional Papuan ceremonial clothing and headdresses. A stylized, yellow, kumul bird of paradise design appears on the national flag.

Population Status

At Risk. Although the bird of paradise population once suffered a dramatic drop due to hunting (live birds, stuffed specimens and feathers are all very popular with collectors), today loss of habitat is a far greater threat to the king and many other bird of paradise species, especially those with restricted ranges.

Where Can You Find Them?

There are a number of places to see these highly decorative birds within the wet montane forests of Papua New Guinea. Baiyer River Wildlife Sanctuary, in the western highlands, protects the largest collection of birds of paradise in the world. Ambua Lodge, Tari, Kiunga and the Moitaka sanctuaries are established bird-watching areas. The Ekame Lodge, a traditional Papua New Guinean longhouse, is regarded as a good location for spotting the king bird of paradise.

Singapore's famous Jurong Bird Park, home to the world's largest aviary and highest man-made waterfall, has a substantial birds of paradise exhibit and is well worth a look. When the author (BTG) visited Jurong Bird Park some years ago, he was very impressed with a number of attractions including the diverse penguin exhibit. Although he was slapped across the back of the head by a large African vulture, he was still over-awed by the Kings of the Sky Show, a remarkable birds-of-prey flying and hunting demonstration.

SALLY LIGHTFOOT CRAB [PAGE 65]
Grapsidae / Grapsus grapsus

Size/Data
The adult Sally Lightfoot carapace (main body shell) is about 3 in. long.

General Description
As the largest rock-runner crab species, the Sally Lightfoot is easily spotted because of its stunning, bright coloring. The adults are red dorsally and bright blue ventrally. Juveniles, however, are black, which enables them to escape predators by helping them blend into their rocky coastline habitats. They have square, flat carapaces and their deeply spooned claws are adapted for grazing on algae and scavenging.

Location/Distribution
These colorful crabs have a range that extends through Bermuda, Florida, Brazil, the Caribbean and the Galápagos Islands.

Behavior
Like most crabs, Sally Lightfoots are omnivorous, feeding on algae and marine detritus. They have even been known to be cannibals. These crabs run so quickly, they can actually skim across the surface of still water to evade capture. Sally Lightfoot crabs release their larvae in pelagic marine environments. The larvae then return to the shore to grow to adulthood, shedding and growing new shells as they increase in size. Their main predators are herons, moray eels, and occasionally hawk-fish.

Did You Know?
- According to legend, this stunning crab was named after Sally Lightfoot, an exotic female dancer from Jamaica whose artistic athleticism was very popular with passing pirates.
- When threatened, these crabs can fire powerful and reasonably accurate squirts of water to startle their attackers.
- There are many different crab species. They range in size from the tiniest malacostracans, which are smaller than .04 inches across, to the biggest, the Japanese Spider Crab, with an incredible leg-span of up to 13 feet!

Population Status
Sally Lightfoots are quite common and thus are considered low risk. However, like all coastal creatures, they are highly vulnerable to both ocean pollution and urban impact and thus (particularly after industrial/urban eco-disasters like oil spills or toxic storm water inundation) can suffer huge population losses in a very short space of time.

Where Can You Find Them?
If you are in the range area of these crabs they can be easily located scampering over stone breakwaters and rocky shores in the "splash zone," which is an area approximately 10 to 13 feet above the water's surface.

KILLER WHALE [PAGE 66]
Delphinidae / Orcinus orca

Size/Data
Length
Male: 26–30 ft.
Female: 23–26 ft.
Weight
Male: (max) 20,000 lbs.
Female: (max) 12,000 lbs.
Dorsal Fin Length
Male: up to 70 in. Female: 35–47 in.

General Description
Killer whales are actually large members of the dolphin family. They have bold markings with black backs, sides, dorsal fins, flippers and upper flukes, with white chins, throats, bellies and under-flukes. Saddle markings on their flanks are a grayish-white and differ slightly in shape on each individual. Their flippers are large and rounded while their dorsal fins are very long and straight. Their tail flukes are exceptionally powerful. At the other end, they have 40 to 50 sharp, curved, oval-shaped teeth that interlock perfectly when the broad jaws are closed. Males are distinguished from females by their larger size and by their longer, vertical dorsal fins. A female's dorsal fin is smaller and curves backward slightly in a manner somewhat like a dolphin.

Location/Distribution
Found in the cooler regions of every ocean of the world.

Behavior
The killer whale is a powerful apex predator that feeds on fish, squid and, to a lesser extent, seals and other whales. Much is made of their ferocious name and lethal capabilities, but in fact orcas are intelligent and often surprisingly gentle creatures who kill only to eat. Killer whales are also highly sociable; they generally live and hunt in a pod (family group).

Mating usually takes place in early winter. Females breed only once every 3 to 8 years. Following copulation, a single calf is born after a very long gestation that can stretch from 390 to 520 days. Scientific studies, both in the wild and in captivity, have found that killer whales demonstrate a high level of parental care.

Did You Know?
- The orca is the fastest-swimming marine mammal, reaching speeds of up to 31 miles per hour.
- The impact splash caused by a breaching killer whale can be heard at a distance of several miles.
- The orca can toss its prey, weighing as much as 650 pounds, high into the air.
- The killer whale's great intelligence makes it a popular exhibit at numerous marine parks, where they can be easily trained to display their power, agility and aquatic athleticism on command. When treated properly, orca form close bonds with their human handlers who can then swim with them in complete safety.

Population Status
Lower Risk. At this time the killer whale is quite widespread and, although conservation dependent, in no immediate danger. There are some concerns where they compete with fishermen for depleted fish stocks. Some fisherman kill the orcas thinking it is killer whales who are responsible for the reduction in fish numbers as opposed to their own intensive, large-scale fishing activity. More recently, there has been an increase in the number of killer whales hunted and captured live for marine parks but this seems to be a quite controlled, highly regulated practice in most countries.
IUCN Red Book Classification: LR/cd

Where Can You Find Them?
British Columbia in the southwestern region of Canada is known for its large populations of killer whales. The coast of British Columbia, Strait of Georgia, Johnstone Strait, the west coast of Vancouver Island and the Inside Passage are great locations for orca watching. The best times are usually in the summer. When the author (BTG) went killer whale watching in winter, he was chilled to the bone and didn't find one single whale. That being said he saw lots of porpoises, seabirds and unusual seals and still had a great time. Killer whales can be seen off the southern beaches of Argentina (some coming right up onto the beach to snatch seals). On South Australia's coastline, also home of some of the world's biggest great white sharks, killer whales may be seen year-round.

POLAR BEAR [PAGE 67]
Ursidae / Ursus maritimus

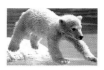

Size/Data
Length
Male: 10 ft.
Female: 8 ft.
Tail: 3–5 in.
Height: 5 ft.
Weight
Male: 770–1,400 lbs. Female: 385–660 lbs.

General Description
Polar bears are heavily built carnivores with large skulls, thick legs and short tails. Their necks are considerably longer than other bears. A polar bear coat is creamy white in color but underneath its fur, the skin is black. They are well suited to cold weather with insulating fat and partially furred paw pads that help retain heat.

Location/Distribution
Polar bears are circumpolar in the Northern Hemisphere, although their range extends south through some of the remote northern coastal regions of Alaska and Canada.

Behavior
Polar bears are the world's largest land carnivores, perfectly equipped for the harsh climate of the far north. Their scientific name means "sea bear" and, being powerful swimmers with almost waterproof fur, they certainly feel at home in the ocean, often drifting for hundreds of miles on pack ice.

Polar bears prey heavily on seals, often ambushing them at their breathing holes in the ice. These giant bears have an excellent sense of smell, enabling them to sniff out prey many miles away or even pinpointing a seal pup in its den, located up to 3 feet underneath the snow, before digging it out and devouring it. Polar bears have no natural enemies and so are completely fearless. They are generally solitary animals but have been known to come together to feed, and, of course, breed.

Male and female bears may indulge in playful courtship fighting sessions before finally mating. Breeding takes place between March and June and will often result in the birth of 2 cubs after a gestation of 195 to 265 days. The mother and cub form a very strong bond and will stay together for about 3 years.

Did You Know?
- A polar bear can sprint up to 25 miles per hour for short bursts but quickly overheats and has to jump into the sea to cool off.
- The Alaskan Inuit (Eskimo) people still hunt the polar bear for fur and flesh but cannot eat its liver, since its high content of vitamin C makes it poisonous to humans. The Inuit kill approximately 130 polar bears per year for traditional subsistence use (hide, meat and handicrafts).
- The photographer (MI) has recently spent 13 months in Canada and Alaska photographing and filming polar bears for his latest wildlife project.